Art Nouveau

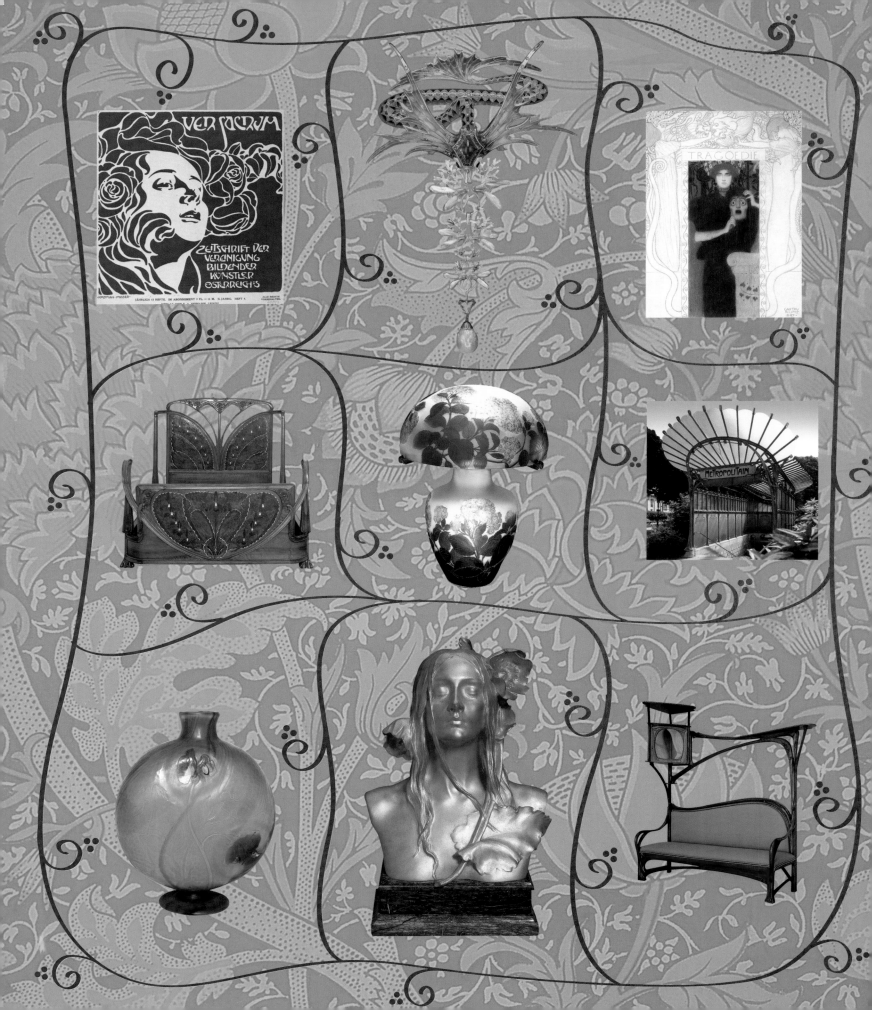

Art Nouveau

Text: Jean Lahor (adaptation)
Translator: Rebecca Brimacombe

Layout:
Baseline Co Ltd
127-129A Nguyen Hue Blvd, Fiditourist, Level 3
District 1, Ho Chi Minh City
Vietnam

Published in 2007 by Grange Books
an imprint of Grange Books Plc
The Grange Kingsnorth Industrial Estate
Hoo, nr Rochester, Kent ME3 9ND
www.grangebooks.co.uk

ISBN: 978-1-84013-891-7

Printed in China

~ Contents ~

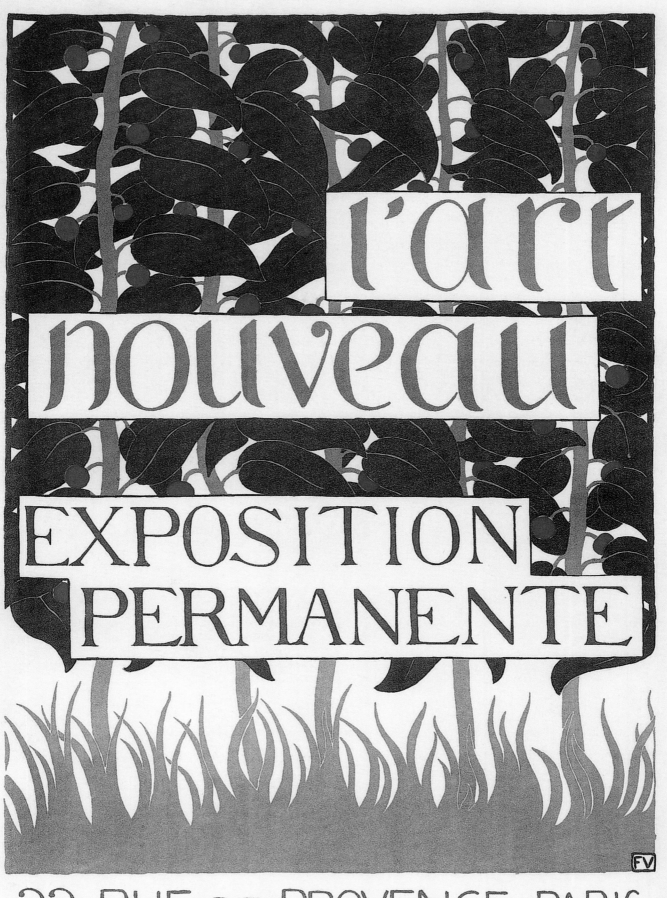

l'art nouveau
EXPOSITION PERMANENTE

22. RUE DE PROVENCE. PARIS

I. The Origins of Art Nouveau

"One can argue the merits and the future of the new decorative art movement, but there is no denying it currently reigns triumphant over all Europe and in every English-speaking country outside Europe; all it needs now is management, and this is up to men of taste." (Jean Lahor, Paris 1901)

Art Nouveau sprang from a major movement in the decorative arts that first appeared in Western Europe in 1892, but its birth was not quite as spontaneous as is commonly believed. Decorative ornament and furniture underwent many changes between the waning of the Empire Style around 1815 and the 1889 Universal Exposition in Paris celebrating the centennial of the French Revolution. For example, there were distinct revivals of Restoration, Louis Philippe, and Napoleon III furnishings still on display at the 1900 Universal Exposition in Paris. Tradition (or rather imitation) played too large a role in the creation of these different period styles for a single trend to emerge and assume a unique mantle. Nevertheless there were some artists during this period that sought to distinguish themselves from their predecessors by expressing their own decorative ideal.

What then did the new decorative art movement stand for in 1900? In France, as elsewhere, it meant that people were tired of the usual repetitive forms and methods, the same old decorative clichés and banalities, the eternal imitation of furniture from the reigns of monarchs named Louis (Louis XIII to XVI) and furniture from the Renaissance and Gothic periods. It meant designers finally asserted the art of their own time as their own. Up until 1789 (the end of the ancien régime), style had advanced by reign; this era wanted its own style. And (at least outside of France) there was a yearning for something more: to no longer be slave to foreign fashion, taste, and art. It was an urge inherent in the era's awakening nationalism, as each country tried to assert independence in literature and in art.

In short, everywhere there was a push towards a new art that was neither a servile copy of the past nor an imitation of foreign taste.

There was also a real need to recreate decorative art, simply because there had been none since the turn of the century. In each preceding era, decorative art had not merely existed; it had flourished gloriously and with delight. In the past, everything from people's clothing and weapons, right down to the slightest domestic object – from andirons, bellows, and chimney backs, to one's drinking cup – were duly decorated: each object had its own ornamentation and finishing touches, its own elegance and beauty. But the nineteenth century had concerned itself with little other than function; ornament, finishing touches, elegance, and beauty were superfluous. At once both grand and miserable, the nineteenth century was as "deeply divided" as Pascal's human soul. The century that ended so lamentably in brutal disdain for justice among peoples had opened in complete indifference to decorative beauty and elegance, maintaining for the greater part of one hundred years a singular paralysis when it came to aesthetic feeling and taste.

The return of once-abolished aesthetic feeling and taste also helped bring about Art Nouveau. France had come to see through the absurdity of the situation and was demanding imagination from its stucco and fine plaster artists, its decorators, furniture makers, and even architects, asking

Félix Vallotton,
L'Art Nouveau, Exposition Permanente,
1896.
Poster for Siegfried Bing's gallery, colour lithograph, 65 x 45 cm.
Victor and Gretha Arwas collection.

all these artists to show some creativity and fantasy, a little novelty and authenticity. And so there arose new decoration in response to the new needs of new generations. [1]

The definitive trends capable of producing a new art would not materialise until the 1889 Universal Exposition. There the English asserted their own taste in furniture; American silversmiths Graham and Augustus Tiffany applied new ornament to items produced by their workshops; and Louis Comfort Tiffany revolutionised the art of stained glass with his glassmaking. An elite corps of French artists and manufacturers exhibited works that likewise showed noticeable progress: Emile Gallé sent furniture of his own design and decoration, as well as coloured glass vases in which he obtained brilliant effects through firing; Clément Massier, Albert Dammouse, and Auguste Delaherche exhibited flambé stoneware in new forms and colours; and Henri Vever, Boucheron and Lucien Falize exhibited silver and jewellery that showed new refinements. The trend in ornamentation was so advanced that Falize even showed everyday silverware decorated with embossed kitchen herbs.

The examples offered by the 1889 Universal Exposition quickly bore fruit; everything was culminating into a decorative revolution. Free from the prejudice of high art, artists sought new forms of expression. In 1891 the French Societé Nationale des Beaux-Arts established a decorative arts division, which although negligible in its first year, was significant by the Salon of 1892, when works in pewter by Jules Desbois, Alexandre Charpentier, and Jean Baffier were exhibited for the first time. And the Société des Artistes Français, initially resistant to decorative art, was forced to allow the inclusion of a special section devoted to decorative art objects in the Salon of 1895.

It was on 22 December that same year that Siegfried Bing, returning from an assignment in the United States, opened a shop named Art Nouveau in his townhouse on rue Chauchat, which Louis Bonnier had adapted to contemporary taste. The rise of Art Nouveau was no less remarkable abroad. In England, Liberty shops, Essex wallpaper, and the workshops of Merton-Abbey and the Kelmscott-Press under the direction of William Morris (to whom Edward Burne-Jones and Walter Crane provided designs) were extremely popular. The trend even spread to London's Grand Bazaar (Maple & Co), which offered Art Nouveau to its clientele as its own designs were going out of fashion. In Brussels, the first exhibition of La Libre Esthétique opened in February 1894, reserving a large space for decorative displays, and in December of the same year, the Maison d'art (established in the former townhouse of prominent Belgian lawyer Edmond Picard) opened its doors to buyers in Brussels, gathering under one roof the whole of European decorative art, as produced by celebrated artists and humble backwater workshops alike. More or less simultaneous movements in Germany, Austria, the Netherlands, and Denmark (including Royal Copenhagen porcelain) had won over the most discriminating collectors well before 1895.

The expression "Art Nouveau" was henceforth part of the contemporary vocabulary, but the two words failed to designate a uniform trend capable of giving birth to a specific style. In reality, Art Nouveau varied by country and prevailing taste.

As we shall see, the revolution started in England, where at the outset it truly was a national movement. Indeed, nationalism and cosmopolitanism are two aspects of the trend that we will discuss at length. Both are evident and in conflict in the arts, and while both are justifiable trends, they both fail when they become too absolute and exclusive. For example, what would have happened to Japanese art if it had not remained national? And yet Gallé and Tiffany were equally correct to totally break with tradition.

Unsigned,
Peacock Table Lamp. Patinated bronze, glass and enameld glass.
Macklowe Gallery, New York.

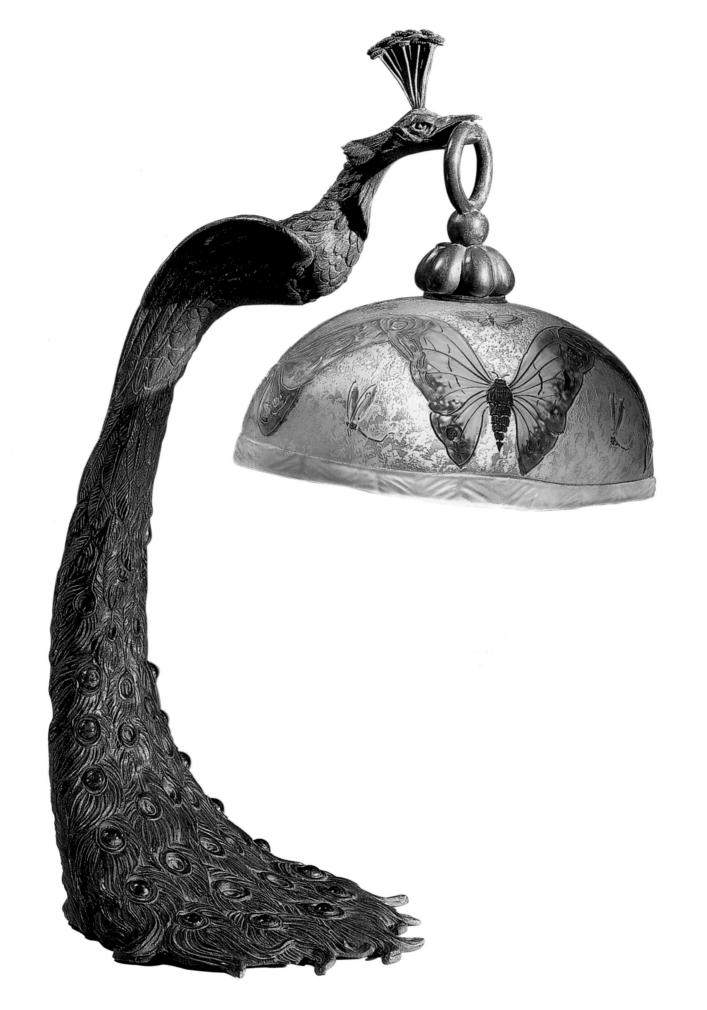

James McNeill Whistler,
Peacock Room from the Frederic
Leyland House, 1876.
Freer Gallery of Art, Washington, D.C.

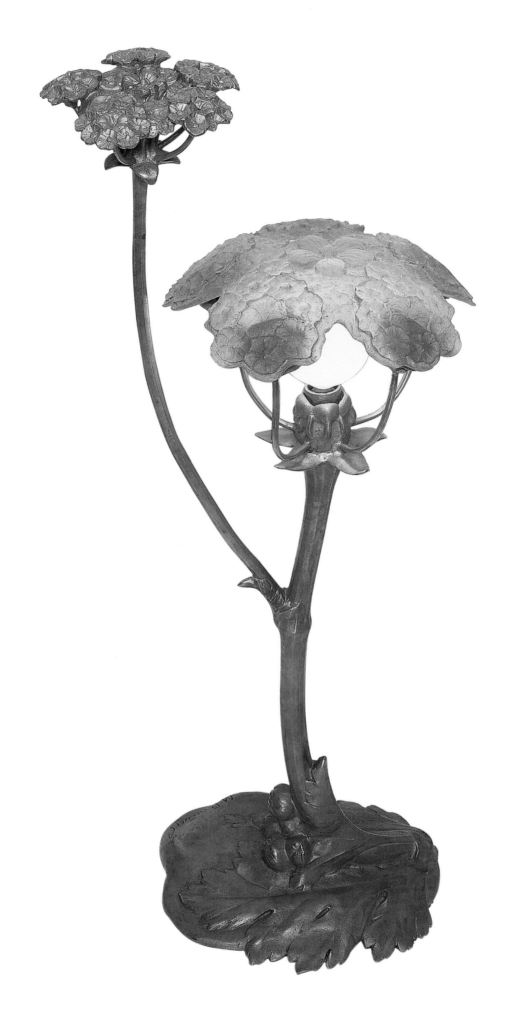

England: Cradle of Art Nouveau

In the architecture of its palaces, churches, and homes, England was overrun with the neoclassical style based on Greek, Roman, and Italianate models. Some thought it absurd to reproduce the Latin dome of Rome's Saint Peter's Cathedral in the outline of Saint Paul's Cathedral, its Protestant counterpart in smoky, foggy, London, along with colonnades and pediments after Greece and Rome, and eventually England revolted, happily returning to English art. The revolution occurred thanks to its architects, first to A.W.N. Pugin, who contributed to the design of the Houses of Parliament, and later to a whole group of mostly Pre-Raphaelite artists who more or less favoured art before the pagan art of the sixteenth century, before the classicising trend so hostile in its origins and its nature to English tradition.

The main proponents of the new decorative art movement were John Ruskin and William Morris: Ruskin, for whom art and beauty were a passionate religion, and Morris, of great heart and mind, by turns and simultaneously an admirable artist and poet, who made so many things and so well, whose wallpapers and fabrics transformed wall decoration (leading him to establish a production house) and who was also the head of his country's Socialist Party.

With Ruskin and Morris among the originators, let's not forget the leaders of the new movement: Philip Webb, architect, and Walter Crane, the period's most creative and appealing decorator, who was capable of exquisite imagination, fantasy, and elegance. Around them and following them arose and was formed a whole generation of amazing designers, illustrators, and decorators who, as in a pantheistic dream, married a wise and charming fugue to a delicate melody of lines composed of decorative caprices of flora and fauna, both animal and human. In their art and technique of ornamentation, tracery, composition, and arabesques, as well as through their cleverness and boundless ingenuity, the English Art Nouveau designers recall the exuberant and marvellous master ornamentalists of the Renaissance. No doubt they knew the Renaissance ornamentalists and closely studied them, as they studied the contemporaneous School of Munich, in all the fifteenth- and sixteenth-century engravings that we undervalue today, and in all the Munich school's niello, copper, and woodcrafts. Although they often transposed the work of the past, the English Art Nouveau designers never copied it with a timid and servile hand, but truly infused it with feeling and the joy of new creation. If you need convincing, look at old art magazines, such as *Studio*, *Artist*, or the *Magazine of Art*,[2] where you will find (in issues of *Studio* especially) designs for decorative bookplates,[3] bindings, and all manner of decoration; note in the competitions sponsored by *Studio* and *South Kensington*, what rare talent is revealed among so many artists, including women and young girls. The new wallpapers, fabrics, and prints that transformed our interior decoration may have been created by Morris, Crane, and Charles Voysey as they dreamed primarily of nature, but they were also thinking about the true principles of ornamentation as had been traditionally taught and applied in the Orient and in Europe in the past by authentic master decorators.

Finally, it was English architects using native ingenuity and artistry who restored the English art of old, revealing the simple charm of English architecture from the Queen Anne period, and from the sixteenth to the eighteenth centuries in England. Quite appropriately they introduced into this revival of their art – given the similarity between the climates, countries, customs, and a certain common origin – the architectural and decorative forms of Northern Europe, the colourful architecture of the region, where from Flanders to the Baltic, grey stone

Maurice Bouval,
Umbellifer, Table Lamp.
Gilt bronze and moulded glass.
Exhibited at the Salon of the Société des Artistes Français in 1903 in Paris.
Macklowe Gallery, New York.

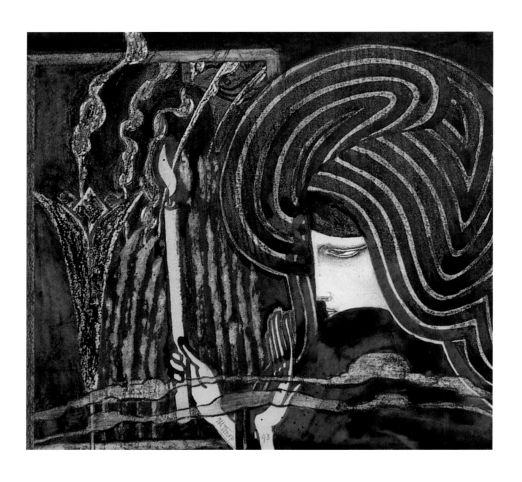

Jan Toorop,
Soul Searching, 1893.
Watercolour, 16.5 x 18 cm.
Kröller-Müller Museum, Otterlo.

Julia Margaret Cameron,
Profile (Maud).
Photograph, 32.3 x 26.5 cm.
Musée d'Orsay, Paris.

William Morris,
Cray, 1884.
Printed cotton, 96.5 x 107.9 cm.
Victoria and Albert Museum, London.

was subordinate to brick and red tile, whose tonality so complements the particular robust green of the trees, lawns, and meadows of northern prairies.

Now, the majority of these architects saw no shame in being both architects and decorators, in fact achieving perfect harmony between the exterior and the interior decoration of a house by any other means was unfathomable. Inside they sought harmony as well by composing with furnishings and tapestries to create an ensemble of new co-ordinated forms and colours that were soft, subdued, and calm.[+]

Among the most highly respected were Norman Shaw, Thomas Edward Collcut, and the firm of Ernest George and Harold Ainsworth Peto. These architects restored what had been missing: the subordination of all the decorative arts to architecture, a subordination without which it would be impossible to create any style.

We certainly owe them such novelties as pastel decor (as in the eighteenth-century domestic interior) and the return of architectural ceramics (likely Oriental in origin), which they had studied and with which they had much greater skill and mastery than anyone else, given their constant contact with it. Thanks to these architects, bright colours like peacock blue and sea green started to replace the dismal greys, browns, and other sad colours that were still being used to make already ugly administrative buildings even more hideous.

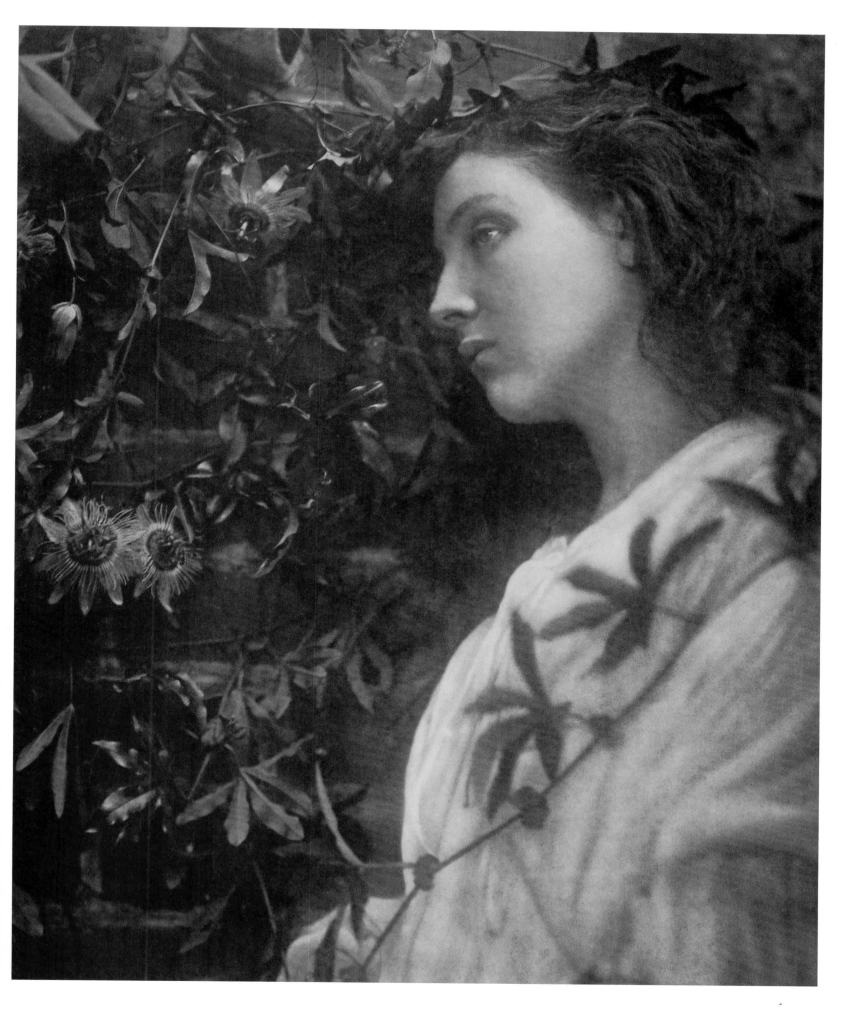

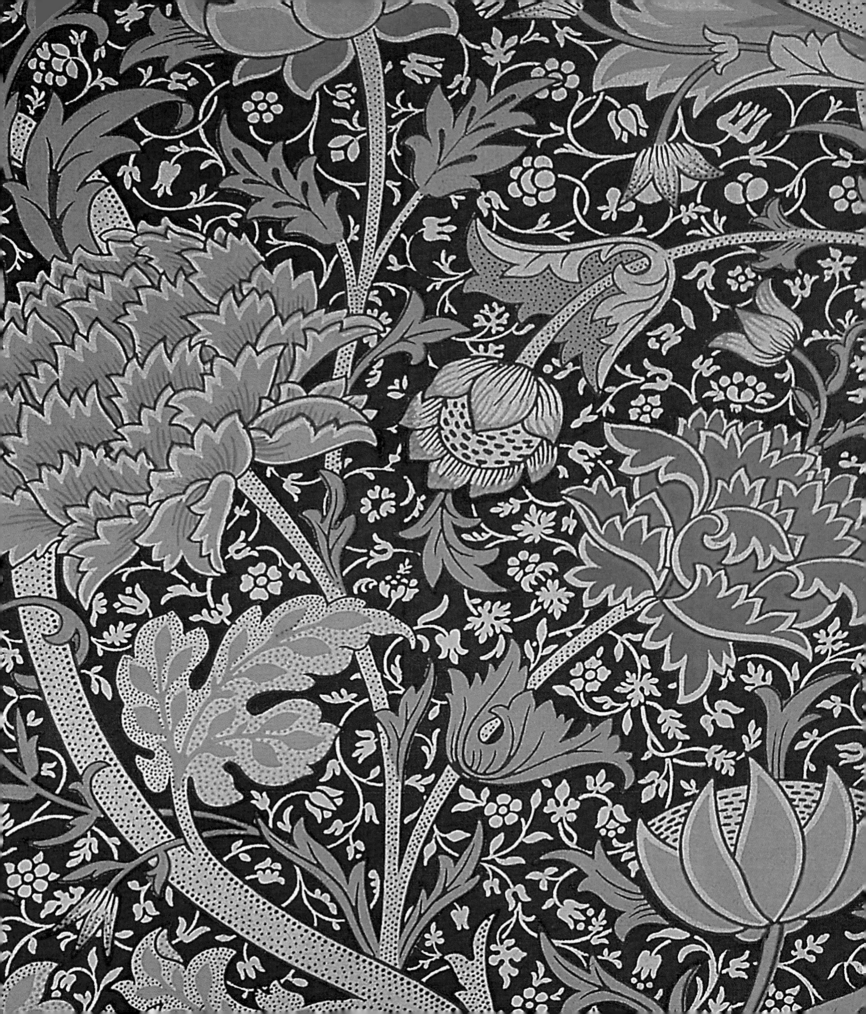

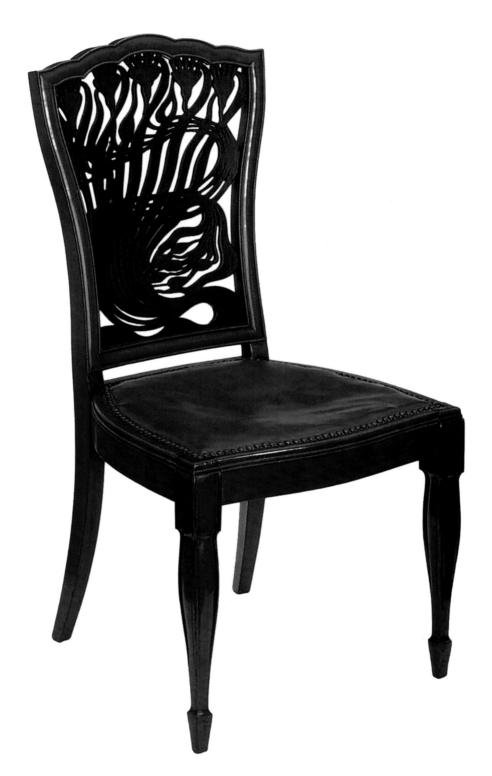

Arthur Heygate Mackmurdo,
Chair, 1882. Mahogany and leather.
Victoria and Albert Museum, London.

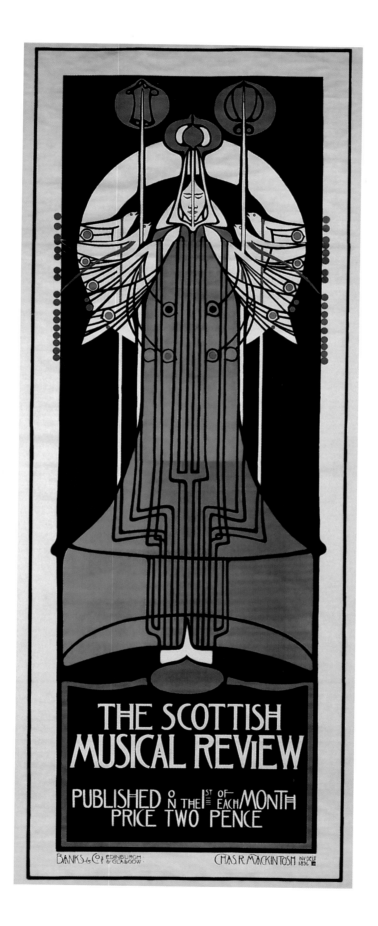

Charles Rennie Mackintosh and
Herbert McNair,
Poster for "The Scottish Musical Review",
1896. Colour lithograph.
The Museum of Modern Art, New York.

The reform of architecture and decorative art in England was therefore national at first. This is not immediately obvious, however, in the work of Morris. But it was the fundamental inclination of this artist and (whether consciously or not) of those in his orbit, who like him passionately embraced English art and history as their own. It meant a return to profiles, colours, and forms that were no longer Greek, Latin, or Italian: an art that was English rather than classical.

Along with wallpaper and tapestries there was truly English furniture being designed that was new and modern, often with superb lines, and English interiors often displayed decorative ensembles with equally superb layouts, configurations, and colours.

Finally, throughout England, there was a desire to go back and redo everything from overall structural ornamentation, the house, and furniture, right down to the humblest domestic object. At one point even a hospital was decorated, an idea retained by the English and later adopted in France.

From England, the movement spread to neighbouring Belgium.

Belgium: The Flowering of Art Nouveau

Belgium has long recognised the talent of its most famous architect, Victor Horta, along with that of Paul Hankar and Henry Van de Velde, and the furniture maker and decorator Gustave Serrurier-Bovy, one of the founders of the Liège School. Art Nouveau owes much to these four artists, who were less conservative than their Flemish counterparts and mostly unassociated with any tradition whatsoever. Horta, Van de Velde, and Hankar introduced novelties to their art that were carefully studied and freely reproduced by foreign architects, which brought great renown to the Belgians, even though the reproductions were executed with slightly less confidence and a somewhat heavier hand.

These four had a great impact. Unfortunately, much of their impact was due to students and copyists (as is often the case with masters) who were sometimes immoderate, exhibiting a taste that comprised the masters. This first became noticeable in relation to Horta and Hankar, even though Horta and Hankar had initially employed their decorative vocabulary of flexible lines, undulating like ribbons of algae or broken and coiling like the linear caprices of ancient ornamentalists, with restraint, distributing it with precision and in moderation. Among imitators, however, the lines grew wild, making the leap from ironwork and a few wall surfaces to overrun the whole house and all its furniture. The result was seen in torsions, in dances forming a delirium of curves, obsessive in appearance and often torture to the eyes. The love of tradition was not as strong in Belgium as it was in England and Belgian artists were preoccupied with discovering new and comfortable interior designs. However successfully they met that challenge, however pleasing the interior arrangements, however unexpected the curves seemed, the new decor still had to be enlivened to satisfy the Flemish taste for abundance and elaborate decoration.

Serrurier-Bovy started by imitating English furniture, but eventually his own personality emerged. Nevertheless, his creations, which for the most part excelled in novelty, generally remained more restrained than the work of subsequent Belgian artists. These Belgians were no less talented and imaginative but, in order to make their work more impressive, they exaggerated

Walter Crane,
Swans, wall paper design, 1875.
Gouache and watercolour,
53.1 x 53 cm.
Victoria and Albert Museum, London.

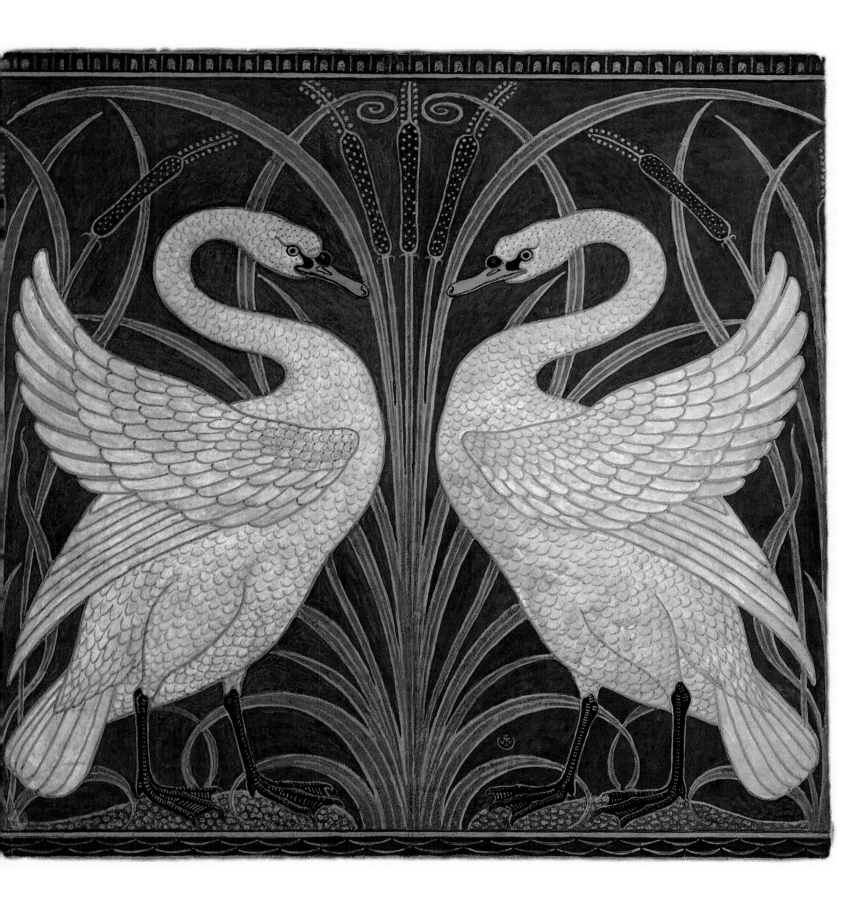

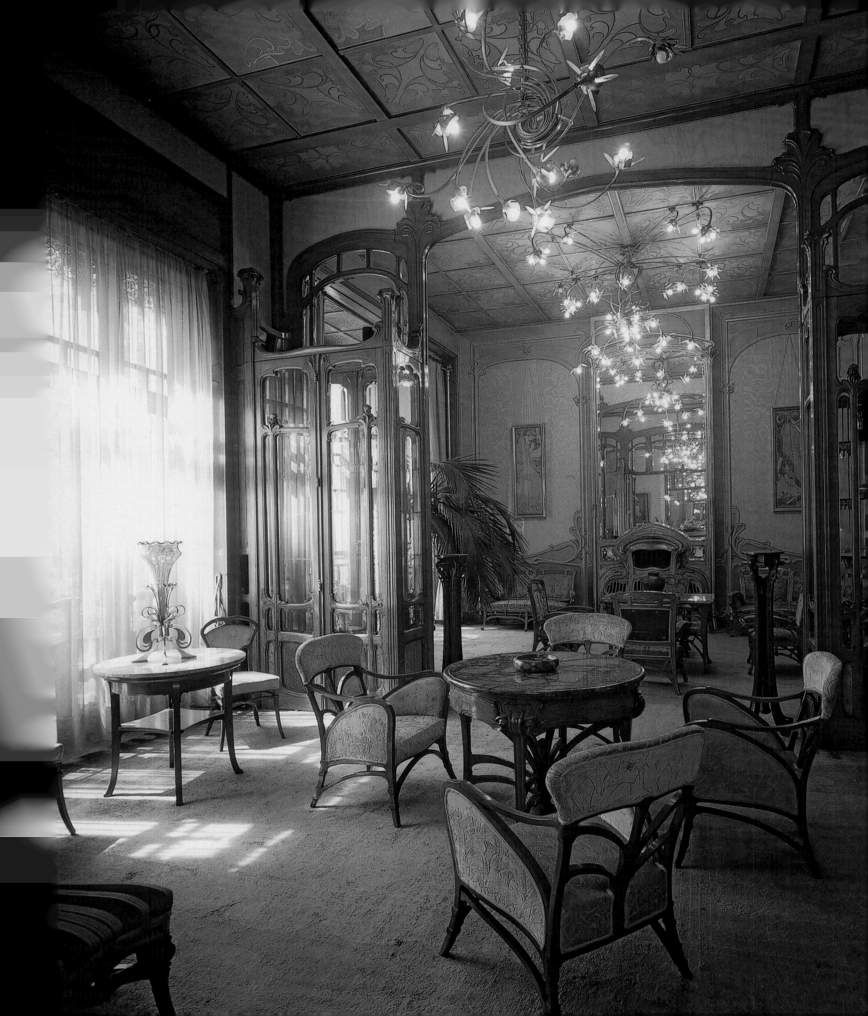

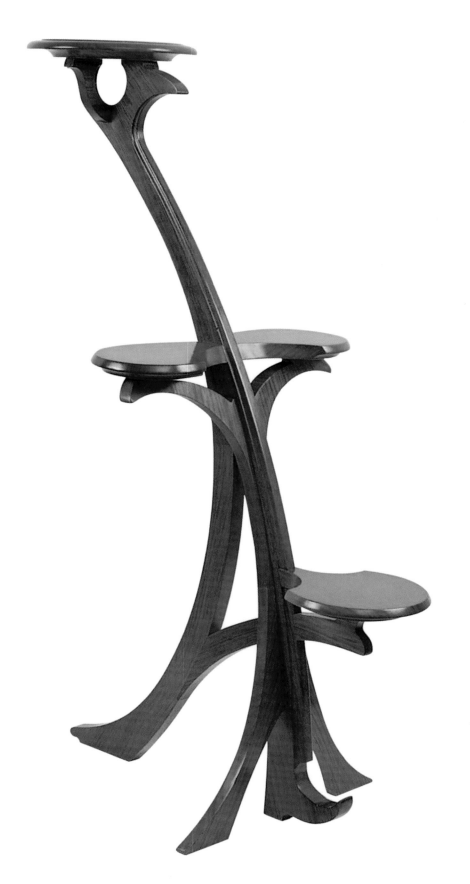

Victor Horta,
Solvay House, view from main salon,
1895. Brussels.
© 2007 – Victor Horta/Droits SOFAM –
Belgique

Gustave Serrurier-Bovy,
Pedestal, 1897. Congolese rosewood.
Norwest Corporation, Minneapolis.

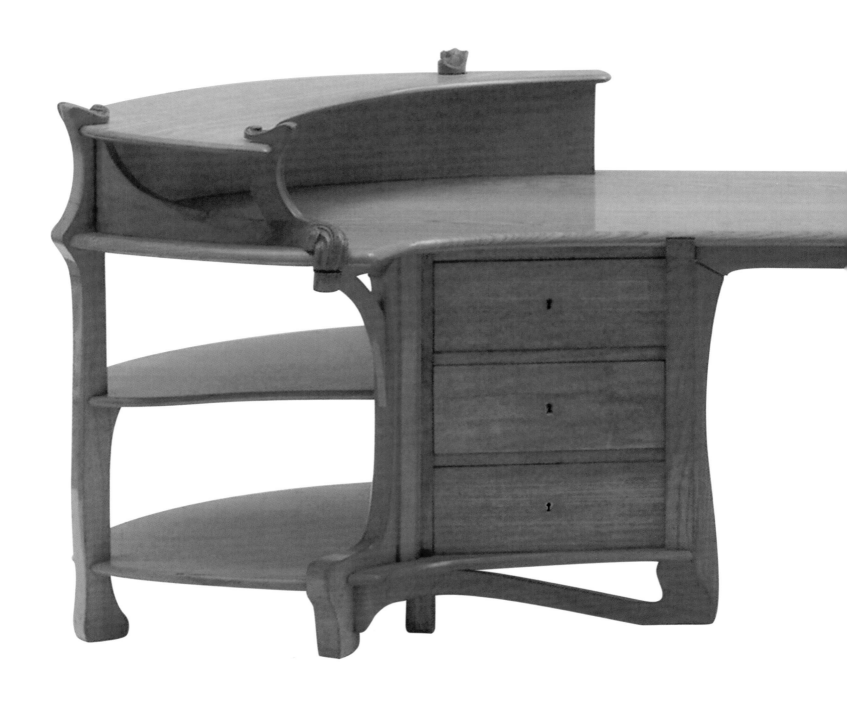

24

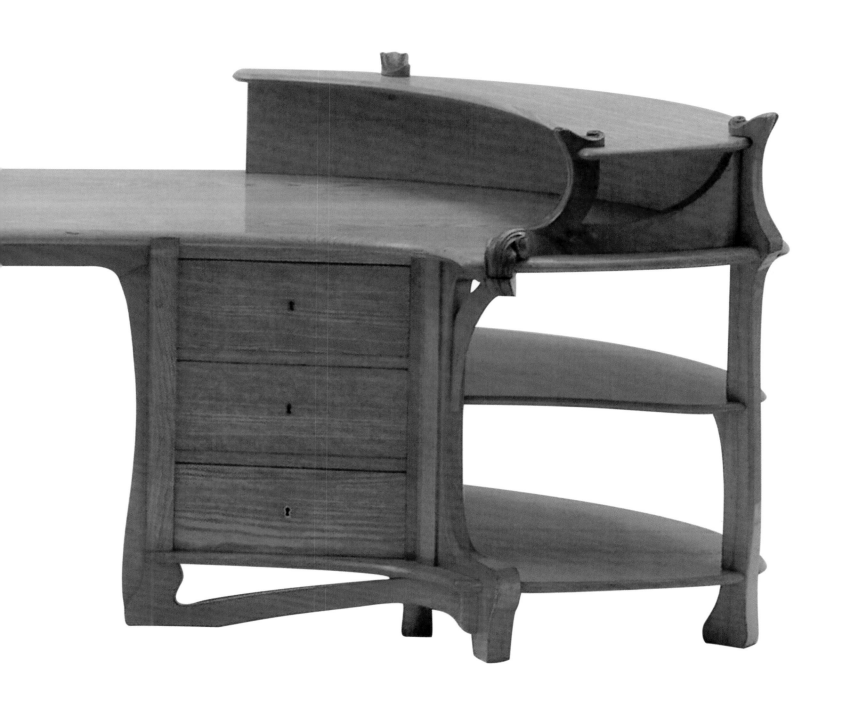

Henry Van de Velde,
Desk, 1900-1902. Wood.
Österreichisches Museum für
angewandte Kunst, Vienna.

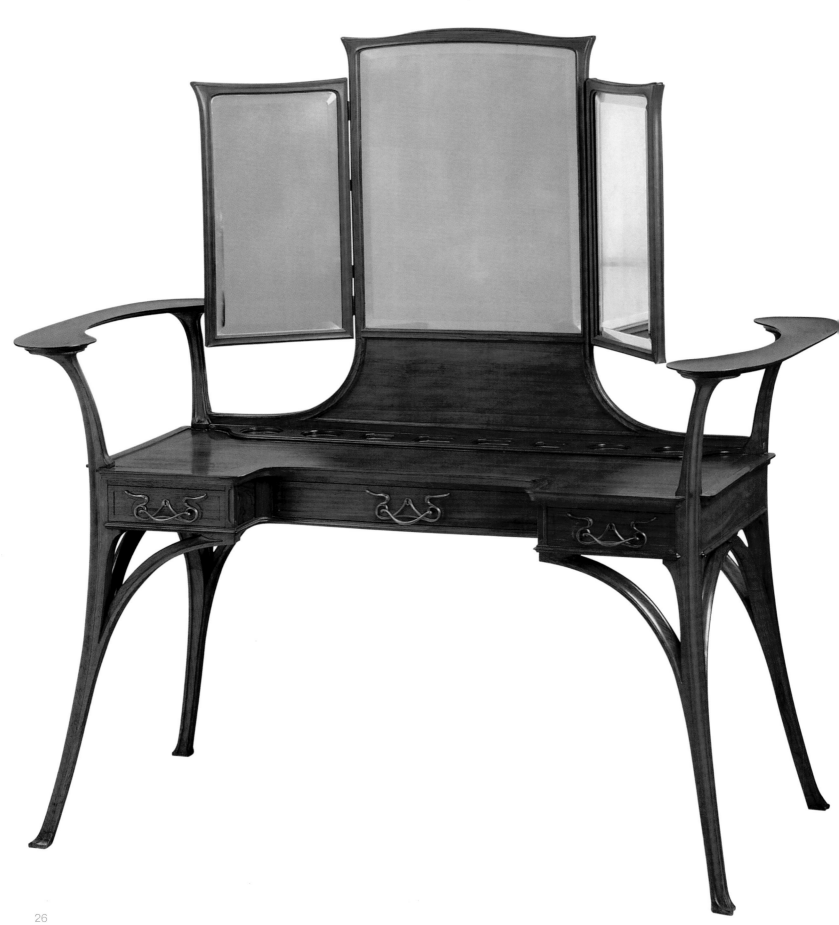

linear decoration in the leitmotif of the line. Curved, broken, or cursive, in the form of the whiplash, zigzag, or dash, the leitmotif of the line would reach a level of contagion by the 1900 Universal Exposition.

If we linger over the Belgian artists, it is because of the important role they played in the renewal of the decorative arts, especially furniture. [5] In this, Belgium, for better or worse, deserves as much credit as England. From England and Belgium the movement then extended to the northern countries and to France, the United States and Germany.

It is true that Germany needed these decorations to help make its Art Nouveau pillars and its geometric furniture decorated with rigid mouldings borrowed from ancient Greek monuments more palpable. (Remember it was only fifty years ago that King Louis of Bavaria had made his capital Munich as Greek as possible).

Displaying the individual character that comes from local resources, customs, and taste, Art Nouveau then also appeared in Austria, Denmark and the Netherlands.

At no point did England, the Netherlands, or Germany excel in statuary, which almost completely disappeared from their versions of Art Nouveau. In order to entertain the eye their artists instead gave precedence to shiny brass decoration cut in the form of openwork arabesques and attached to woods that were either naturally rich in colour or artificially highlighted.

France: A Passion for Art Nouveau

The passion for Art Nouveau was different in France. Instead of decorating with schematically stylised flora and fauna, French artists concentrated on embellishing new forms with sculpted ornamentation that retained the flower's natural grace and showed the figure to best advantage. This was already the focus of French exhibitors in 1889. But those artists were looking for novelty in absolute realism. Their successors remembered that the refined art of the eighteenth century had derived its charm from the free interpretation of nature, not its rigorous imitation. The best among the artist craftsmen endeavoured to instil their designs with the gentle harmony of line and form found in old French masterpieces and to decorate them with all the novelty that flora and fauna could provide when freely interpreted. Although the best furniture makers, such as Charles Plumet, Tony Selmersheim, Louis Sorel, and Eugene Gaillard, had little use for sculpture, it was sometimes a handy aid, as seen in certain ensembles by Jules Desbois and Alexandre Charpentier. By employing freely interpreted flora and the human figure, these two designers (who also designed stunning contemporary jewellery) were able to produce dynamic new poetic effects in which shadow and light played an important role. Such was also the case with René Lalique, whose works evoked exquisite fantasies, or the more robust jewels executed by Jean-Auguste Dampt, Henry Nocq, and François-Rupert Carabin, for example. French objects such as these were more sumptuous and more powerfully affecting than the graphic rebuses seen in Brussels and Berlin.

Art Nouveau exploded in Paris in 1895, a year that opened and closed with important milestones. In January, the poster designed by Alphonse Mucha for Sarah Bernhardt in the role of Gismonda was plastered all over the capital. This was the event that heralded the Art Nouveau poster style, which Eugène Grasset had previously tackled, in particular in his posters

Charles Plumet and **Tony Selmersheim**,
Dressing Table, 1900.
Wood, padauk and bronze.
Museum für Kunst und Gewerbe, Hamburg.

Jacques Gruber,
Roses and Seagulls.
Leaded glass, 404 x 300 cm.
Musée de l'Ecole de Nancy, Nancy.

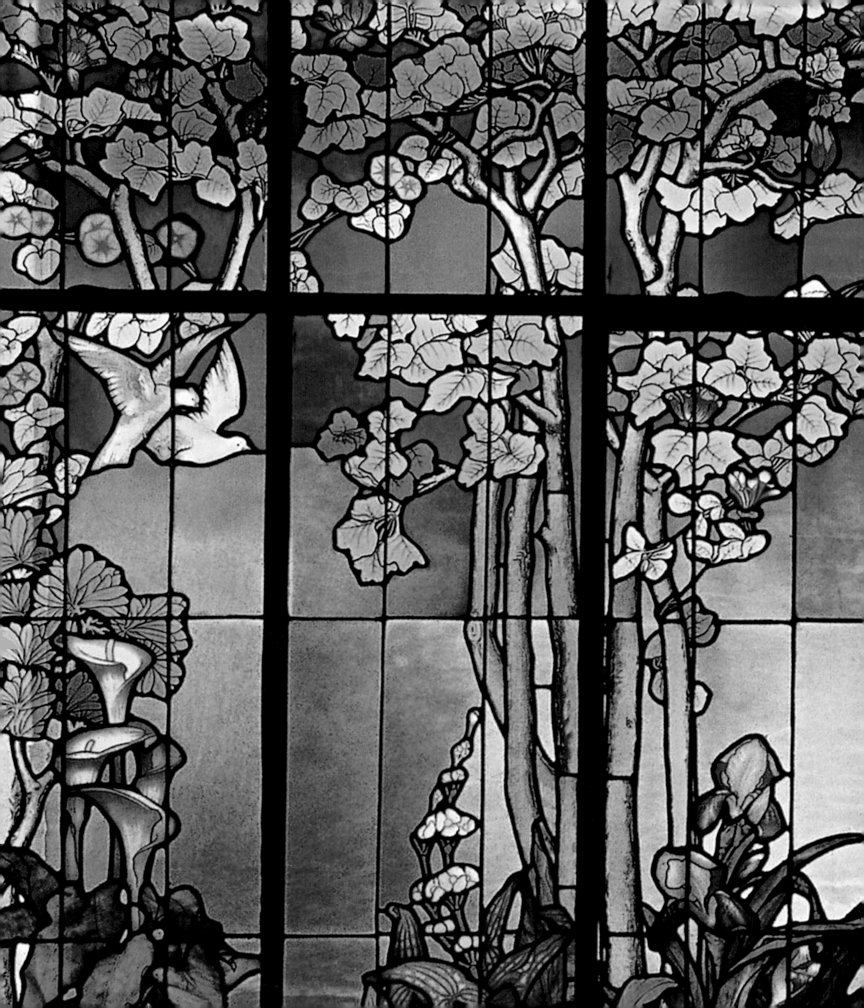

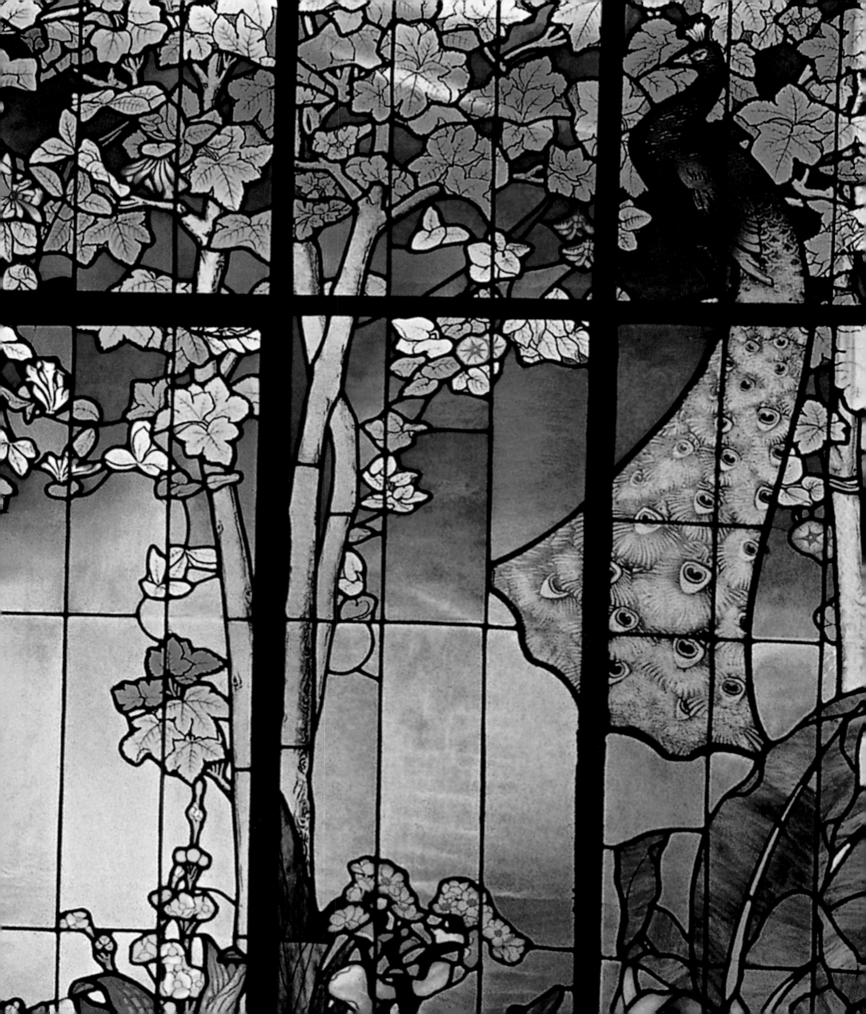

for *Encres Marquets* (1892) and the *Salon des Cent* (1894). Then December saw the opening of Bing's Art Nouveau boutique, which was entirely devoted to propagating the new genre.

It was also around this time that Hector Guimard built Castel Béranger (circa 1890). Two years later, Baron Edouard Empain, the engineer and financer of the Paris Metro construction project, selected Guimard to design the now famous Metro stations. Empain's choice, however, was strongly opposed at the time. Some feared that Guimard's architecture represented too new an art form and that the style, derided as *style nouille* (literally translated "noodle style"), would ruin the look of the French capital. An obstinate jury prevented Guimard from completing all the stations, in particular the station near Garnier's Opera: Art Nouveau appeared totally at odds with Garnier's style, which was a perfect example of the historicism and eclecticism the new movement was fighting against.

At the same time, French brasseries and restaurants offered themselves as privileged sites for the development of the new trend. The Buffet de la Gare de Lyon opened in 1901. Rechristened Le Train Bleu in 1963, it counted Coco Chanel, Sarah Bernhardt, and Colette among its many regulars. With the addition of Maxim's restaurant on the rue Royale, dining establishments henceforth became perfect models of Art Nouveau.

In 1901 the Alliance des Industries d'Art, also known as the Ecole de Nancy (School of Nancy), was officially founded. In accordance with Art Nouveau principles, its artists wanted to abolish the hierarchies that existed between major arts like painting and sculpture and the decorative arts, which were then considered minor. The School of Nancy artists, whose most fervent representatives were Emile Gallé, the Daum brothers (Auguste and Antonin) and Louis Majorelle, produced floral and plant stylisations, expressions of a precious and fragile world that they nevertheless wanted to see industrially reproduced and distributed on a much larger scale, beyond coteries of galleries and collectors.

Art Nouveau ultimately proliferated endemically throughout the world, often through the intermediary of art magazines such as *The Studio*, *Arts et Idées* and *Art et Décoration*, whose illustrations were henceforth enhanced with photos and colour lithography. As the trend spread from one country to the next, it changed by integrating local colour, transforming itself into a different style according to the city it was in. Its breadth of influence included cities as distant as Glasgow, Barcelona and Vienna and even reached such faraway and unlikely spots as Moscow, Tunis and Chicago. All the different names used to describe the movement along its triumphal march – Art Nouveau, Liberty, Jugendstil, Secessionstil, and Arte Joven – emphasised its newness and its break with the past, in particular with the mid-nineteenth century's outdated historicism. In reality, Art Nouveau drew from many past and exotic styles: Japanese, Celtic, Islamic, gothic, baroque and rococo, among others. In the decorative arts, Art Nouveau was welcomed with unprecedented enthusiasm, but it also met with scepticism and hostility, as it was often considered strange and of foreign origin. Germany, for example, disparaged the new decorative art as the "Belgian tapeworm style". France and England, traditional enemies, tended to trade blame, with the English retaining the French term "Art Nouveau" and the French borrowing the term "Modern Style" from the English.

Art Nouveau reached its apogee in 1900, but quickly went out of fashion. By the next major Universal Exposition in Turin (1902), a reaction was clearly underway. In the end, Art Nouveau strayed far from its original aspirations, becoming an expensive and elitist style that, unlike its successor Art Deco, did not lend itself to cheap imitation or mass production.

Georges Clairin,
Sarah Bernhardt, 1876.
Oil on canvas, 200 x 250 cm.
Petit Palais, Musée des Beaux-Arts de la
Ville de Paris, Paris.

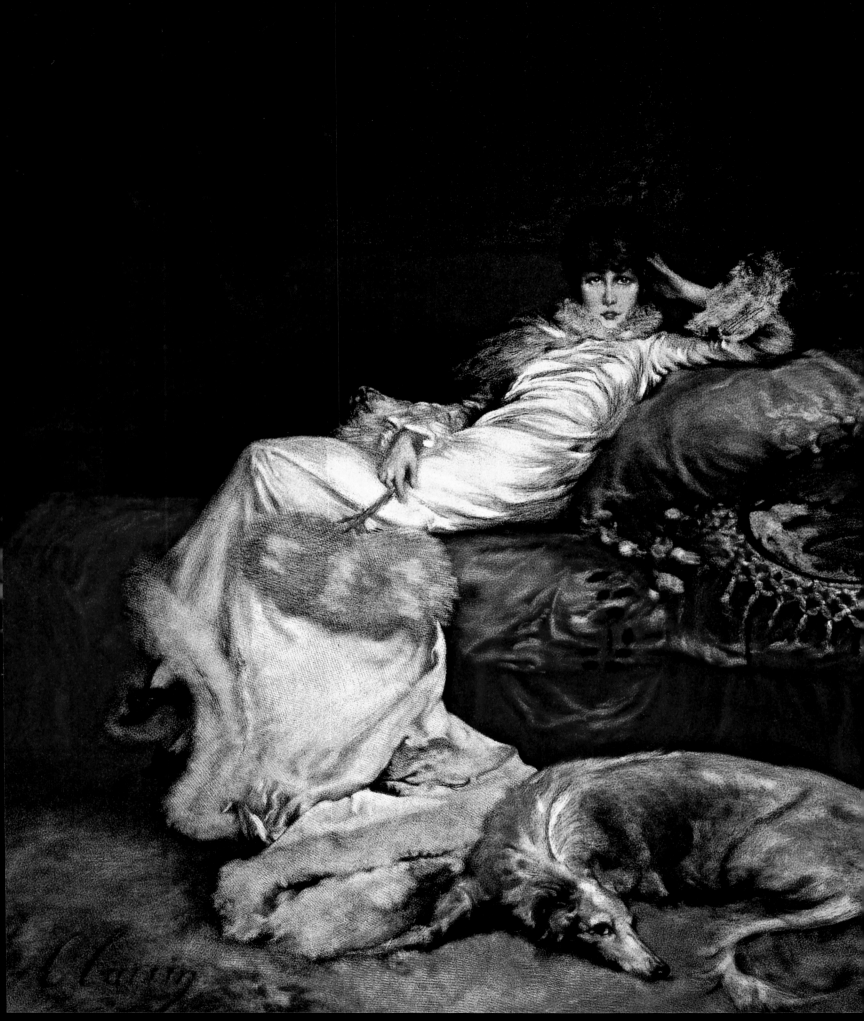

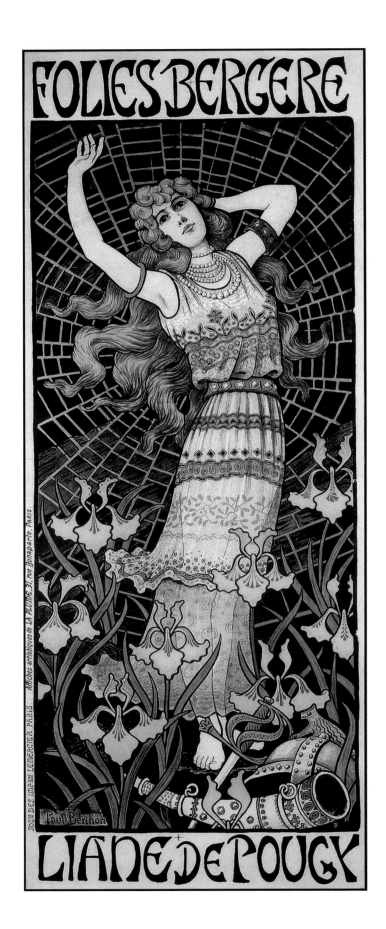

Paul Berthon,
Liane de Pougy aux Folies-Bergère.
Colour lithograph.
Victor and Gretha Arwas collection.

Eugène Grasset,
Snow-drop. Plate 32 from *Plantes et leurs applications ornementales (Plants and their Application to Ornament)*, 1897.
Victoria and Albert Museum, London.

Victor Prouvé,
Salammbô, 1893.
Mosaic leather and bronze.
Musée de l'Ecole de Nancy, Nancy.

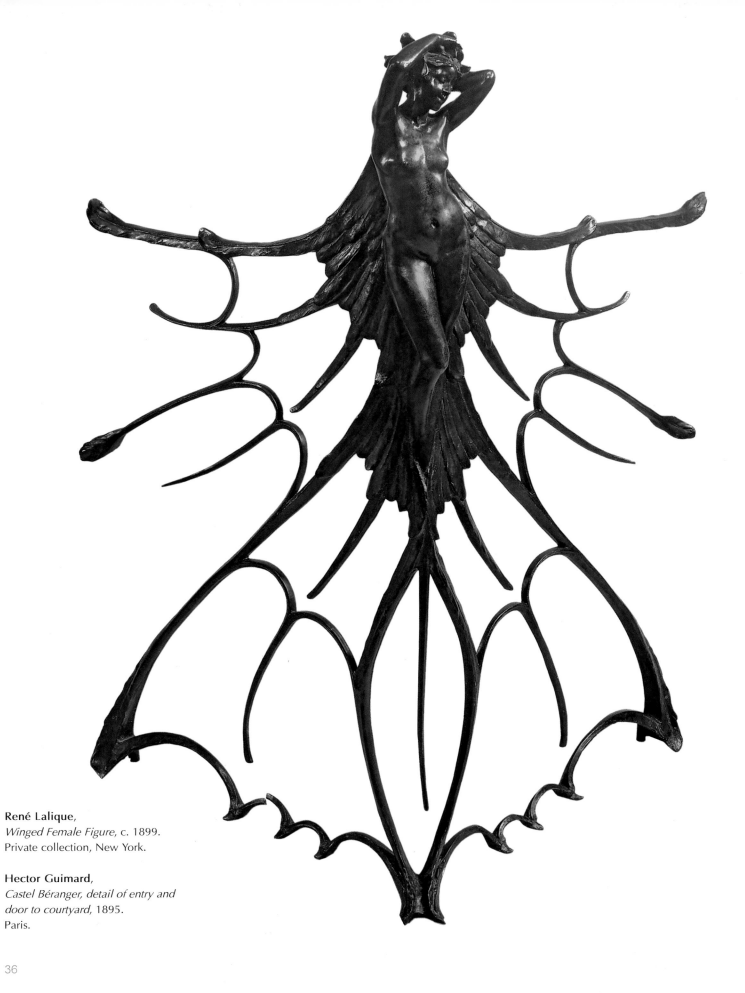

René Lalique,
Winged Female Figure, c. 1899.
Private collection, New York.

Hector Guimard,
*Castel Béranger, detail of entry and
door to courtyard*, 1895.
Paris.

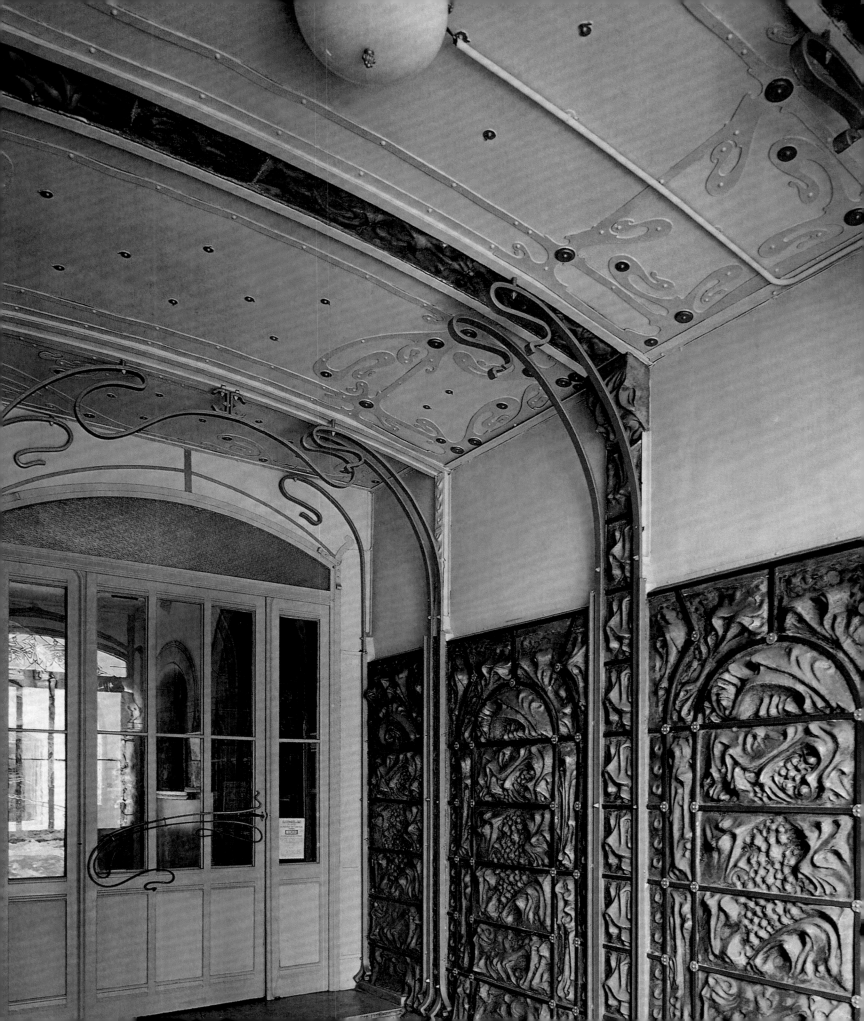

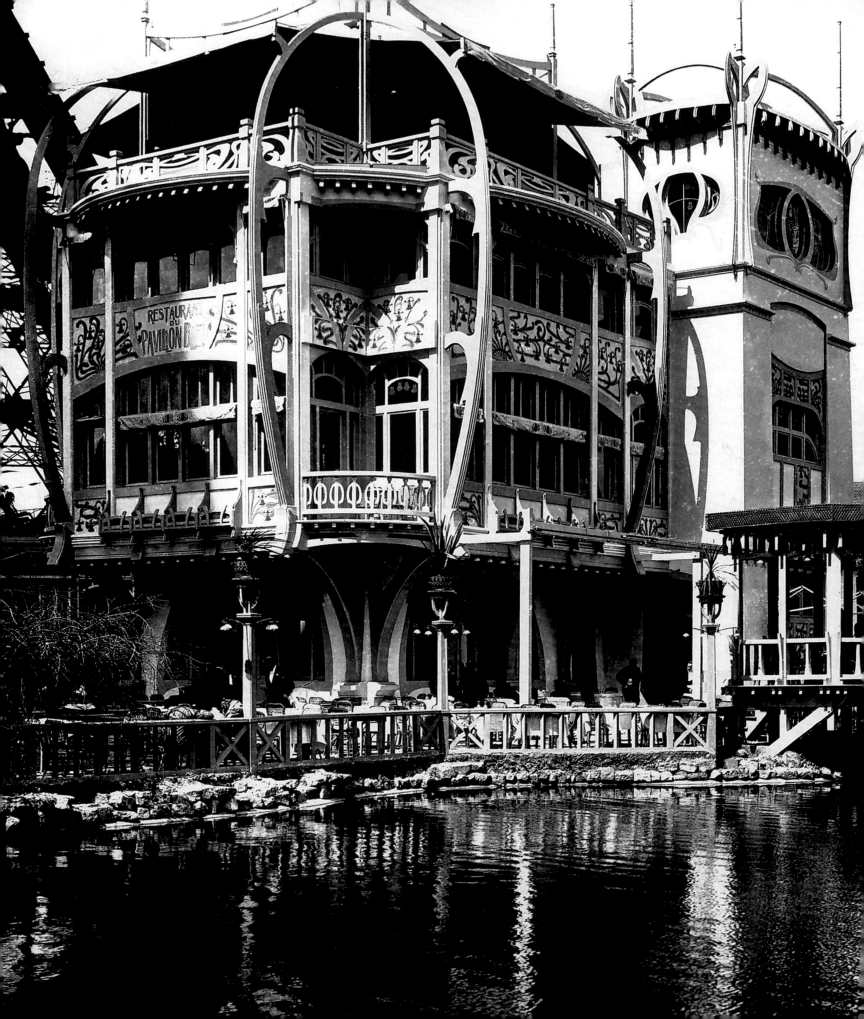

II. Art Nouveau at the 1900 Universal Exposition in Paris

History has selected England, Belgium and France as the undisputed primary sources of Art Nouveau's development in the late nineteenth and early twentieth centuries, but contemporaries were unaware of this supremacy. In its section devoted to the decorative arts, the 1900 Universal Exposition in Paris, which called for the construction of both the Grand and Petit Palais, among other buildings, offered a sampling that gave a taste of the real flavour of the period. For example, Gaudí, now inseparable from Spanish Art Nouveau and a major architect who gave us the image of Barcelona we know today, was the Exposition's major no-show: he failed to participate in the construction of the pavilions and none of his plans were shown. At the same time, countries such as Russia, Hungary and Romania, long since forgotten in the history of Art Nouveau, were well represented alongside other countries that history wrongly seems to barely remember.

The French Pavilion

France showed great artistic merit in bijouterie, joaillerie, ceramics and glassware – all magical arts of fire – as well as in sculpture and medallions. The triumph of France in all these arts was unmistakable.

In the enchanting art of glass, one of the world's oldest arts, and one that seemed to have exhausted every conceivable combination of line and colour, every quest for a perfect union between stones, precious metals and enamel, between chasing and the gluing of precious stones and pearls, Lalique was a genius who could surprise, dazzle and delight the eye with new and truly exquisite colorations in all his creations, with the fantasy and the charm of his imagination with which he animated them, and with his bold and inexhaustible creativity. Like a philosopher grading stones on their artistic value alone, sometimes elevating the most humble to highest honours and drawing unfamiliar effects from the most familiar, and like a magician who can pull something out of thin air, Lalique was a tireless and perpetual inventor of new forms and beauties, who truly created an art form in his own style, which now and forever bears his name.

As is the prerogative of genius, Lalique steered his art into unchartered territory and others followed whatever direction he took. There was joy and pride at the triumphant manifestation of French taste in its plateresque palace, thanks to the masters of French bijouterie, joaillerie, and silver, such as Lalique, Alexis Falize, Henri Vever, Fernand Thesmar, and many others,[6] all relatively prestigious, and thanks to the masters of glass and ceramics, such as the still unrivalled Gallé, the Daum brothers, and the artists of the Manufacture nationale de Sèvres, and Albert Dammouse, Auguste Delaherche, Pierre Adrien Dalpeyrat and Lesbros among others.

It was a splendid victory for Art Nouveau as a new decorative art movement, given what Lalique and the other French masters set out to accomplish. They had endeavoured to free themselves from imitation, from the eternal copy, from the old clichés and plaster casts that were

Gustave Serrurier-Bovy,
Pavillon bleu Restaurant at the 1900 Universal Exposition in Paris.
Photograph.
Private collection.

40

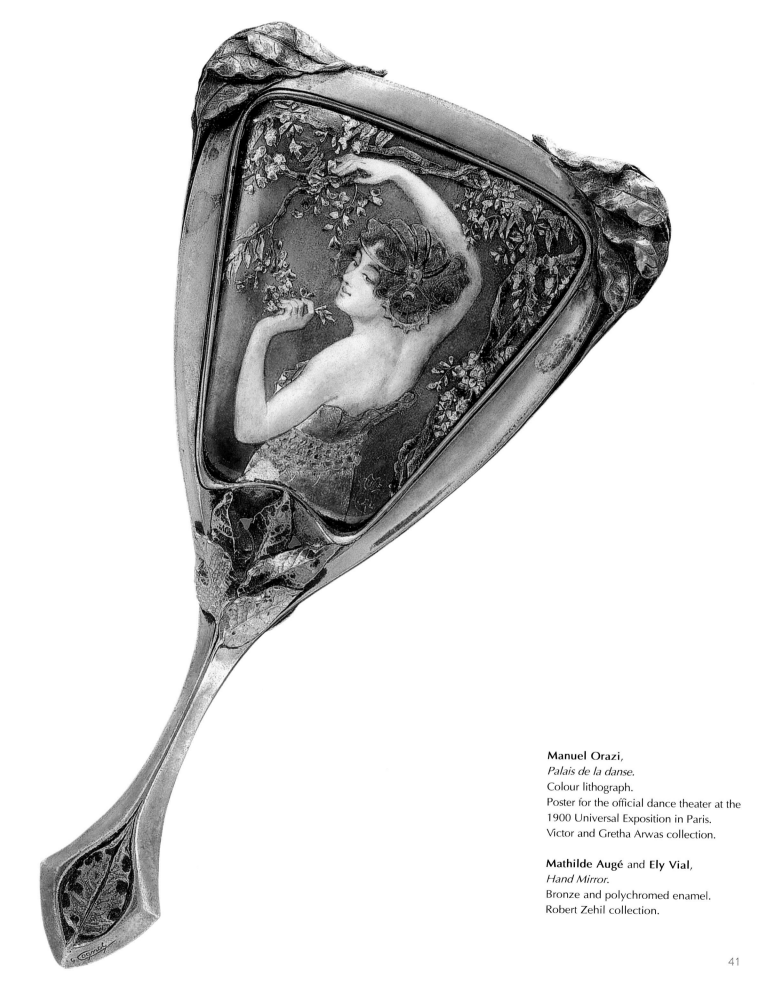

Manuel Orazi,
Palais de la danse.
Colour lithograph.
Poster for the official dance theater at the
1900 Universal Exposition in Paris.
Victor and Gretha Arwas collection.

Mathilde Augé and **Ely Vial,**
Hand Mirror.
Bronze and polychromed enamel.
Robert Zehil collection.

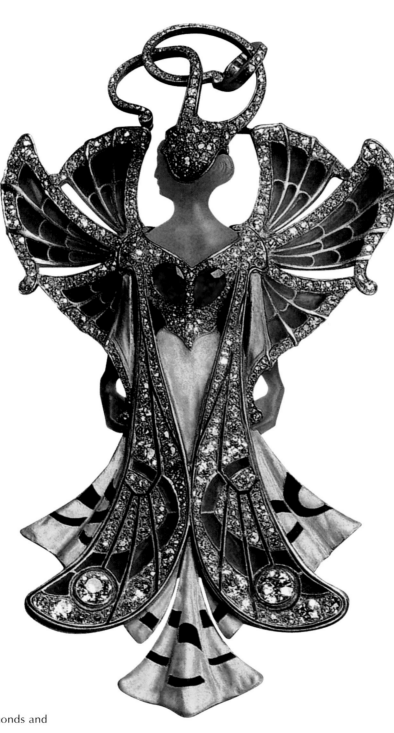

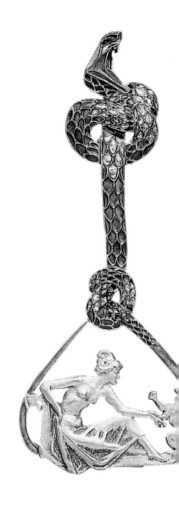

Henri Vever,
Sylvia Pendant, 1900.
Gold, agate, rubies, diamonds and
pink diamonds.
Exhibited at the 1900 Universal
Exposition in Paris.
Musée des Arts Décoratifs, Paris.

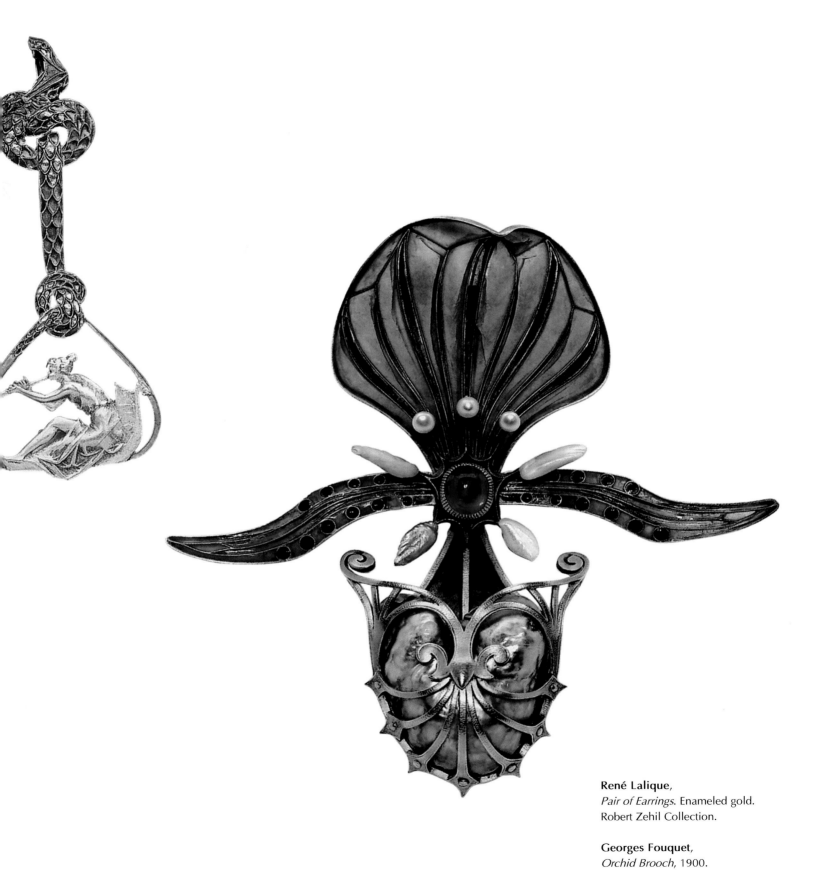

René Lalique,
Pair of Earrings. Enameled gold.
Robert Zehil Collection.

Georges Fouquet,
Orchid Brooch, 1900.
Gold, enamel, rubies and pearls.
Anderson collection.

always being recycled and had already been seen and were now overly familiar and worn-out. Their work was new, even to them. These masters on the Esplanade des Invalides therefore deserve our utmost gratitude, because in this exhibition they made certain that France's artistic supremacy would be revealed once and for all. The French exhibitors included the artists of the Manufacture nationale de Sèvres, whose revitalised works of perfect beauty may have saved the life and the honour of French manufacturers; other masters of the applied arts; and no doubt a few practitioners of the fine arts, whose work did not always display the same quality as the work of the minor artists they were so contemptuous of. But whatever one's opinion of the new decorative art, similar victories were henceforth more and more difficult to win, as France's steady rivals made even greater strides.

The English Pavilion

Art Nouveau was already brilliantly represented in England by 1878, especially in furniture. The movement was in its early stages, but England and Belgium, for various reasons, were underrepresented at the 1900 Exposition in Paris.

English furniture was only prominently displayed by Mr. Waring and Robert Gillow and by Ambrose Heal.

For every few well-conceived pieces displaying an elegance that was truly new, there were countless others that were overly contorted and ornate, in ugly colours and poorly adapted to function, or designed with such excessive simplicity and pretense that English furniture was seriously compromised in the eyes of critiques – and everyone else. One could grope and

Hector Guimard,
Vase. Patinated bronze and ceramic.
Robert Zehil collection.

Keller and **Guérin**,
Artichoke Vase. Stoneware.
Exibited at the 1900 Universal
Exposition in Paris.
Robert Zehil collection.

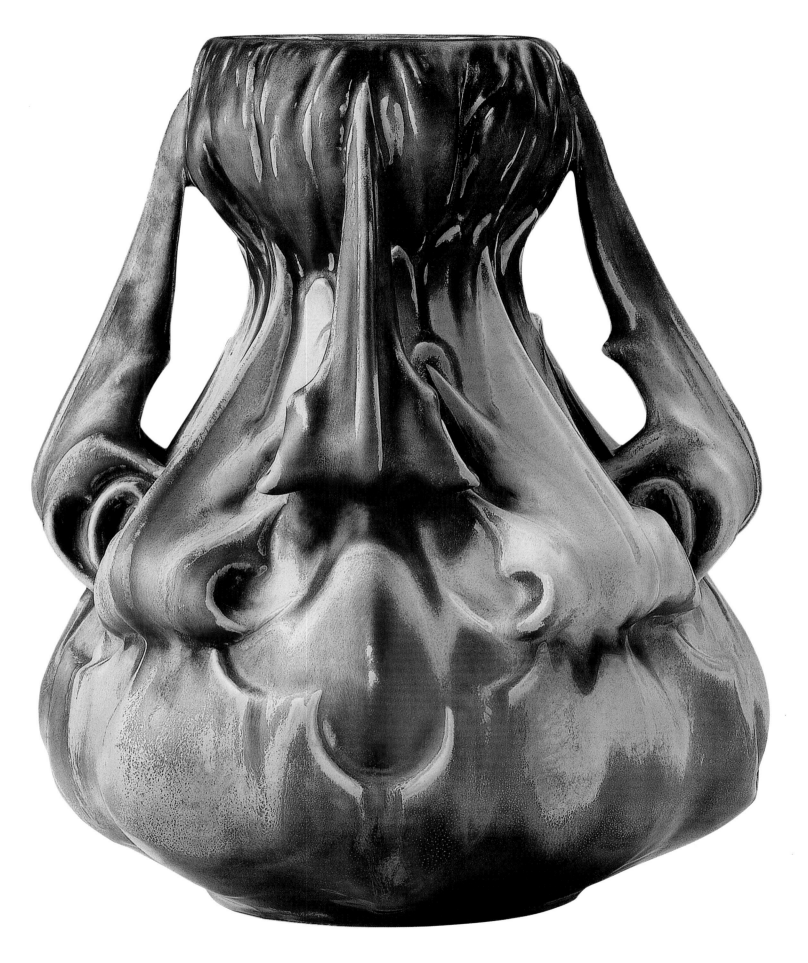

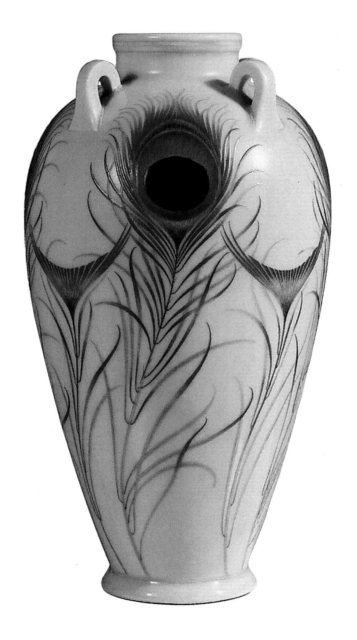

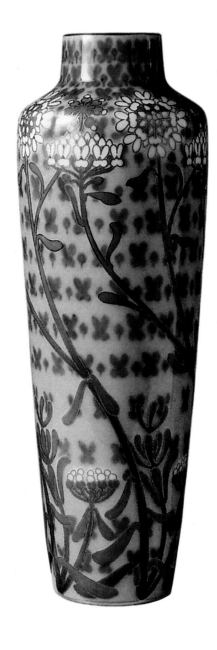

Manufacture nationale de Sèvres,
Vase from Bourges.
French *pâte nouvelle* porcelain.
Exhibited at the 1900 Universal
Exposition in Paris.
Robert Zehil collection.

Manufacture nationale de Sèvres,
Vase from Montchanin. Porcelain.
Exhibited at the 1900 Universal
Exposition in Paris.
Robert Zehil collection.

search about, but with a few exceptions, the furniture was too often imperfectly designed – without logic and serious purpose, a structural frame or even comfort in mind. These criticisms, however were perhaps best directed less at England and Belgium than to other foreign countries.

England failed to show anything really new or exceptional that year. And yet there was one perfect example of its highly developed artistic mastery: the little pavilion that housed the miniature fleet of the Peninsular and Oriental Steamship Company, a supremely elegant piece owing to the collaboration of Collcutt (architect), Moira (wall decoration) and Jenkins (sculptures).[7]

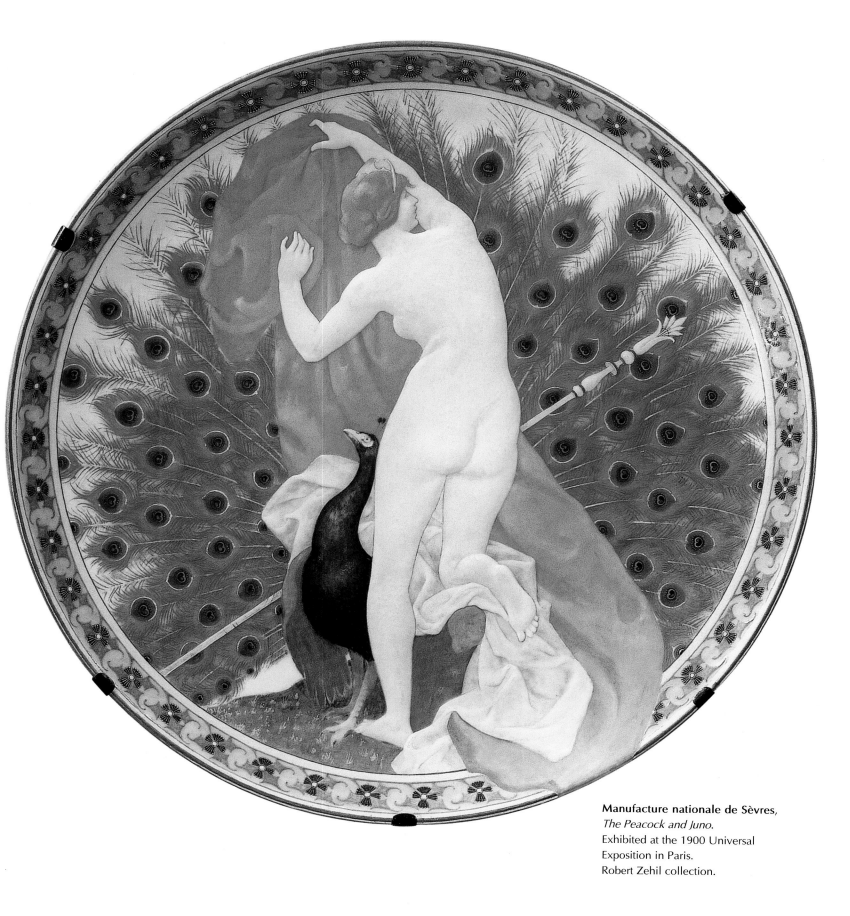

Manufacture nationale de Sèvres,
The Peacock and Juno.
Exhibited at the 1900 Universal
Exposition in Paris.
Robert Zehil collection.

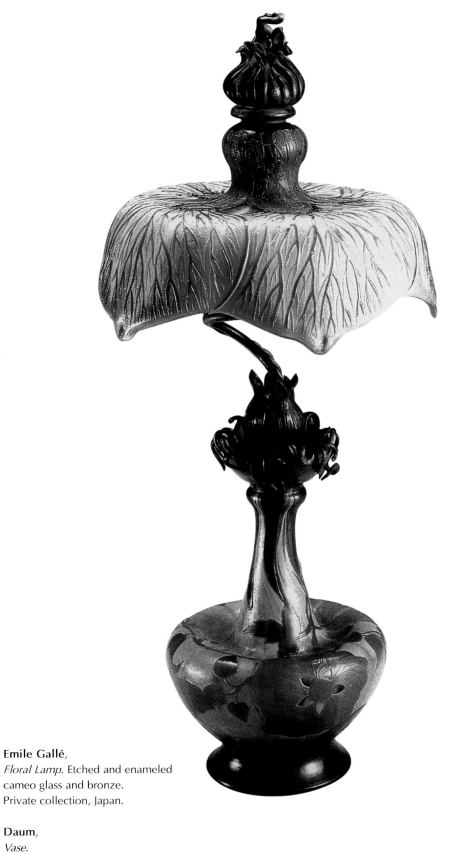

Emile Gallé,
Floral Lamp. Etched and enameled
cameo glass and bronze.
Private collection, Japan.

Daum,
Vase.
Wheel carved cameo glass and wood.
Private collection.

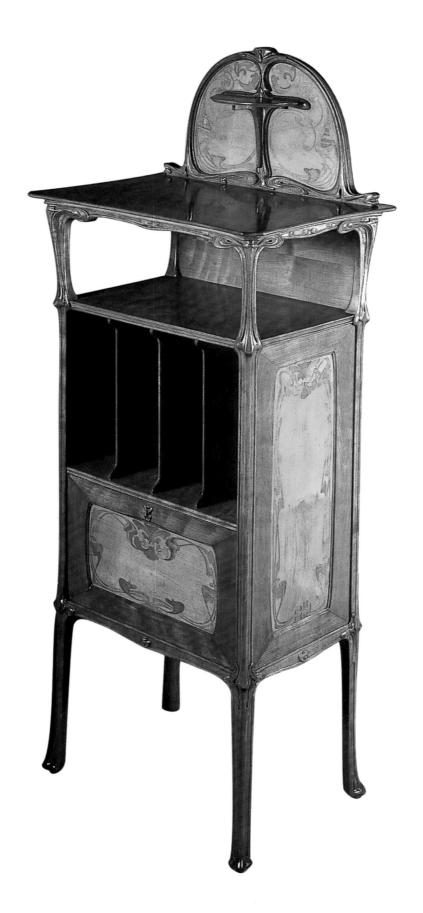

Edouard Colonna,
Music Cabinet. Marquetry.
Made for the Art Nouveau pavilion at the
1900 Universal Exposition in Paris.
Macklowe Gallery, New York.

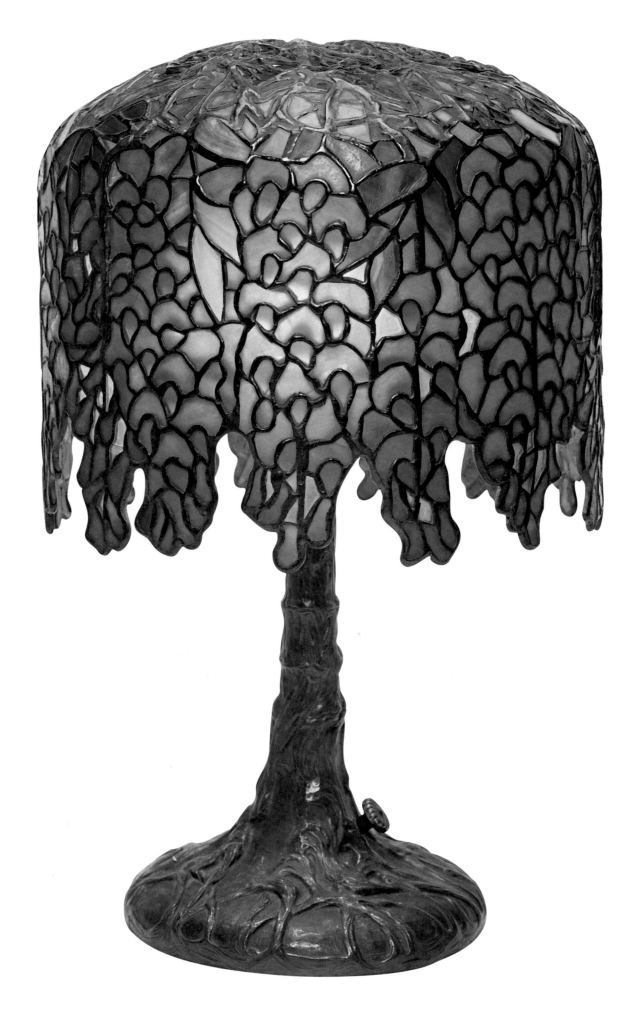

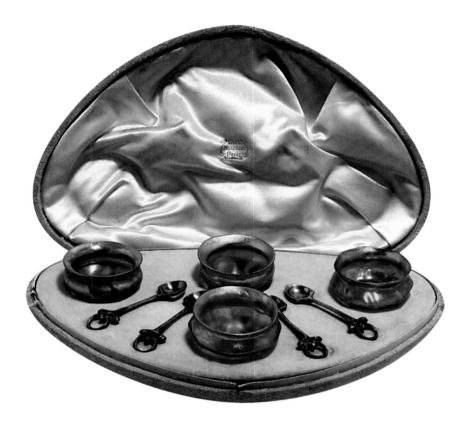

The American Pavilion

The decorative arts owe much to the United States, at least to the admirable New York artist Louis Comfort Tiffany, who truly revived the art of glass, as did Gallé in France but with different techniques. Like the brilliant artist from Nancy, Tiffany was not satisfied with being a prestigious glass artist: he was also a silversmith and ornamentalist. Above all he was a great poet, in the sense that he was continually inventing and creating beauty. For his young country, bursting with energy and brimming with wealth, Tiffany seems to have dreamed of an art of unprecedented sumptuousness, only comparable to the luxurious art of Byzantium in its combination of gravitas and bedazzlement. Tiffany has provided us with much joy. One senses his desire to revive lost grandeur and to create new splendours such as had never been seen before. He meant for his mosaics to create a sense of wonder when they decorated stairways and adorned residences. Such homes would be illuminated by day with dazzling and opalescent Tiffany windows and by night with Tiffany lamps and chandeliers, splendid and calm like mysterious stars; in such settings, Tiffany glass would emit sparkling beams as if shot from precious stones or would filter in the tender, milky, lunar gleam of the light of dawn or of dusk. Tiffany was among the biggest winners of this Exposition, along with certain French masters, the Danes and the Japanese.

Tiffany & Co.,
Wisteria Lamp. Bronze and glass.
Private collection.

Tiffany & Co.,
Set of four glasses and spoons in an Art Nouveau box.
Favrile glass and silver gilt.
Macklowe Gallery, New York.

The Belgian Pavilion

Belgium was entitled to a large space at the exposition, due to the respect and interest it attracted on account of its traditions, its history and its connection with Art Nouveau issues, pursuits, and curiosities, indeed on account of all its artistic and industrial labour, which was great for such a small nation.

Unfortunately, Belgium exhibited little; even the exhibit at the Grand Palais failed to include the worthy Belgian school of sculpture. This was a lively and passionate school with many excellent artists that are honoured today, the foremost being Constantin Meunier, a moving master of noble simplicity and a poet of stoic and heroic human labour (like his counterpart Millet in France) and a master of human compassion (like his counterparts Jozef Israels and Fritz von Uhde). At least Belgium's undeniable and major influence on Art Nouveau made itself felt throughout the Exposition. But Serrurier-Bovy, Théo Van Rysselbergh, Armand Rassenfosse and many others, and especially Horta, Hankar and Georges Hobé generated a lot of comment by their absence in the Palais des Invalides and the Palais des Beaux-Arts.

What was nevertheless very beautiful, and worthy of the new Belgian art, was Franz Hoosemans' silver work and Philippe Wolfers' bijouterie. Also highly interesting were Bock's ceramics (especially the delicate artist's lively stoneware masks) and Isidore de Rudder's sculpture.

The German Pavilion

In the semi-absence of England and Belgium it was Germany (and perhaps France) that best represented Art Nouveau at the 1900 Universal Exposition. Germany's progress in decorative art was astonishing, and considering the country had stopped following and studying foreign artistic production, the revelation came as a surprise, almost a shock. Art Nouveau was the victor throughout Germany, from Berlin to Vienna.

In Prussia, the style reflected imperial taste, no doubt somewhat heavy and massive, as the new Germany, now moving closer to Kaiserism, chose a decorative style reminiscent of French First Empire.

The minor gallant courts of eighteenth-century Germany had followed the French model, demanding nothing of art but frivolity, prettiness and feminine charm and mannerisms – the delightful style of Madame Pompadour, which culminated in the rococo and the baroque. Later, at the start of the twentieth century, it was necessary and made sense for the robust and serious German empire to adopt a solid and severe style.

Germany acquired a reputation for beautiful and elaborate wrought iron; a return to past traditions (such as painted facades and sculpted woodwork); and above all, its rich development (in every sense of the word) of its decorative art and its consistent attention to the decoration and preservation of its national architecture, for the Germans (like the English) were actively restoring their architectural heritage throughout German cities and provinces.

The movement in Germany therefore was also on the whole very national in orientation. Dominated by foreign influences throughout the seventeenth and eighteenth centuries, Germany had reconnected its present to its noble past and, in restoring cities like Hildesheim and Brunswick, among many others, with a great deal of respect and patriotism, it rightly

Philippe Wolfers,
Vase, c. 1900. Glass and metal.
Private collection, Brussels.

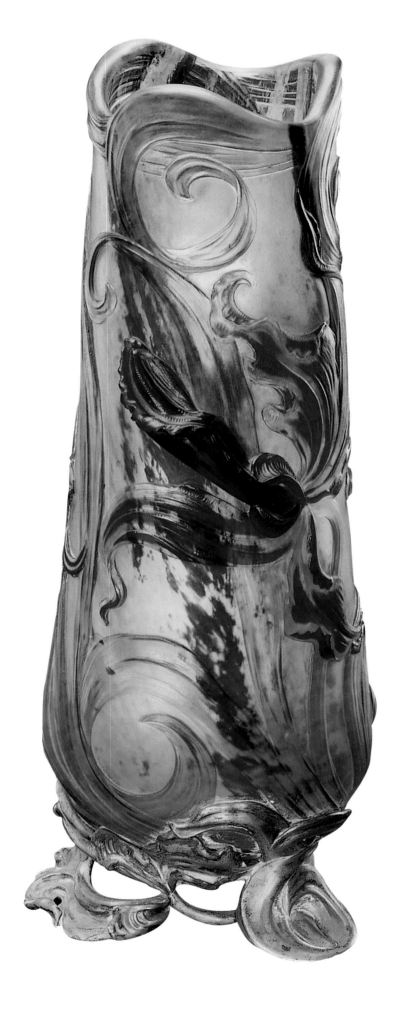

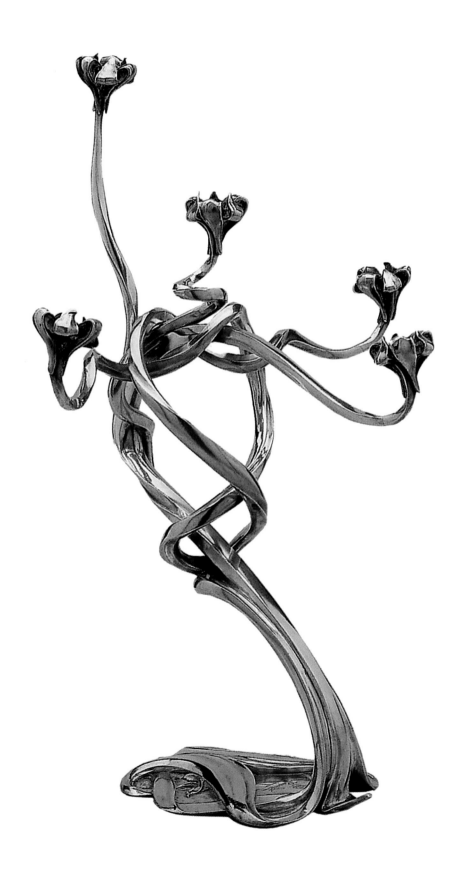

Fernand Dubois,
Candelabra, c. 1899. Plated bronze.
Musée Horta, Brussels.

Henry Van de Velde,
Candelabra, 1898-1899. Silver.
Musées royaux d'Art et d'Histoire,
Brussels.

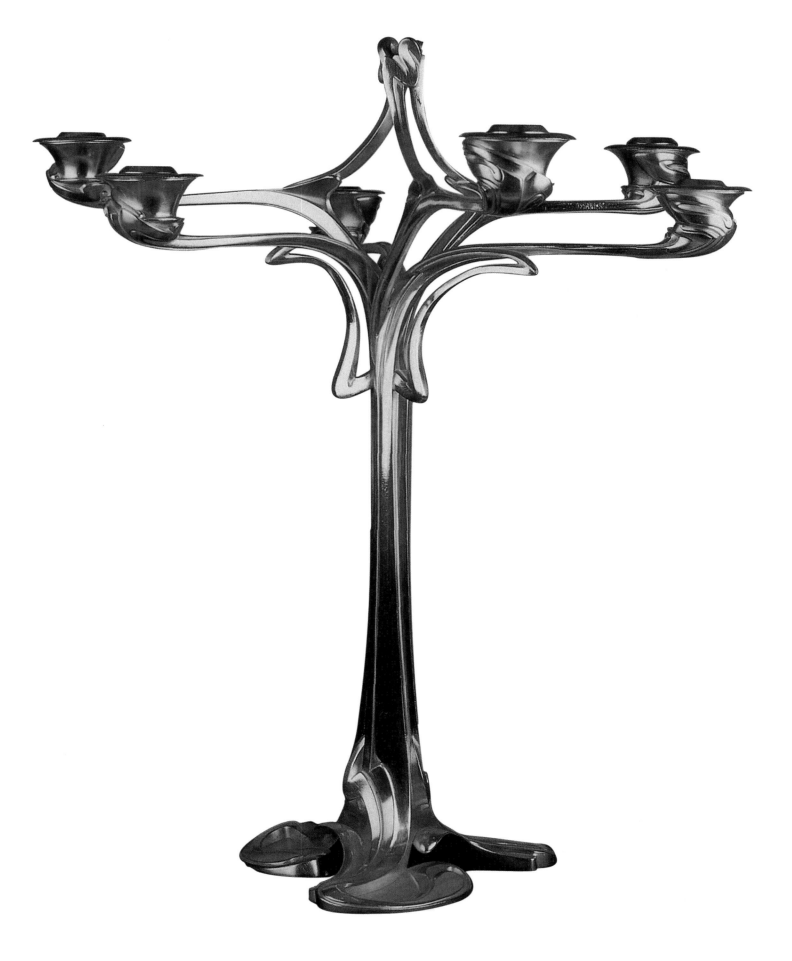

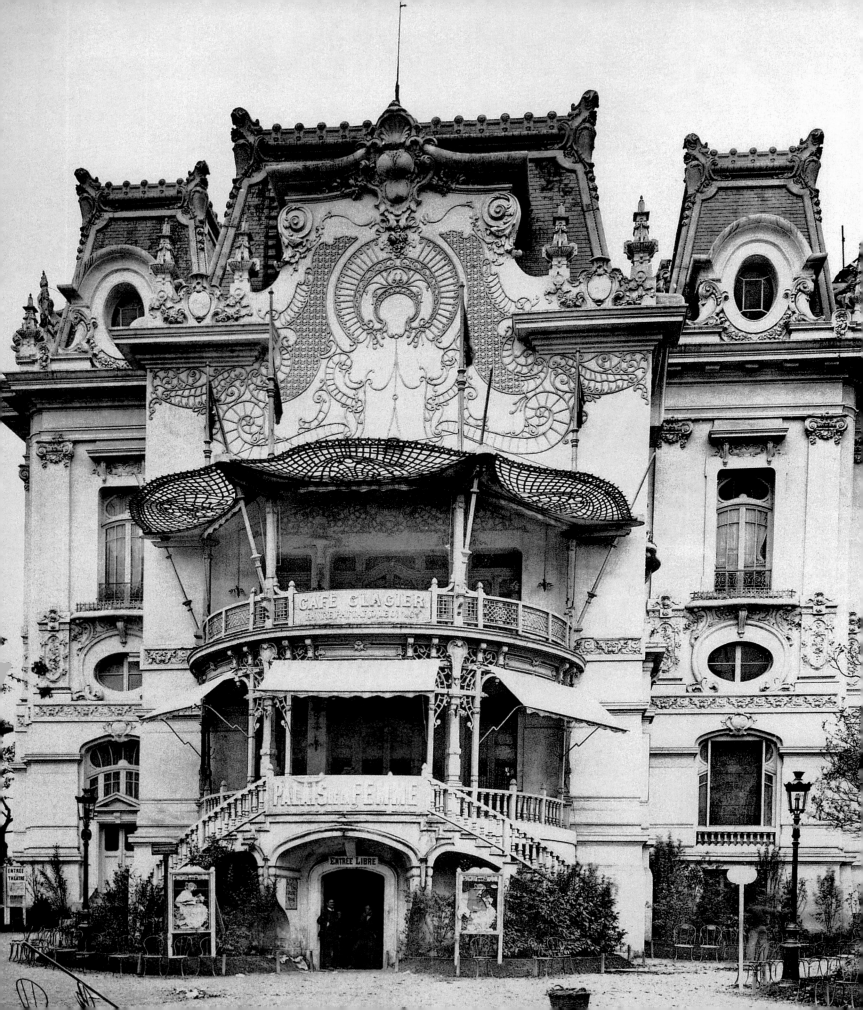

rediscovered its taste for polychrome, painted facades, and the colourful sculpted wood, that, in places, made for such a charming decor.

But internationalism and cosmopolitanism triumphed in German furniture (especially in Austria, perhaps due to the artists of the Secession, who were under many foreign influences), where Germans executed Art Nouveau's famous dancing line with complete abandon, exuberance and frenzy.

Yet, even in furniture, there was no less proof of renewed German taste and the highly charged and sometimes excellent new German awareness of decorative art. Germans demonstrated a fervent desire for decorative art, which they satisfied by thoroughly applying it everywhere, to everything and for everybody.

As for wrought iron, the Germans, who were fond of techniques utilising fire, softened it, moulded it, shaped it and worked wonders with it. The black vegetation and flowers that they obtained, and all the sumptuous ironwork of German doors and gates, truly evoked the magnificence of ancient Germany.

The Germans also made extensive and highly skilled use of wood. The beautiful vaulted ceiling of Professor Riegelmann, which was made entirely of sculpted wood, represented an imitation of the ancient ceilings of the German and Swiss Renaissance, now dotted with electric lights for night.

Unsigned,
Facade of the Women's Pavilion at the 1900 Universal Exposition in Paris.
Photograph.
Private collection.

Richard Riemerschmid,
Mug, 1902. Stoneware.
Victoria and Albert Museum, London.

Finally, the Germans exercised great artistry in their delightful application of mural painting and polychrome to the decoration of buildings and houses, for example, the slender and elegantly built Pavilion de la rue des Nations, which was the brilliant work of the architect Johannes Radke, and also the reproduction of the Phare de Brême (Bremen Lighthouse) with its superbly decorated entrance. Whereas all of this was not absolutely new, it was justifiably revitalised, reclaimed from their national heritage and outstanding in every way.

Yes, the Germans, too, had scored a wonderful artistic victory. They had, above all, demonstrated a most praiseworthy passion that rarely concerns us today: the desire to include art, decoration, and beauty in all things.

Compare the attention they brought to the task of fitting out and arraying their painting galleries to the almost careless indifference that France applied to preparing its own galleries and you will see the lesson to be learned here.

Among the deserving works remaining for discussion among the Exposition's German sections of applied art is the furniture of Spindler. With Spindler (as with the Nancy masters Gallé and Majorelle) one finds that the marquetry of his furniture is beautiful, whereas the line is somewhat less so, too often tentative or affected.

Spindler was an Alsatian who exercised astonishing mastery to great effect in his marquetry; possessing the skills of a painter, he put poetry and emotion into his wood panels.

Germany was also notable for beautiful electric chandeliers – a new genre of decorative art that the Germans (and the English) were typically adept at. The Exhibition's Bremen Lighthouse was decorated with motifs reflecting the function of the illuminated building. A splendid fixture with a shark and sea birds at the centre of a large crown and with electric globes suspended from fishing hooks, descending lightly like pearls, remains a stunning example. Was the artist thinking of the lavish crowns of the Visigoths? It would prove that a talented artist can always derive new and modern motifs from ancient themes if he really wants to.

Max Läuger's wall-hung fountains and ceramic chimneys were also extremely beautiful. The chimneys were English-style with enamelled plaques framing the fireplace recess, but in a dark green, severe style. In Germany, the large stove placed against the wall familiar to northern countries had become a popular Art Nouveau motif, sometimes depicted in sunny interiors that were bright and dazzling due to the enamel and the copperware that decorated them.

In ceramics, one could admire new high-fire porcelain with pure enamel produced by the Royal Manufactory of Charlottenburg and the Meissen factory, and earthenware from the Mettlach factory.

German tradition dominated the sumptuous silver work of Professor Götz (from Karlsruhe) and Professors Heinrich Waderé, Fritz von Miller and Petzold (from Munich), all worthy of renown.

The art of Bruckman, Deylhe, and Schnauer (from Hamburg) and Schmitz (from Cologne) was more modern.

Germany also exhibited beautiful stained glass windows, whose design, manufacture, and colour brought honour to Professor Geiger (from Fribourg), as well as Llebert (from Dresden), and Luthé (from Frankfurt).

As for glass, need we remind you of the exquisite work of the engraver Karl Köpping, who produced glasses on long, refined, slender stems like flowers, charming in both form and colour?

Bernhard Pankok,
Armchair, 1897. Pear wood and silk.
Kunstindustrimuseet, Copenhagen.

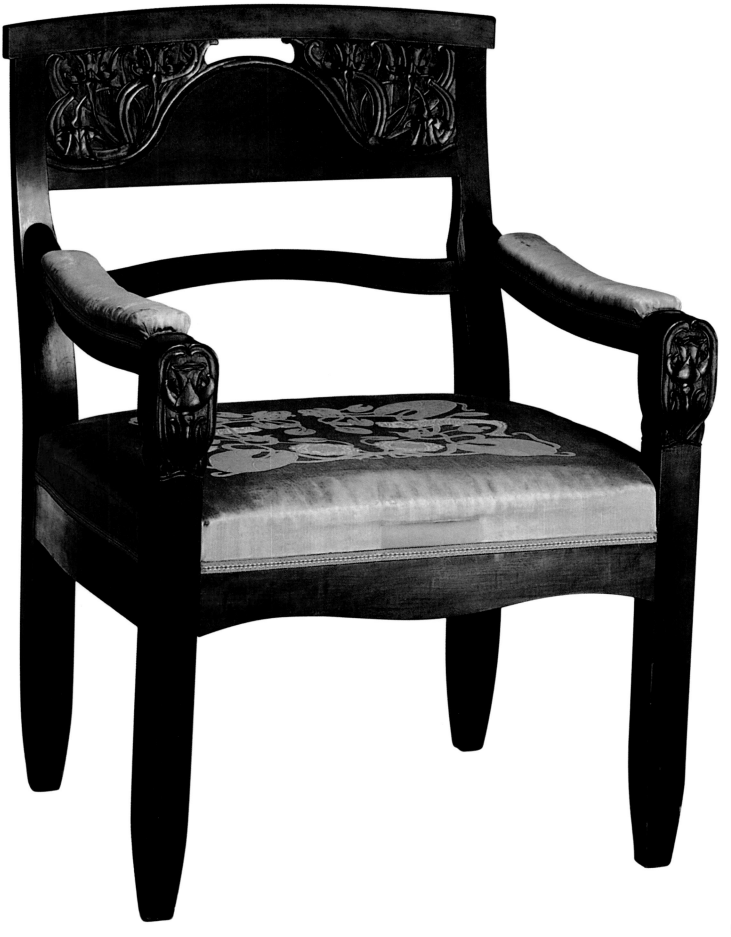

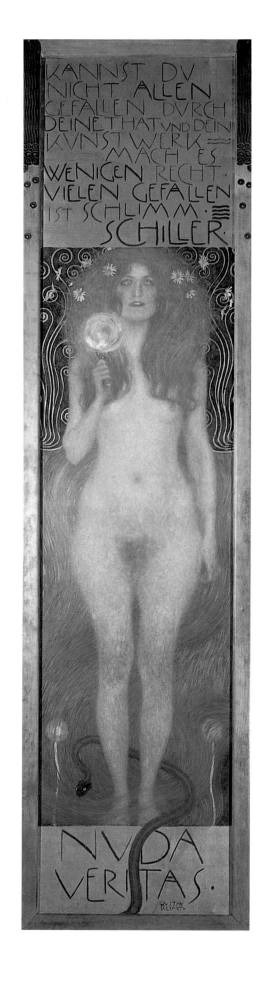

Gustav Klimt,
Nuda Veritas, 1899.
Oil on canvas, 252 x 56 cm.
Österreichisches Theatermuseum,
Vienna.

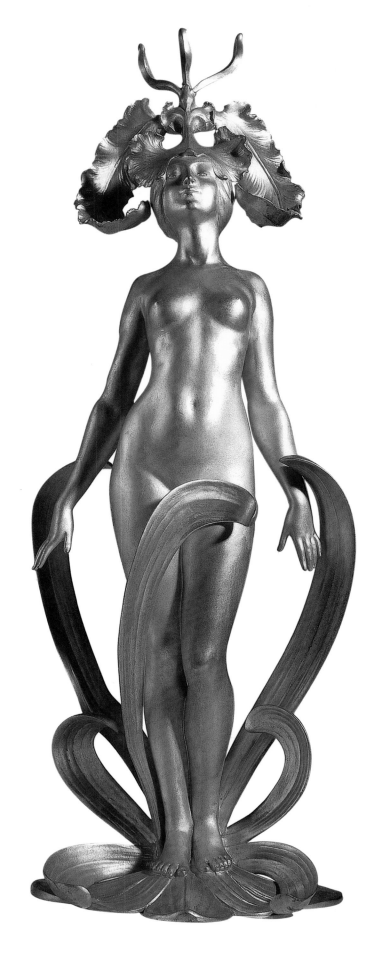

Louis Chalon,
Orchid Maiden. Gilt bronze.
Victor and Gretha Arwas collection.

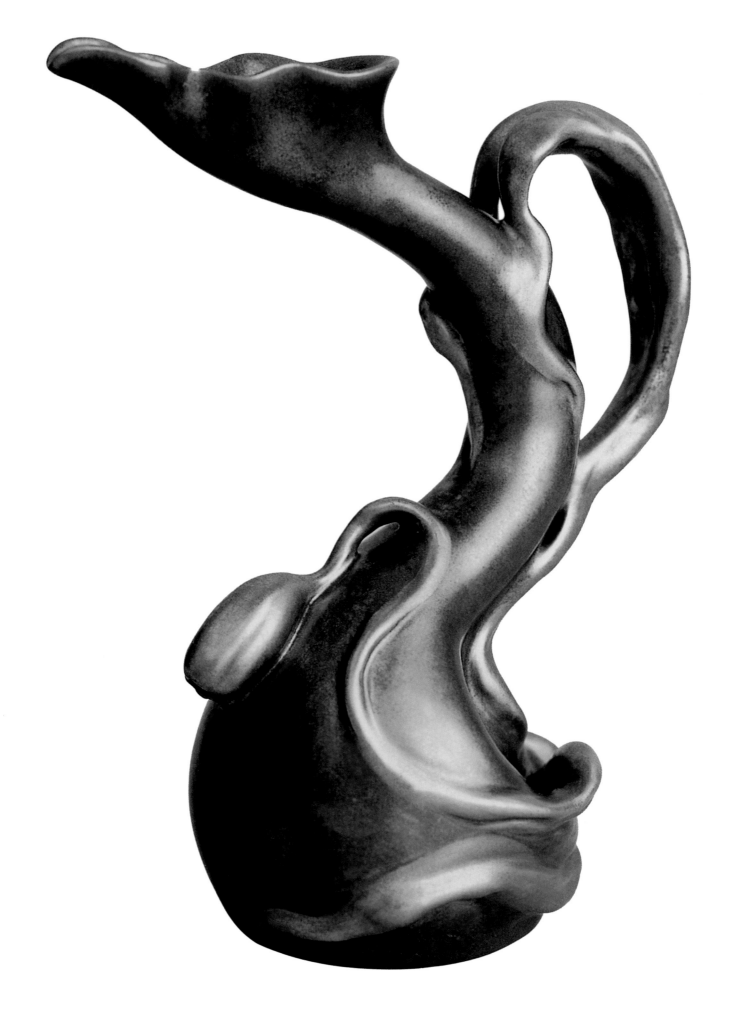

The Austrian Pavilion

Austrian art contrasted sharply with that of northern Germany. Whereas northern Germany's art was often severe and dreary, labouring under an excessive burden of discipline, Austrian art was rather pleasant and feminine.

In the Austria of Vienna, Art Nouveau was less nationalist and idiosyncratic than in northern Germany. A crossroads of many peoples where cosmopolitanism reigned, Vienna was necessarily dominated by its excellent School of Applied arts, directed by chevalier Salla, which showed work of the highest quality. The wonderful lace produced by the Herdlickas and by Miss Hoffmaninger, which was so innovative in its design and technique, is definitely worthy of the label Art Nouveau.

The Hungarian Pavilion

Hungary, still focused on independence, seemed to express a desire for artistic autonomy in relation to Vienna.

Proud of its glorious past, rich in ancient and wonderful treasures that radiated magnificent Oriental influences, Hungary, which had completed its new and beautiful Budapest Museum of Applied Arts under the active and highly intelligent direction of Jenö Radisics de Kutas, seemed unable still to decide between two different paths in art (and literature): the faithful preservation of its national tradition or the path to an art that was free. The latter choice had its merits, but it also had the drawback of building the same sumptuous and banal homes in Budapest as in Frankfurt, Vienna, and Berlin.

Like Romania, Hungary mined the depths of its past for decorative motifs that would enable it to establish an originality in art that was as pure and distinct as the uniqueness of its music and literature.

Hungary attracted attention at the Exposition primarily with its historical pavilion and the decor of its sections, as well as its earthenware, glazed stoneware, glass and copper enamel. Beautiful coloured porcelain vases were a credit to the Herend Factory.

Miklos Zsolnay excelled in metallic reflections: in the polychrome surface of the vestibule leading to the recently created Museum of Applied Arts, the reddish-gold reflections of his glazed bricks produced a magnificent fiery effect. *Bapoport*'s new copper enamel work in blues and pinks was also exquisite and extremely fine.

There was too little on display from Bohemia, but it showed the same dual tendencies and Bohemia's School of Decorative Arts still wavered between them. Prague also had its own Museum of Applied Art and a National Museum, valued above all for an extraordinary collection of traditional popular costume.

Among the Bohemians, the following deserve mention: the iridescent glass manufactured by de Spaun that was inspired by the Favrile Glass and that made a version of Tiffany (certainly less refined) accessible to all; the decorative high-fire porcelain manufactured by Messrs. Fisher and Mieg of Pirkenhammer, under the direction of a Frenchman named Carrière; and lastly, the Decorative School of Prague for its simple glazed earthenware, so lovely in form and decoration.

Thanks to the architecture of their pavilion and to the brilliant decorative talent of Alphonse Mucha (who drew and painted with fertile imagination, as passionately as a Gypsy playing the violin)[8] Bosnia and Herzegovina, still completely Oriental, enjoyed great success at the Exposition. In spite of their political and social transformation, these countries had remained faithful to Oriental tradition in their art and they would have been wrong to abandon it.

Zsolnay Factory,
Vase, 1899.
Faience, porcelain with Eazin glaze.
Museum of Applied Arts, Budapest.

Jan Kotěra,
Chair, 1902. Wood.
Museum of Decorative Arts, Prague.

Carlo Bugatti,
Chair. Mahogany, mother of pearl,
abalone and gilt bronze.
Macklowe Gallery, New York.

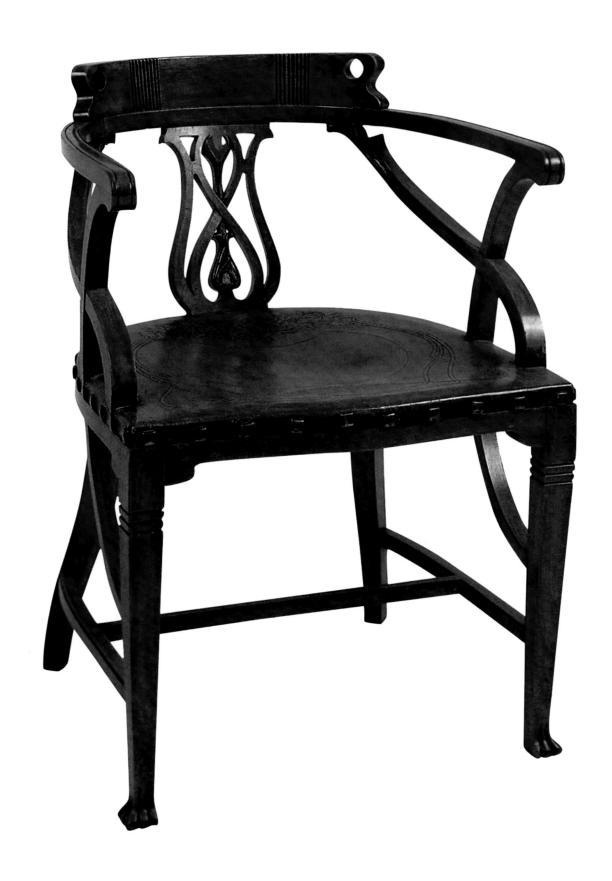

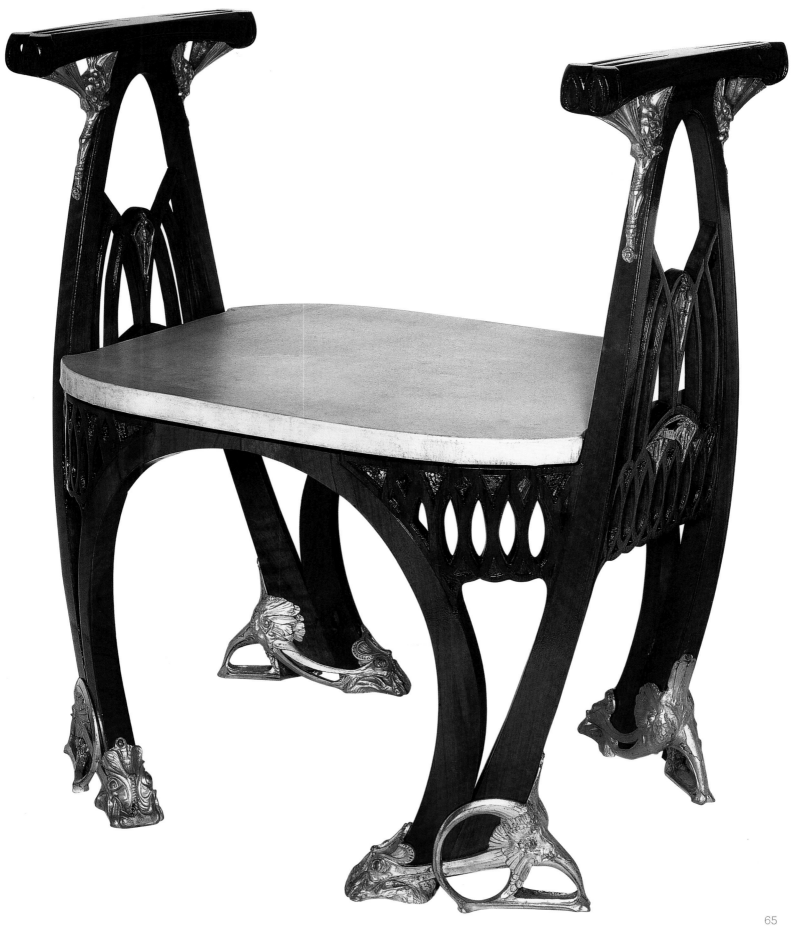

The Dutch Pavilion

The traditional decor of the Netherlands is so charming that it would have been a shame to want to change it. In the buildings of the early twentieth century, in the Hague and in Amsterdam, neo-Flemish taste, masterfully handled, usually triumphed. But the Netherlands also participated in the new movement, often with exceptional feeling. What a pity that the Netherlands failed to exhibit architectural drawings at the Exposition, because some of the houses in the new quarters being built near the museum had exquisite line and coloration: light touches of soft colour in the pale green hues that harmonise so well with brick. Department stores, boutiques, brasseries and new cafes in Amsterdam and elsewhere boasted truly innovative ornament.

The fabric designs of Thorn Prikker, as well as those of Jan Toorop, were also of interest. These designers apparently based their peculiar visions of long, bony figurines on the strange, grimacing puppets among the Pantheon of characters in the Javanese Puppet Theatre, proving that Dutch taste was not always severe and Protestant. Dutch contact with the Far East may be source of the imagination and fantasy that sometimes appears in Dutch forms and decoration. The Far East could also be the source of the forms and decoration produced by the Rozenburg factory in The Hague (later deservedly appointed royal manufacturer by the Queen) that gave Dutch porcelain – so exotic,

Alf Wallander,
Vase, 1897. Porcelain.
Kunstindustrimuseet, Copenhagen.

St Petersburg Imperial Glassworks,
Vase, 1904. Wheel carved plated glass.
Victoria and Albert Museum, London.

intricately shaped and decorated, but also extremely beautiful, rare and pure – its astonishing lightness. Dutch glazed clay pottery with polychrome decoration was also notable. Finally, Joost Thooft and Labouchère deserve acknowledgement for reviving the former Porceleyne Fles factory (especially Jacoba earthenware), thereby revitalising the art of Old Delft.

The Danish Pavilion

The Royal Copenhagen factory deserved every form of praise it received, as did the Bing and Gröndahl Porcelain Factory, which fearlessly went into competition and friendly conflict with Royal Copenhagen, but which, under the skilled and stern management of Willumsen, concentrated on plastic decorations. There is little that has not already been said about these porcelains, about their blue and white colorations, so soft and tender and easy on the eye, about the decoration of the plates and vases, where the Danes with such taste and dexterity evoked Japan's delicate decoration even as they translated it. It was Sèvres that paid this Danish factory its greatest tribute by henceforth imitating it gloriously, but in a way that did both factories justice. Sèvres owed its own renaissance and resounding victory partly to the Danish factory. Certainly Sèvres surpassed its rival, but it was a rival from whom it had learned how to win. Royal Copenhagen porcelain long remained the undisputed artistic triumph of this gentle and noble country.

But there were other examples of Danish artistry. Copenhagen's Town Hall, designed by Martin Nyrop, was then among the most beautiful in Europe, and its traditional, exceedingly pure style, with its thoroughly national decor, made it one of the most interesting, if not the most extraordinary building in Northern Europe.

The Swedish and Norwegian Pavilions

Sweden's contribution to the Exhibition was hardly an Art Nouveau revelation, although the movement had penetrated the country and was apparent in simple buildings, country homes, and railroad stations, sometimes with charming modernity. This rather disturbed the Swedish societies for industrial art that had been established to encourage and maintain respect for Sweden's national tradition, and thus Art Nouveau met with some ambivalence.

Among the Scandinavian countries, Norway most faithfully upheld its artistic traditions and respected spirit of its people.

Norway contributed some well-executed pieces of furniture that were among the best in the Exposition. These items were in the style of Norway's exemplary national ornamentation (somewhat transposed and modernised), which is so unusual, refined and vigorous and of which Norway (along with Iceland) preserves the most precious remains in certain types of architecture, ivories and sculpted wood.

The decoration by Johan Borgersen (from Christiania) of one the Norwegian sections with beautiful, rich Scandinavian-style tracery sculpted in red and green-stained wood was worthy of distinction. It is still cause for amazement that the dining room of the Norwegian Arts and Crafts Association, with its green-stained woodwork and red mahogany furniture, enhanced with elegant verdigris metal fittings, was not awarded a silver medal at the time.

József Rippl-Rónai,
Woman in Red, 1898.
Embroidered tapesty.
Museum of Applied Arts, Budapest.

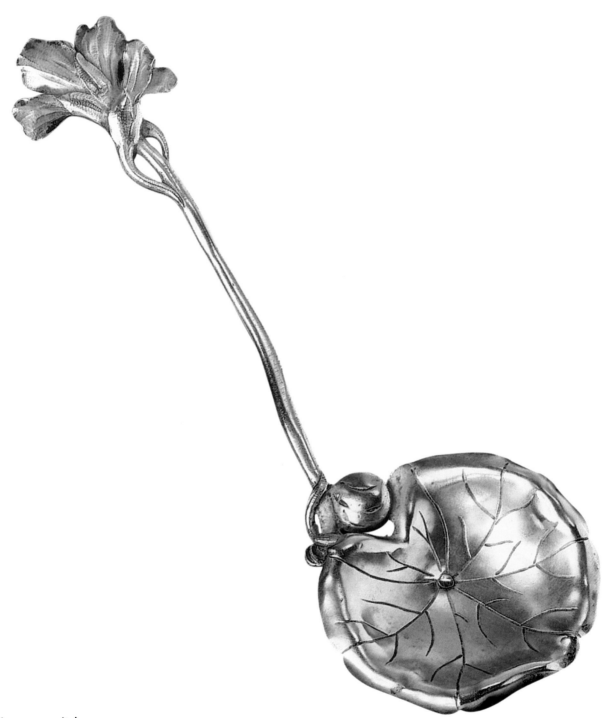

Prince Bojidar Karageorgevitch,
Spoon. Silver. Exhibited at the 1900
Universal Exposition in Paris.
Robert Zehil collection.

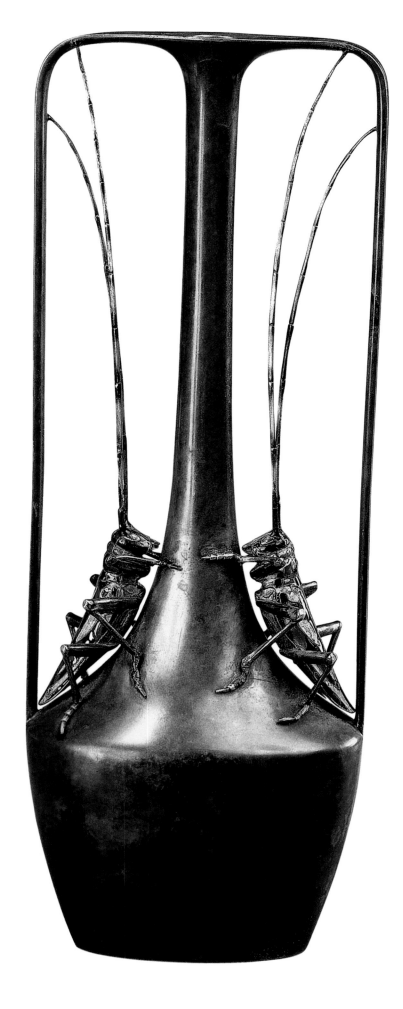

Henri Vever,
Vase with Crickets.
Bronze and enamelled silver. Exhibited
in the Salon of the Société Nationale
des Beaux-Arts in 1904, in Paris.
Robert Zehil collection.

Fine-quality enamel work also flourished in Norway. It was the same art of enamel as found in Russia, and Anderson, Olsen and Marius Hammer handled it with equal brilliance among the silversmiths of Christiania and Bergen. Tostrup, an artist with a sensitive imagination and perfect execution was foremost among them, producing (in Christiania) translucent enamels of extreme beauty and refinement. One of his works in particular was exquisitely designed in form and colour: a blue enamel cup on a stem, it looked poised to open like the calyx of a magic flower.

Finally, the following works were also admirable: the beautiful earthenware of Lerche and the tapestries of Frida Hansen (along with the more old-fashioned tapestries of Gehrard Munthe and Holmboe).

The Russian Pavilion

Russia and Finland surprised and delighted viewers. Here, more than anywhere else, unadulterated national tradition appropriately triumphed in Art Nouveau. In short, Russia rediscovered the hidden treasures of its past and awoke to the profound soul of its peoples. One day Russia (like England), in the midst of its aesthetic revolution, was shocked to see a Latin monument – standing out from the rest and by a talented French architect, but still a copy after Rome's Saint Peters Cathedral – being raised in the centre of its capital to serve as the cathedral of its Greek Orthodox faith. Russia (like England) thus wanted a new Art that responded to its new and fervently felt patriotism. However beautiful was Etienne Falconnet's statue of Peter the Great, crowned with laurels and, under his divine emperor's toga, heroically nude in the winter snow, it was not as prized by the Russians, who were in the process of extricating themselves from western influence, as the vigorous and superb statue of Peter the Great with his boots on, majestically clenching his stick in one hand with authoritative determination: the Peter the Great by Russia's first truly great sculptor, Markus Antokolski.

In architecture, this patriotic sentiment created the highly respected neo-Russian Style, which was especially prevalent in Moscow, in the Church of Saint-Saviour and in Red Square, in the Museum of Antiquities and the new Gastinoï-Dvor. Ingenious architects with confident taste made brilliant use of enamel and mosaic coverings in the richly polychrome decoration of churches, monuments and houses, such as the neo-Russian style Igoumnov house in Moscow.

But the national aesthetic movement was first evident in music. The new Russia had deigned listen to its popular music, all the folk songs in which Russians cried, moaned, and sighed, or were suddenly lifted up in gaiety and joie de vivre, wildly laughing and dancing along the Volga and the Black Sea, and in them the new Russia discovered the melancholy, sorrows, dreams, and exaltations of its people. Russians listened with surprise and delight to sad songs expressing the infinite sorrow of the Russian steppes, to lonely songs reflecting the bleakness of Russia's autumn and winter skies, and to tender and strange songs full of the affection and eccentricity of the individuals among its vast sea of peoples. So they came, after Glinka, the Russian musicians: Cui, Borodine, Tchaikovsky, Mussorgsky, Balakirev, Seroff, Rimsky-Korsakov and their followers. For starters, they wanted to become Russian again (or simply to remain Russian). Although they would not deliver on all their promises and achieve all their dreams, they nevertheless created a lively and active new school of music that was already illustrious.

In the realm of painting, some Russian artists managed to free themselves from foreign influences. But in our eyes, the man who made the greatest contribution to the new decorative art

Mikhail Vrubel,
The Swan Princess, 1900.
Oil on canvas, 142.5 x 93.5 cm.
The State Tretyakov Gallery, Moscow.

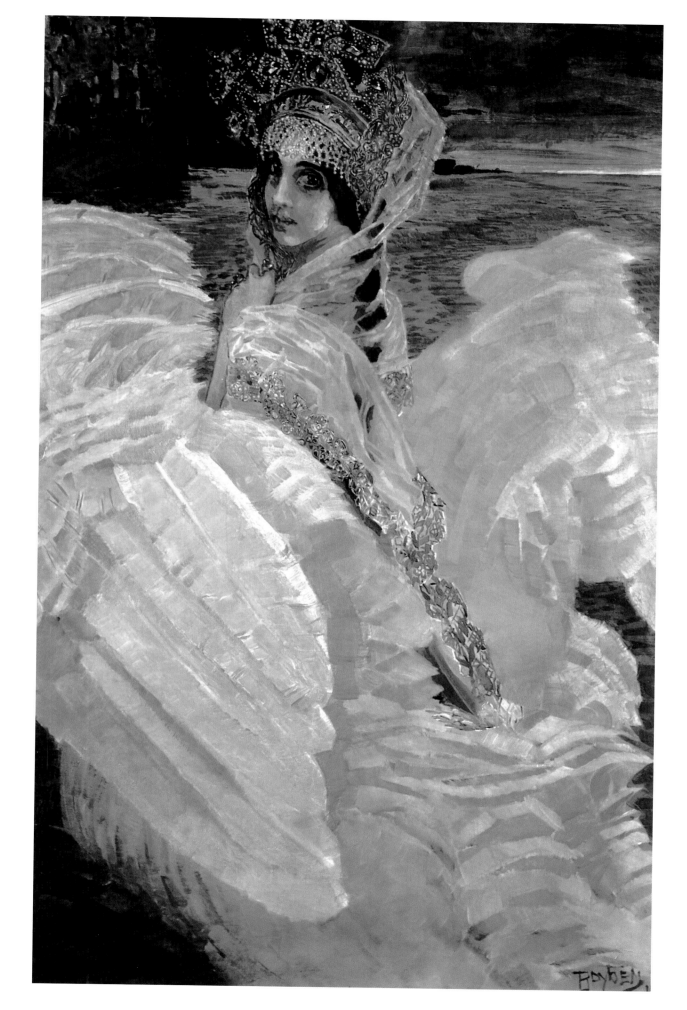

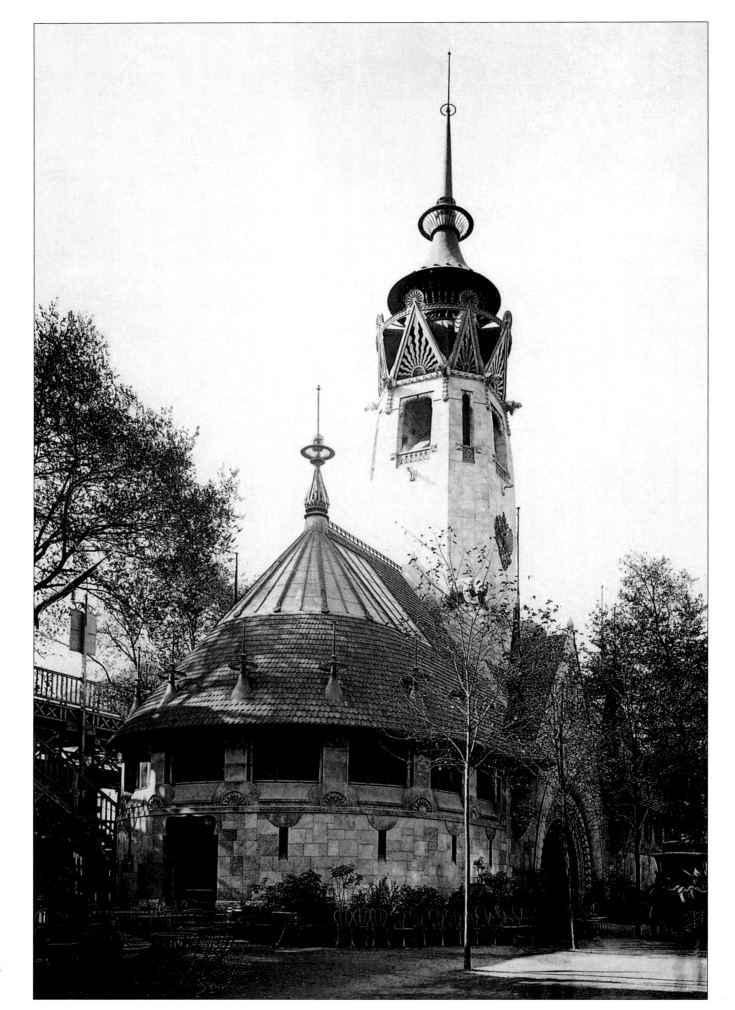

was unquestionably Viktor Vasnetsov, a supreme artist. It was an astonishing display of ignorance about foreign art, when no one at the Exposition knew how to classify or judge him (not to mention the fact his work was simply under-represented). Such a master deserved more than a silver medal! To us, Vasnetsov is among the top Russian and European artists, along with Ilya Répine, Antokolski, and the amazing Troubetzkoï, who has just emerged, although in temperament and in their art the latter artists are more western than Vasnetsov, less faithful to older tradition than he was and ethnically semi-eastern. Vasnetsov alone was responsible for almost the entire decoration of Kiev's Saint-Vladimir Cathedral, one of the most glorious monuments of contemporary Russian art. In this church and elsewhere Vasnetsov infused many paintings with moving religious and national mysticism. The legendary ancient soul of Russia lives again in Vasnetsov. This mystic is moreover (and primarily) an exquisite master ornamentalist, a miniaturist whose work looks like it came out of the convents of old.

Several of Vasnetsov's menus (for example, the one intended for the banquet of the last coronation) are masterpieces of the purest Russian ornamental style. Finally, Vasnetsov decorated and furnished his Moscow *isba* (a northern style country cabin) in the latest fashion, which happened to be the most traditional and the simplest of styles: the rustic style. Perhaps this house, where Vasnetsov authored everything, and where everything makes for a harmonious ensemble, is the source of the delightful new decorative art we now see flourishing in Russia and which was given a strong impetus by Vasnetsov's victory at our Exposition.

The favour enjoyed north of the Kremlin by all the artists who contributed to the Exposition's Russian Village in the Trocadero Gardens is well known. But one master stood out among the others: M. Constantin Alexeievitch Korovine, a painter, sculptor and architect who was responsible for the vigorous and colourful naïve-style constructions in the popular northern style. As a painter Korovine also produced the decorative landscapes in the Russian Palace of Asia, which revealed his very individual and sincere talent. Anyone who has perused the collection of albums at maison Mamontof, or who has admired the delightful Russian stringed instruments known as balalaikas made by Alexandre Lakovlevitch Golovine, Malioutine, Princess Ténicheff, and Korovine (again) will understand how decorative art in Russia rightly regenerated itself from the mysterious and invigorating resources of popular tradition.

Lastly, the art of enamel was also shown to brilliant advantage by Owtchinnikoff and Gratscheff. [9]

The Finnish Pavilion

Finland was located some distance from Russia at the exhibition, as if Finland wanted to distinguish herself from Russia. The Finnish pavilion was a highly original and pure masterpiece of decoration and architecture. It also provided a good demonstration of the extent to which the newest, most modern art could draw on past tradition and how right it was for a people of national pride and passion to attach themselves to their own tradition. Everyone justifiably praised Eliel Saarinen, the exceptional and sensitive artist who created the Finnish Pavilion. The entire pavilion's ornamentation, both exterior and interior, was new and intriguing, harmonious in line and colour, solemn, impeccable. It represented an art that was entirely individual and remote, foreign, strange and nevertheless very modern, where appeared,

Gesellius, Lindgren & Saarinen, *Finnish Pavilion for the 1900 Universal Exposition in Paris*. Photograph. Museum of Finnish Architecture, Helsinki.

translated in exquisite taste, the memories of a profound past, including memories of ancient peasant houses or old-fashioned country churches with bell towers.

A beautiful illustration will be that of Kalewala by Akseli Gallen-Kallela, whose mural paintings for this pavilion revealed a mystical genius haunted by heroic and divine legends.

The Romanian Pavilion

Romania, which owes its artistic heritage to the East and to the Greek Orthodox church, was taking back its memories, its dispersed fragments (as did Hungary), in order to forge a new art, at least in its architecture. The queen of Romania (simultaneously a respected poet, artist and queen) presided over and contributed more than anyone in her country to this positive restoration of national tradition. Not only in the architecture of churches, buildings and houses, currently sometimes splendidly decorated with oriental polychrome, but she also contributed in the exquisite art of embroidery decorating the costumes that remain so colourful in many regions of Romania, and which is being abandoned and will perhaps soon disappear regardless of what is done with those other still cherished remains of the past, popular song and dance.

The Swiss Pavilion

Among the smaller countries, which can be rather large in their sense of history and in their current activity, Switzerland is of great interest to us because it was reclaiming its old artistic traditions in order to revitalise and modernise them. Switzerland was headed in this direction at the last Exposition in Geneva, which revealed (although less effectively and thoroughly than the amazing national museums established in Basel and Zurich) a national art that was truly Swiss and either misunderstood or unknown to us, an art of its own, despite certainly more than one foreign influence (primarily Germany's). Nothing was more original, charming and gay than the decoration of its pavilions for Food and its pavilion for the Swiss Watch-making Industry, by Bouvier.

Finally, the following Swiss achievements should be noted: the cloisonné enamels on wood or plaster, so charming in decoration by Heaton of Neufchatel; the silks of Saint-Gall and Adlissweill (which warranted greater vigilance from the French silk trade in Lyons out of jealous respect for these worrisome Swiss rivals); the greater attention given to the needed revival of all art forms; and the work of Geneva's School of Industrial Arts.

The Universal Exposition of 1900 presented a much grander view of Art Nouveau's development than the image of Art Nouveau retained by subsequent decades. The event is therefore a true testament to the trend, defining the new movement as nearly universal and moreover highly national in character. The aesthetic renewal that came out of the Decorative Arts and that rapidly spread to other areas (such as architecture and music), advocating Unity of Work (one Art in everything and for everything) really was present in nearly every western country, but each country chose to apply its own taste to the trend and in this way the movement was a multi-faceted cultural phenomenon among different populations. England's Modern Style (born out of the Arts and Crafts movement), France's Art Nouveau, Germany's Jugendstil, and even the Austrian Secession movement are all good examples. If the ideals of modernity and aesthetics remained the same, the works themselves always responded to purely national taste and expertise.

Akseli Gallen-Kallela,
The Flame (Finnish ryijy rug), 1899.
Woven wool.
Museum of Art and Design, Helsinki.

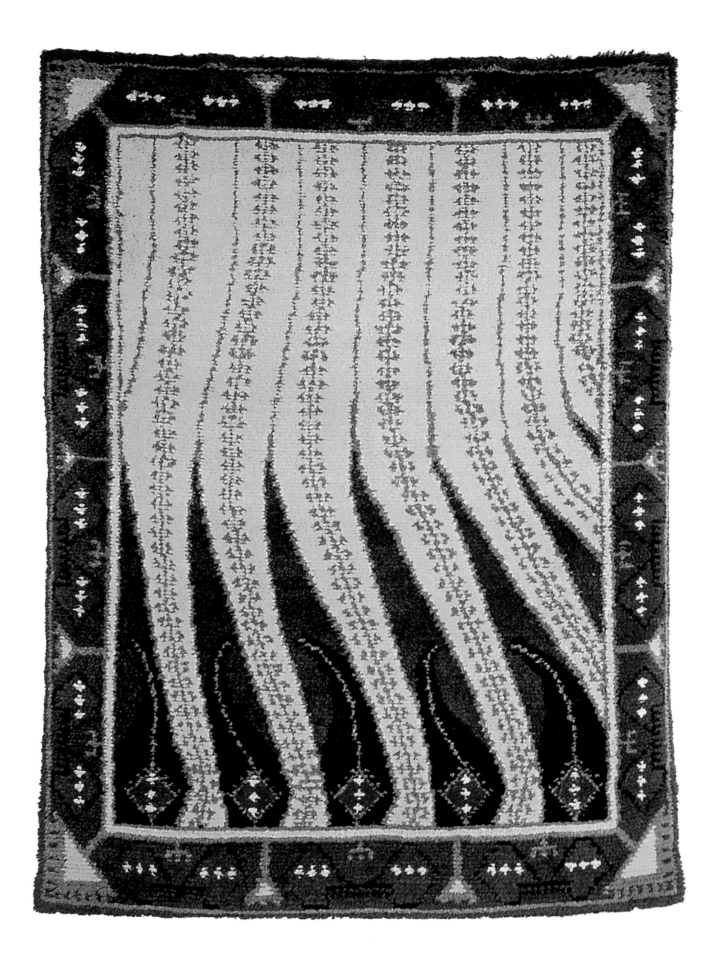

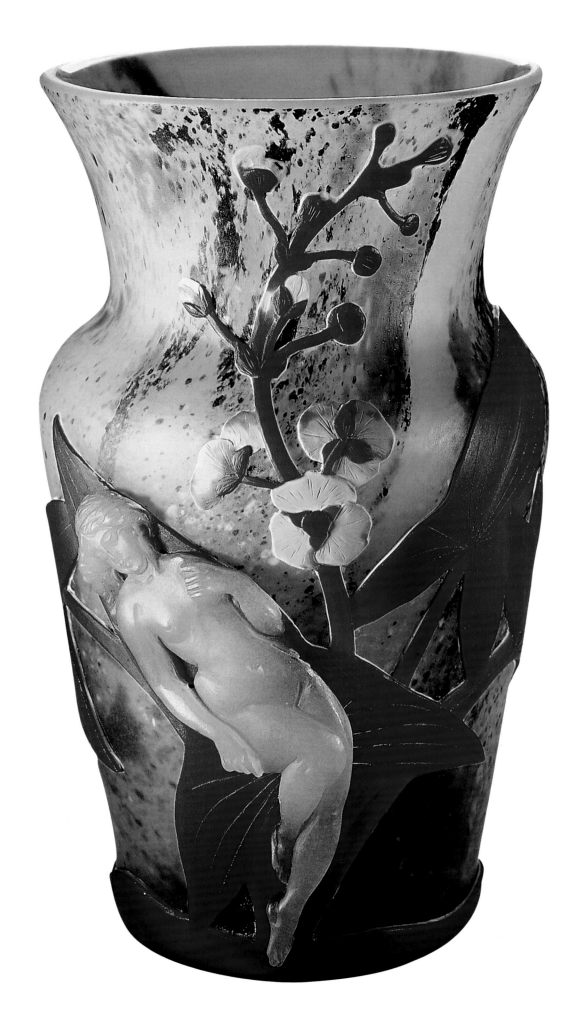

Conclusion

Art Nouveau was confirmed as a trend in 1900 as a result of the Universal Exposition, which proclaimed the movement's quasi-universal victory.

Art Nouveau meant marvels of joaillerie, bijouterie, silver, glass, mosaics and ceramics.

In the beginning, Art Nouveau was produced by architects and decorators returning to their roots in national traditions (or who simply wished to remain faithful to the same), who were able to derive magnificent and delightful new variations from old domestic themes that had been more or less forgotten.

Art Nouveau was also the work of French architects like Paul Sédille and Jean-Camille Formigé, who (on the heels of their predecessors Henri Labrouste and Emile Vaudremer) eagerly combined novelty with talent, taste, and ingenuity and were able to introduce ornamental iron and ceramic work to the visible structural skeleton of modern construction and homes.

Art Nouveau was the eccentric Barcelona of Gaudí (although notably absent from the 1900 Universal Exposition), which provided Spain such a colourful and appropriate image.

Art Nouveau was the work of English, Belgian and American architects, subject neither to classical principles or the imitation of Greek and Italian models, but deeply and completely committed to modern life, who created a solemn, refined style that was not always faithfully copied by their imitators, work that was new and original and usually excellent: a youthful and lively architecture that truly represented their respective countries and time.

Art Nouveau meant pastel-coloured wallpaper, tapestries,[10] and fabrics that made French interiors sing with exquisite harmonies and French walls burst forth with delightful new flora and fauna.

Art Nouveau appeared in the form of illustrated books, such as those decorated by Eugène Grasset, Alphonse-Etienne Dinet, James Tissot, Maurice Leloir, and Gaston de Latenay, in France; Morris and Crane, among others, in England; German artists in Berlin and Munich; and Russian artists in Moscow.[11]

Among a few masters in France, England, and the United States, Art Nouveau was the art of bookbinding.

Art Nouveau was the art of the poster, because posters were needed during this era of insistent advertising. Of course, we refer to the poster as created by Jules Chéret, such as it was and continues to be interpreted after him in England, the United States, Belgium, and France by many exceptional artists with imaginative flair: posters displaying delightful whims of colour, harmony, and line, sometimes exhibiting grace and beauty, and posters displaying pyrotechnics, razzle-dazzle, and the use of harsh and brilliant colours.[12]

Art Nouveau was the printmaking of Henri Rivière, respected interpreter of the French and Parisian landscape. In the simplicity of his images, Rivière sometimes applied more truth and more genuine and moving poetry than was available in works of the most famous classical masters, and his wondrous rendering, perfect colour, and eloquent Impressionism, evoke and even surpass the very Japanese works that inspired him.

Eugène Michel,
Vase. Wheel etched cameo glass.
Robert Zehil collection.

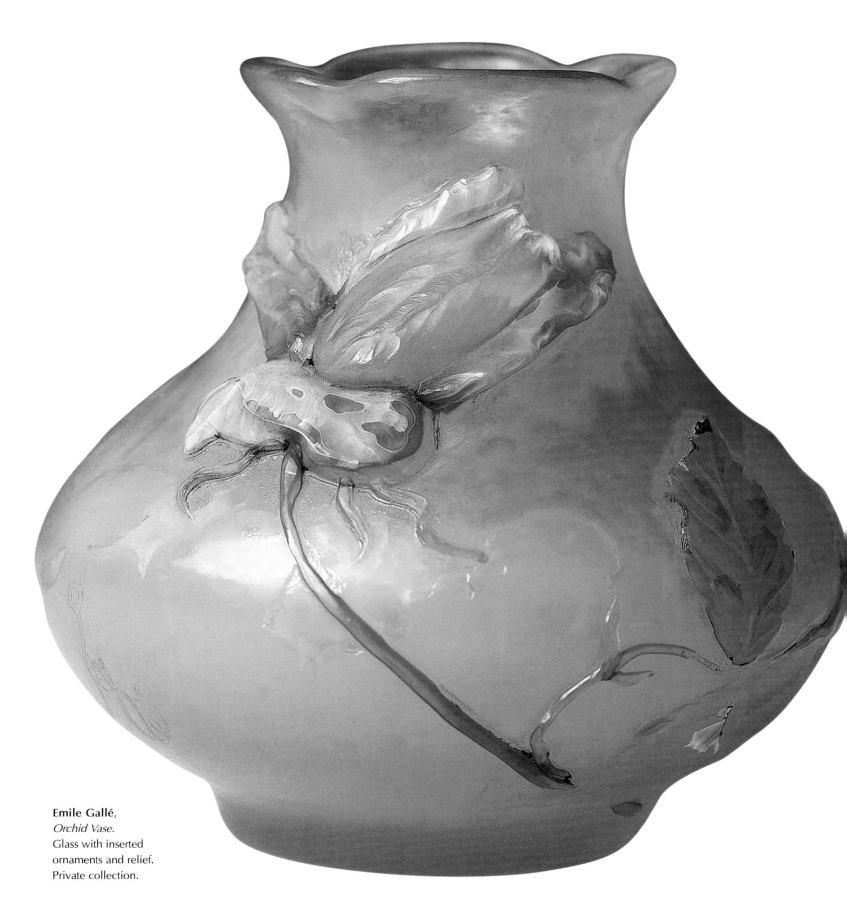

Emile Gallé,
Orchid Vase.
Glass with inserted
ornaments and relief.
Private collection.

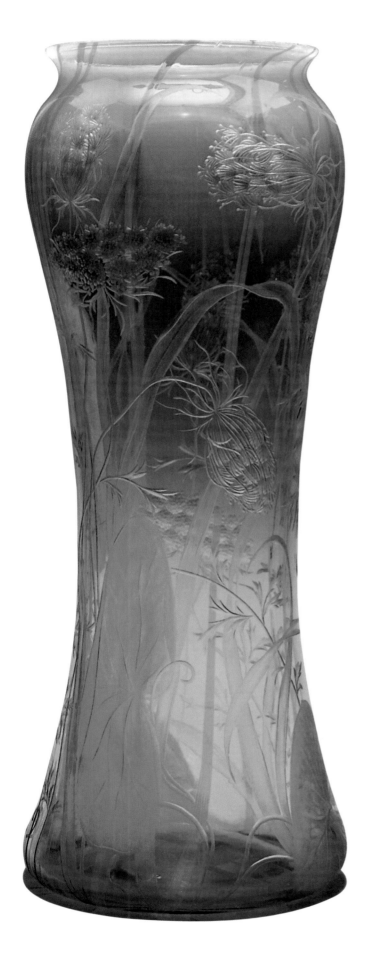

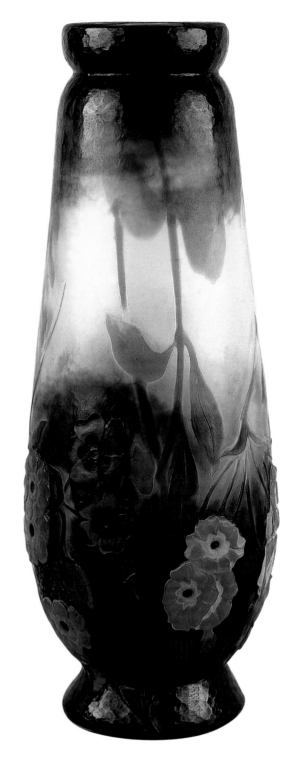

Tiffany & Co.,
Vase, 1895-1898.
Favrile glass, carved and etched.
The Metropolitan Museum of Art,
New York.

Daum,
Vase. Carved cameo glass.
Private collection.

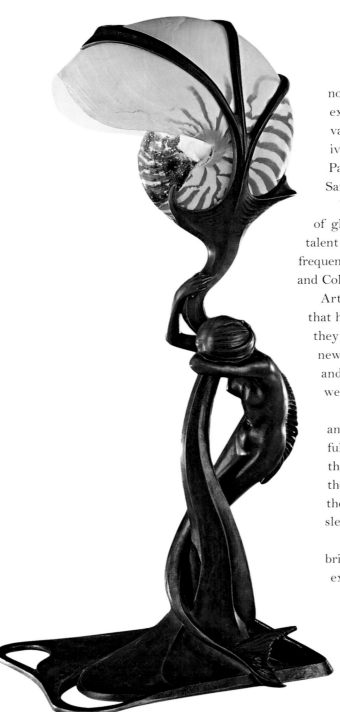

Art Nouveau was the art of the minor masters of statuettes, whose graceful novelties took the form of delicate figurines shamelessly dangling, crouching, or extending themselves in supple nudity on every imaginable object (such as cups, vases, and desk accessories), as well as more serious works in bronze, marble, and ivory. In France, these masters included the refined Carl Wilhelm Vallgren, Jean-Paul Aubé, Raoul Larche, Agathon Léonard and Fortini; while Belgium had Charles Samuel; Vienna had Gustav Gurschner and Germany had Mrs Burgev-Hartman.

Within the Art Nouveau movement, French bijouterie had Lalique, while the art of glass had Gallé and Tiffany. Gallé's now-acknowledged gifts went well beyond mere talent into the realm of genius and extraordinary ingenuity. The arduous efforts and frequently beautiful execution of Plumet and Selmersheim, Majorelle, Gaillard, de Feure and Colonna also deserve mention.

Art Nouveau was the furniture of Van de Velde and Horta: the desks and chairs that had plant feet, the dressers and buffets perfectly fused with the architecture that they coordinated with. In furnishings (already often expertly handled) it was the new library of the open bookcase that held (in addition to books) bibelots, figurines and items of ceramic and glass that were as vital sustenance for the eyes as books were to the mind.

What was even more outstanding and typical of the new style (and what became and remains standard), was the English wardrobe with full-length mirror and the fully-designed and decorated bathroom interior, including another English novelty that would become standard: the mirrored étagère similar to chimney glass. Here the exquisite work of Charpentier and Aubert also comes to mind: for example, their decorative ceramic wall covering depicting water blooms with a frieze of slender nude bathers.

Art Nouveau was the decoration of the fireplace and mantle framed in glazed brick or tile, wood, bright copper, or onyx, which was most effectively conceived and executed by the English.

Then there was the period's innovation in lighting, the illumination of interiors that in the past had often been too dark and too heavily draped. Here Art Nouveau is associated with truly magical applications of electricity (yet to be thoroughly exhausted), which was definitely a boon to the movement. Electricity lent itself to all lighting needs and already necessitated a transformation in lamps, which was handled with great creativity in Germany, England, and the United States, where in the hands of Tiffany the lamp was transformed into a variety of configurations, forms, and lighting. Interiors might therefore be enchantingly lit by opaque glass skilfully and softly coloured to take on the appearance of onyx, jade, and rare stones and at the same time have Tiffany Favrile glass and lamps by Gallé or Daum adding their own charming illumination and magical iridescence to the mix.

Art Nouveau is the sum of all these artists. Their names alone evoke the period, so beloved by our modern cities, which decisively broke with the past and enabled art to undergo renewal: a renewal preserved forever in the words Art Nouveau – and what greater honour could an artistic movement have than to be eternally new?

Gustav Gurschner,
Nautilus Lamp, 1899.
Bronze and nautilus shell.
Virginia Museum of Fine Arts, Richmond.

Unsigned,
Portfolio on its Stand. Leather.
Robert Zehil collection.

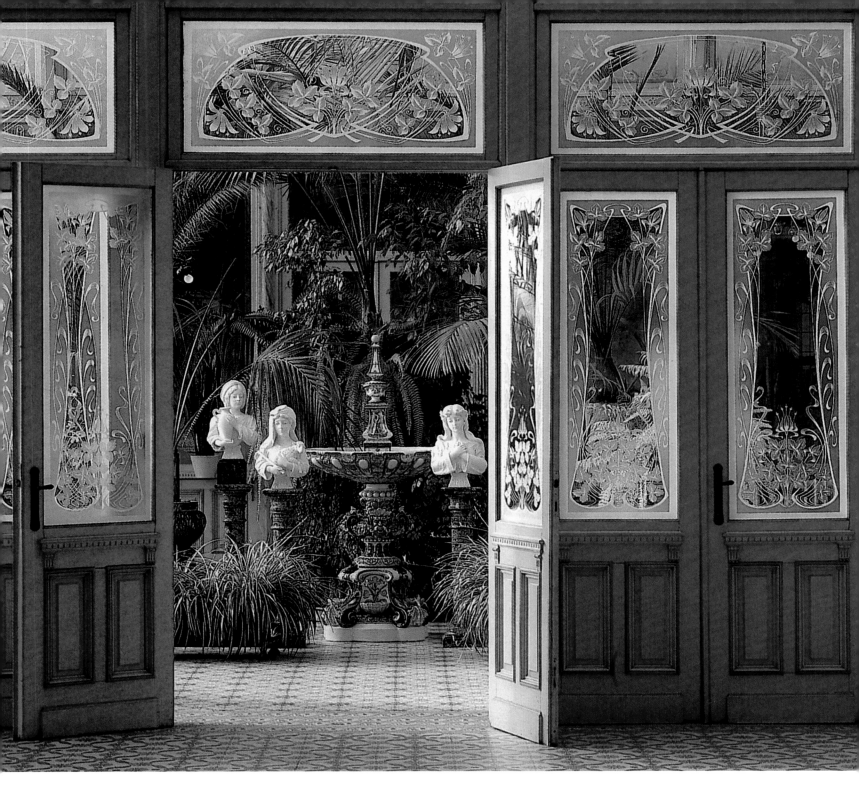

Charles-Henri Delanglade,
Loïe Fuller. Marble.
Robert Zehil collection.

J. Prémont and **R. Evaldre**,
*Winter Garden at the Ursulines
Establishment*, c. 1900.
Wavre-Notre-Dame.

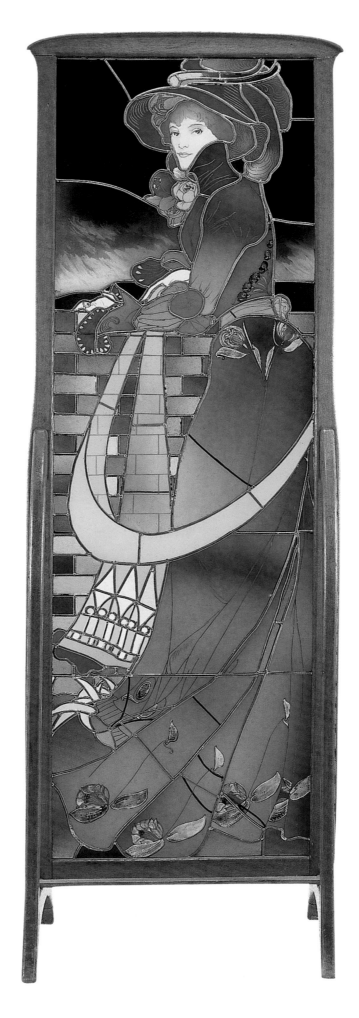

Georges de Feure,
Polychrome Leaded Glass Panel.
Glass.
Robert Zehil collection.

Hippolyte Lucas,
At Water's Edge. Aquatint.
Victor and Gretha Arwas collection.

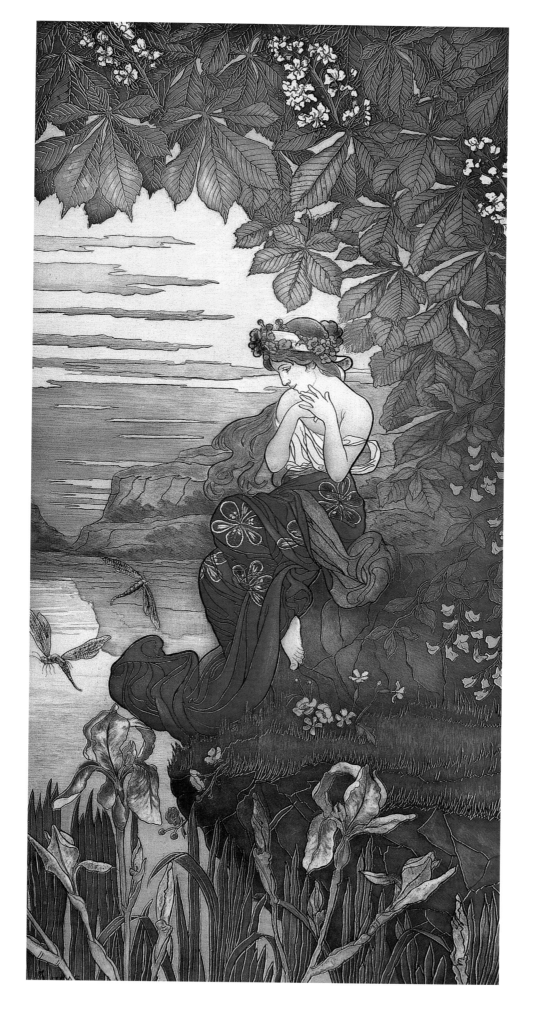

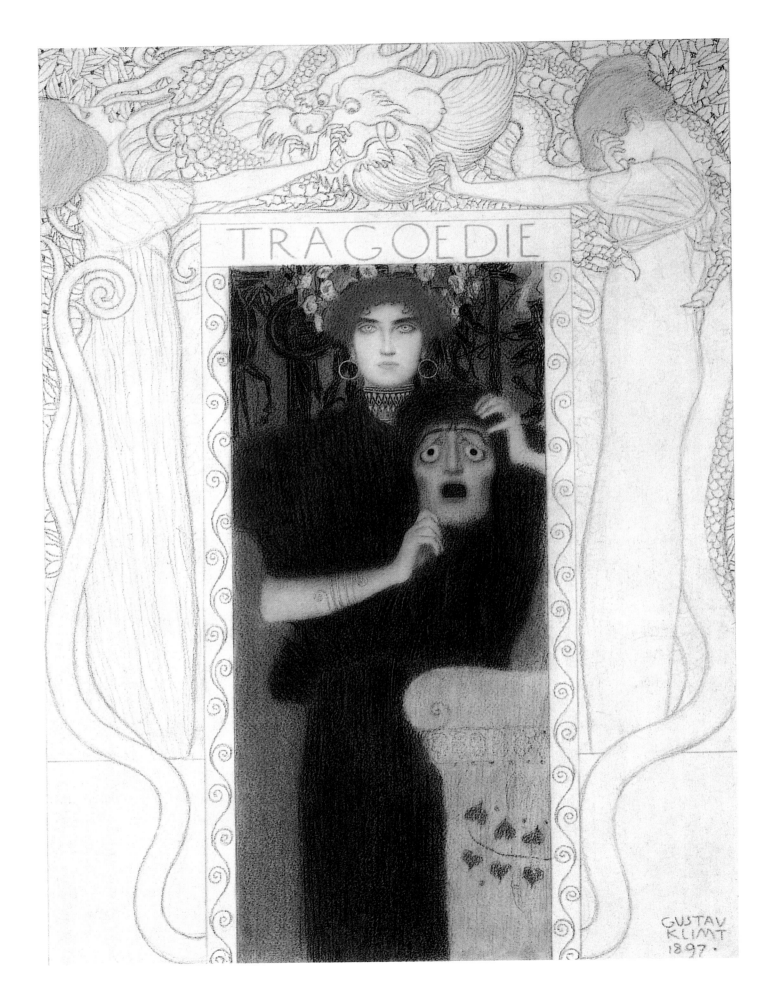

Major Artists

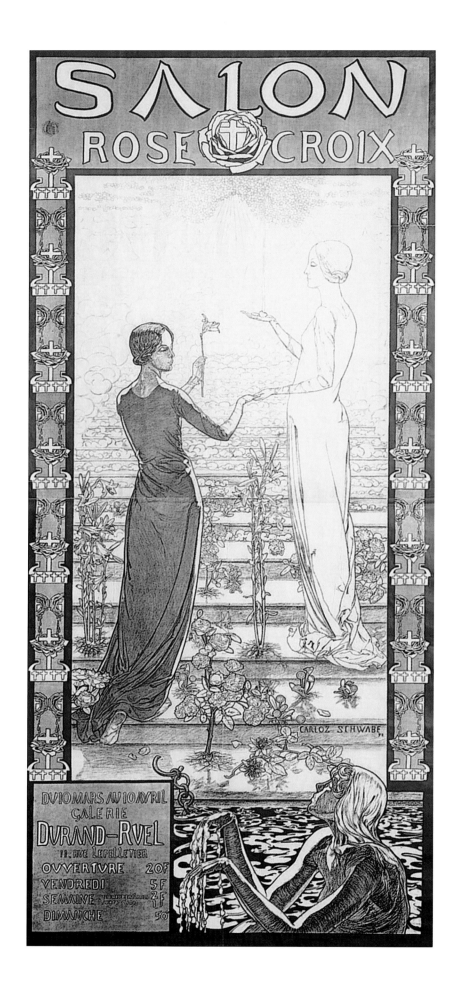

Painting

Fernand Khnopff (Grembergen-lez-Termonde, 1858 – Brussels, 1921)

The son of a magistrate, Fernand Edmond Jean-Marie Khnopff was born in Belgium, in Grembergen-lez-Termonde, in 1858. He was the eldest of three children.

In 1859, his father was appointed as a public prosecutor and Khnopff family moved to Bruges. His brother Georges, a future musician, poet and art critic, was born in 1860; his sister Marguerite was born in 1864.

The next year the Khnopff family moved again to live in Brussels.

In the Belgian capital, Khnopff continued his education by studying law at the Faculté de droit at the Université Libre and began frequenting Xavier Mellery's painting studio. Sometime between 1876 and 1879 he interrupted his law studies in order to enter the Brussels Académie des beaux-arts, where he met James Ensor.

Khnopff's first paintings were mainly landscapes, depicting in particular the town of Fosset where he normally summered.

Inspired by the writing of Gustave Flaubert, Khnopff painted his first Symbolist work in 1883 and participated in the founding of the Les Vingt. Mentioned in the influential art magazine *L'Art Moderne*, Khnopff appeared in the annual exhibitions of Les Vingt until the group disbanded ten years later.

In 1885, while fascinated by the occult theories of the Rose-Croix, Khnopff met Joséphin Péladan, for whose novels he illustrated the frontispieces. Khnopff regularly exhibited in the Salon of the Rose-Croix.

In 1887, the artist painted the enigmatic portrait of his younger sister Marguerite that he always kept with him. As a woman who was both pure and sexually attractive, in the eyes of the painter she represented a type of feminine ideal, and it was she whom Khnopff depicted several times in his masterpiece entitled *Memories*, the subsequent year.

Particularly active in the bourgeois milieu of Brussels and Paris, Khnopff quickly became the portraitist of choice.

In 1889, Khnopff, who was drawn to England, began to develop relationships with pre-Raphaelite painters, especially Burne-Jones.

The next year the Hanover Gallery in London held an exhibition devoted to Khnopff. During this period Khnopff participated in many international exhibitions in London, Munich, Venice, and Paris.

Khnopff is known for the faded tonalities of his colours that increase the viewer's experience of nostalgia and detachment before his paintings.

While a correspondent for Belgium, he was also associated with the art magazine *The Studio*, for which he worked until 1914.

In June 1898, the Austrian Secession (an Art Nouveau off-shoot), welcomed Khnopff as a guest of honour, alongside Rodin and Puvis de Chavannes. Khnopff composed his famous canvas, *The Caresses*, the same year.

In 1903, financier Adolphe Stoclet commissioned Khnopff to decorate the music room of his Art Nouveau mansion, the Palais Stoclet, which also included Gustav Klimt's famous mosaic murals.

Gustav Klimt,
Tragedy (Allegory), final drawing, 1897.
Black chalk and wash heightened with white and gold, 42 x 31 cm.
Wien Museum, Vienna.

Carlos Schwabe,
Salon de la Rose-Croix, poster for the group's first exhibition, 1892.
Lithograph, 199 x 80 cm.
Private collection.

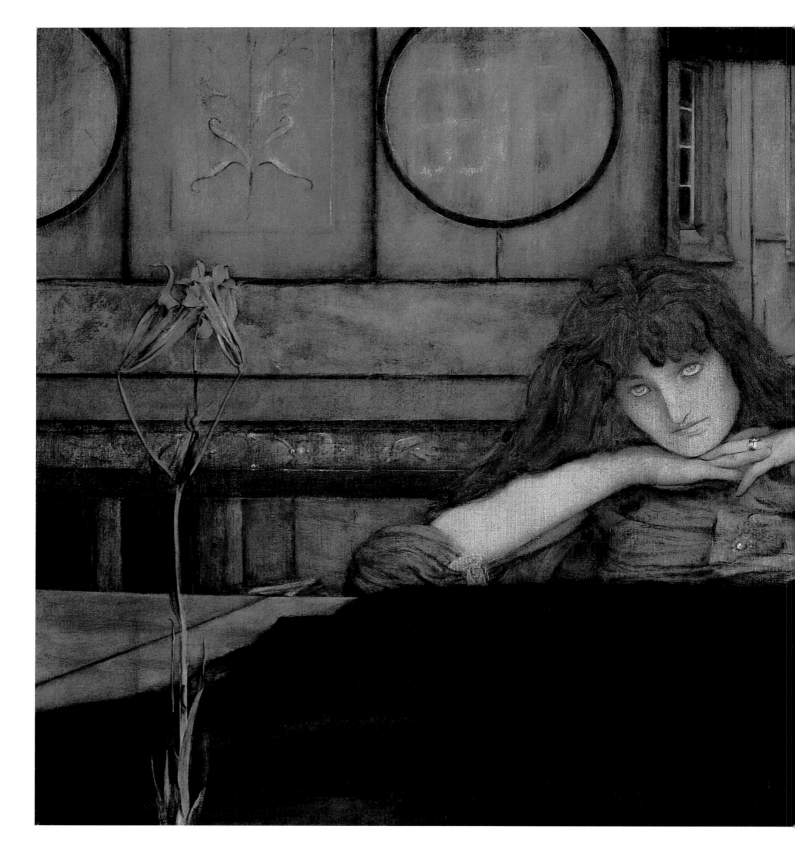

Fernand Khnopff,
I Lock My Door Upon Myself, 1891.
Oil on canvas, 72 x 140 cm.
Neue Pinakothek, Munich.

At the same time, Khnopff started a series of pastels around Georges Rodenbach's symbolist novel *Bruges la Morte (The Dead City of Bruges)* and designed costumes for various operas playing at the Théâtre de la Monnaie in Brussels.

In 1908, he married Marthe Worms, but the marriage only lasted three years.

Fernand Khnopff died in Brussels on 12 November, 1921.

The Symbolist movement was an important influence on Khnopff, but his effort to render multiple meanings makes him equally part of the Art Nouveau trend. Like the career of Jan Toorop, Khnopff's career proceeded to impact the formation and spread of Art Nouveau; in turn, the "painter of closed eyes" inspired other artists, including Gustav Klimt.

Jan Toorop (Purworedjo, 1858 – The Hague, 1928)

The son of a civil servant whose job required travel to Dutch trading posts and an English mother, Johannes Théodor Toorop, known as Jan Toorop, was born in Indonesia on the island of Java in 1858.

In 1863 the Toorop family moved to the island of Banka in southern Sumatra.

Upon returning to the Netherlands in 1869, Jan Toorop attended secondary schools in Leiden and Winterswijk. In 1881, he continued his education in the town of Delft at the Academy of Amsterdam.

As a result of his background, Toorop developed a highly individual style in which he combined Javanese motifs with Symbolist influences, creating willowy figures that prefigured the undulating style of Art Nouveau.

In 1882, he moved to Brussels where he enrolled in the Académie des arts décoratifs.

Two years later he exhibited in Paris in the Salon des Artistes Indépendants and in Brussels joined Les Vingt.

Toorop also made several trips to England where he discovered the works of the Pre-Raphaelites and William Morris.

In 1886, he married Annie Hall.

The next year, while Seurat's *Sunday Afternoon* or *La Grande Jatte* was being shown in Brussels, Toorop fell ill and became temporarily blind.

In 1889, Toorop and his wife settled in England alongside Guillaume Vogels and the painter prepared an exhibition showcasing Les Vingt artists for display in Amsterdam. A year later he returned to the Netherlands and began painting his first pointillist canvases inspired by Seurat.

Around 1890, Toorop encountered Symbolism when he discovered Belgian writer Maurice Maeterlinck's poetry, which Toorop considered a revelation. Although Toorop's art would henceforth appear Symbolist, primarily on account of his frequent use of mythological subjects, the treatment and execution of his work remained firmly anchored in Art Nouveau.

The paintings, which evoke shadow puppet theatre, exhibit the voluptuous, curvilinear designs of decorative Art Nouveau wallpaper, where analogous design elements and decorations are endlessly repeated. In depictions of all sorts of genuine mysteries, Toorop based his figures on a feminine silhouette with long, willowy arms interlaced with infinite waves of long hair and placed them in a world where heaven and earth had no boundaries.

During this period the artist also designed several posters and illustrated various works, for which he mainly employed elegant arabesques reminiscent of the work of Aubrey Beardsley.

Louis Welden Hawkins,
A Veil. Pastel on paper.
Victor and Gretha Arwas collection.

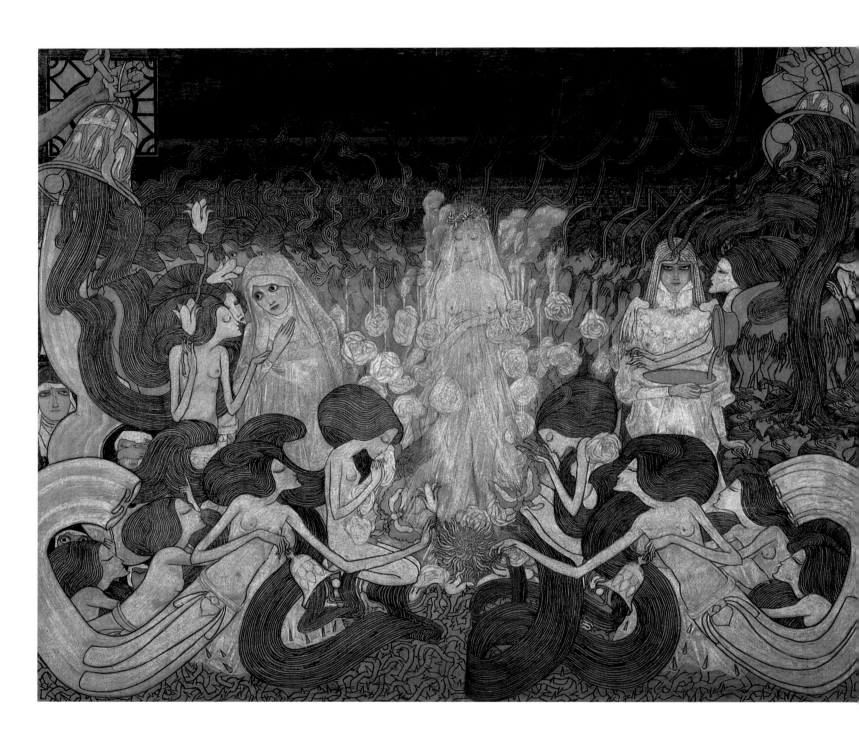

Jan Toorop,
The Three Fiancées, 1893.
Black and colour chalk on paper, 78 x 98 cm.
Kröller-Müller Museum, Otterlo.

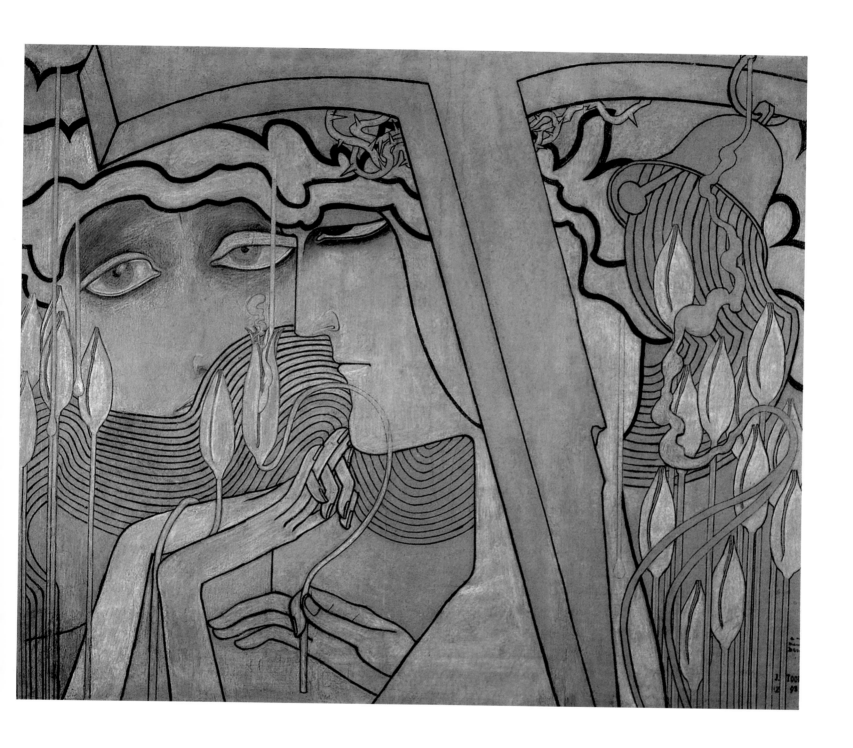

Jan Toorop,
Desire and Satisfaction, 1893.
Pastel on beige paper, 76 x 90 cm.
Musée d'Orsay, Paris.

THE STUDIO

AN ILLVSTRATED MAGAZINE OF FINE AND APPLIED ART.

No. 12. March 15th, 1894.

Concerning Repousse Work
By NELSON DAWSON. (Illustrated.)

Fernand Khnopff
By W. SHAW SPARROW. (Illustrated.)

London as a Sketching Ground
LETTERS TO ARTISTS No. 6.
By HERBERT MARSHALL, R.W.S.

English Embroidered Bookbindings,
By CYRIL DAVENPORT, F.S.A.

Some Old Keys
(Illustrated), by AYMER VALLANCE.

Awards in the Pianoforte, Repoussé, Carpet, & Allongé Paper Competitions (Illustrated), &c., &c., &c.

SIXPENCE

OFFICES: 16 HENRIETTA ST COVENT GARDEN, LONDON

MONTHLY

In 1905, Toorop came upon the path of religion and saw in it a second revelation. Baptised Protestant at age ten, he converted to Catholicism and henceforth structured his work around his faith. His art thus became more religious and mystical.

The painter subsequently revisited neo-Impressionism and then simplified his style. He refined his formerly undulating Art Nouveau lines, which became stiff and more severe, but nevertheless retained their extreme delicacy.

Toorop died in La Haye in 1928.

Until the twentieth-century rupture, Toorop's art filled the gap between Symbolism and Art Nouveau in a remarkable manner. His departures make him one of the most brilliant representatives of Symbolism and Art Nouveau, whereas the different developments of his style make him a precursor of most of the avant-garde movements of the twentieth century.

Aubrey Beardsley (Brighton, 1872 - Menton, 1898)

Aubrey Vincent Beardsley was born in the United Kingdom in Brighton in 1872.

The artistic and musical gifts of the Beardsley children, Aubrey and his sister Mable, were detected early on. The young Aubrey, however, suffered from tuberculosis and experienced an attack at age nine, the first of a long series of crises that would leave him paralysed several times during his life.

In 1884, the children were sent to live with an aunt after their mother became sick.

Beardsley attended the Bristol Grammar School for four years. During this period, he put his drawing talent to good use by making caricatures of his teachers and also by illustrating the school's journal, *Past and Present*.

Beardsley's first foray into the art world was a meeting with the famous painter Sir Edward Burne-Jones. Aubrey and his sister had shown up at the painter's studio without invitation and were stopped by a servant who intercepted them at the door. But Mable's red hair caught the master's eye and he gestured to allow them in. Greatly impressed by the drawings Aubrey had in his portfolio, Burne-Jones advised the young artist to take evening classes at the Westminster School of Art.

In the early 1890s, Beardsley produced a number of important illustrations and covers, in particular for Sir Thomas Malory's *Le Morte d'Arthur*, an epic work for which he drew over three hundred illustrations, vignettes and ornaments.

His meeting of Oscar Wilde in 1893 was decisive. Wilde's scandalous play *Salome* was published in French in 1894 and Beardsley produced the black and white illustrations for the English translation made by Lord Alfred Douglas.

No longer satisfied with a single means of artistic expression, Beardsley rapidly felt the need to develop new modes of expression. To this end, he got involved in the English translation of Wilde's text. In response to his enthusiasm, Oscar Wilde made a copy of the play that he dedicated to Beardsley.

Nevertheless, Wilde's enchantment with young Beardsley's art diminished when the illustrated edition came out. Wilde felt Beardsley's Art Nouveau style drawings showed too much Japanese influence, which was inappropriate for a Byzantine work. In truth Wilde was concerned about the illustrations' impact: Beardsley's drawings were so strong on their own, independent from the text, that they eclipsed the author's work.

The arrival of the first volume of *The Yellow Book*, which they published along with Henry Harland, definitively established Beardsley's reputation. The magazine was a success among

Aubrey Beardsley,
Poster for The Studio, 1893. Engraving.
Victoria and Albert Museum, London.

Aubrey Beardsley,
The Peacock Skirt, drawing from Oscar Wilde's *Salome*, 1893.
Black ink and pencil on paper.
Harvard University Art Museums, Cambridge.

Aubrey Beardsley,
The Toilet of Salome, drawing from Oscar Wilde's *Salome*, 1893. Engraving.
Private collection.

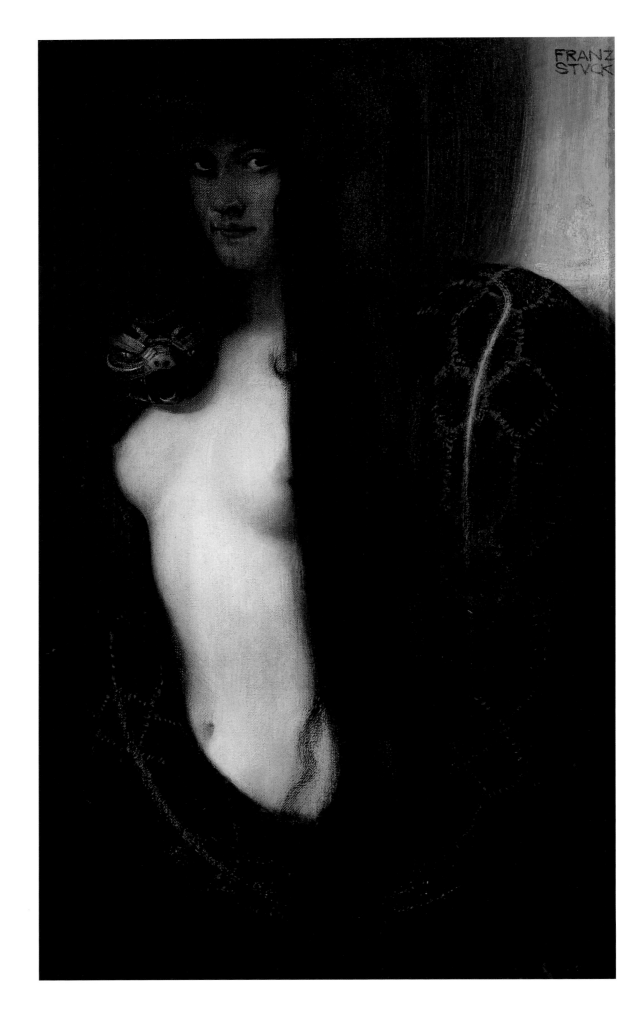

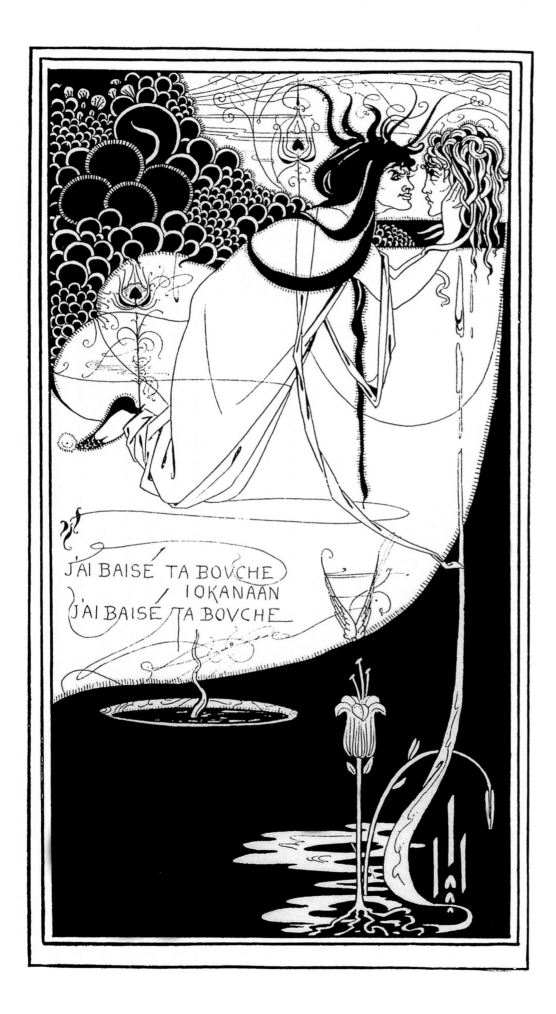

J'AI BAISÉ TA BOVCHE
IOKANAAN
J'AI BAISÉ TA BOVCHE

Franz von Stuck,
Sin, 1893.
Oil on canvas, 95 x 60 cm.
Neue Pinakothek, Munich.

Aubrey Beardsley,
I Have Kissed Your Mouth Iokanaan,
drawing from Oscar Wilde's *Salome*,
1893. Engraving.
Victoria and Albert Museum, London.

readers, but critics found it indecent and attacked it. At the same time, Wilde was becoming increasingly resentful of Beardsley's growing involvement in the project and Beardsley left *The Yellow Book* in April of 1895. Beardsley would henceforth have no more contact with Wilde. Society found Wilde's morals questionable; in May Wilde was sentenced to two years hard labour.

Afterwards, Beardsley met Leonard Smithers, primarily known for his erotic publications. Together they founded a journal called *The Savoy*, which allowed Beardsley to express himself through both drawing and writing.

When publication ended in December 1896, Beardsley continued to illustrate other authors for Smithers, who ended up publishing an album of Beardsley's works.

With his health declining, Beardsley travelled to the south of France, but the gentle climate failed to produce the doctor's prescribed effects.

On the night of 15 or 16 March 1898, Beardsley died at the age of twenty-five, either as a result of his illness, or by his own hand, as a result of his weariness.

Despite too short a career, the innovative style of Beardsley's drawings had a significant impact on Art Nouveau, to which he offered a vision in black and white that was both individual and striking.

Eugène Grasset (Lausanne, 1845 – Sceaux, 1917)

Eugène Grasset was born in 1845 in Switzerland, on the banks of Lake Léman, in Lausanne.

The son of Samuel Joseph Grasset, an artist, sculptor and decorator, Eugène learned to draw from François Louis David Bocion, then in 1861, entered Zurich's Polytechnicum where he attended architecture classes.

After completing his studies, in 1866 he travelled to Egypt, which would be an inspiration for later productions.

In 1869 and 1870, Grasset worked in his hometown simultaneously as a theatre set designer, painter and sculptor. The next year he went to live in Paris, where he discovered and became enamoured of Japanese art, in particular through the photographs of Charles Gillot.

In France Grasset worked for various tapestry and ceramics factories, and even for jewellers, and rapidly acquired a good reputation.

In 1880, he designed a dining room and furniture for Gillot. The furniture, of oak and walnut, was sculpted with imaginary animals and figures from popular art.

Grasset spent the next three years illustrating the medieval tale of *Les Quatre Fils Aymon (The Four Sons of Duke Aymon)*. His use of interpenetrating text and image revolutionised the aesthetics of book illustration.

At the same time, he contributed to the decoration of the essential French cabaret named *Le Chat Noir* and in 1885 he designed his first poster for the *Fêtes de Paris*, which marked the beginning of his career as a poster artist.

Between 1890 and 1903, Grasset taught courses in decorative design at the Ecole Guérin, where his students included Augusto Giacometti and Paul Berthon.

Also in 1890, he designed the poster for *Jeanne d'Arc* starring Sarah Bernhardt and the since famous *semeuse* logo of the female sower used on the Larousse dictionary. The logo would appear on the majority of works published by Larousse between 1890 and 1952, when it was abandoned, before reappearing in the 1960s.

Eugène Grasset,
Salon des Cent, 1894.
Print for a colour poster.
Victor and Gretha Arwas collection.

Eugène Grasset,
Contemplation, 1897.
Colour lithograph on silk.
Victor and Gretha Arwas collection.

Louis Welden Hawkins,
Autumn, c. 1895.
Oil on canvas.
Victor and Gretha Arwas collection.

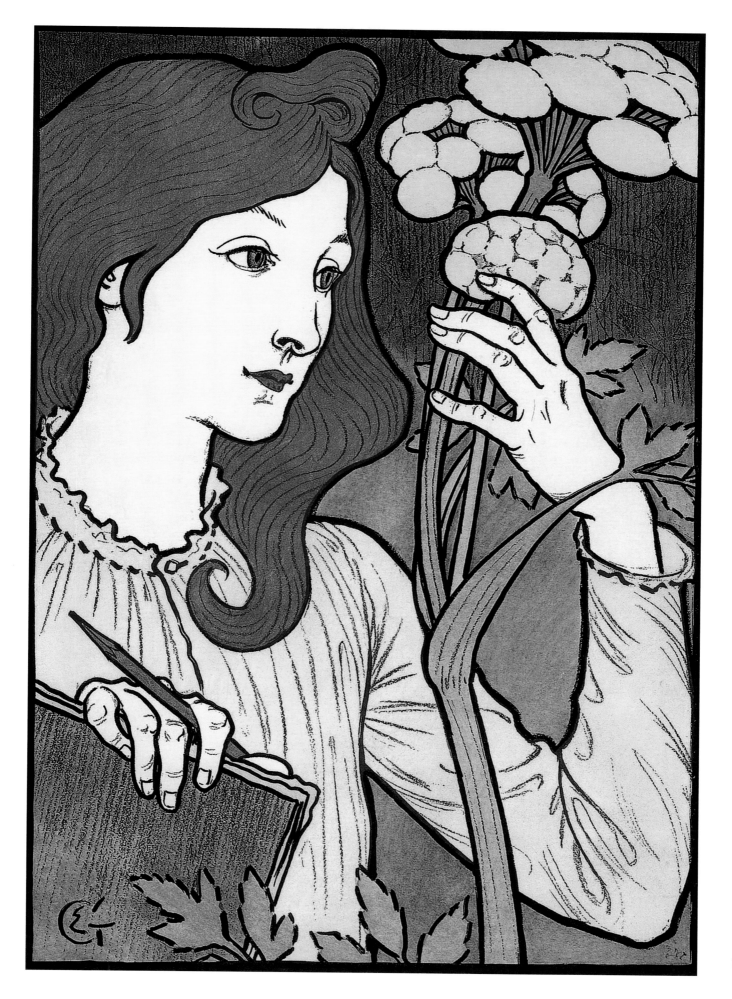

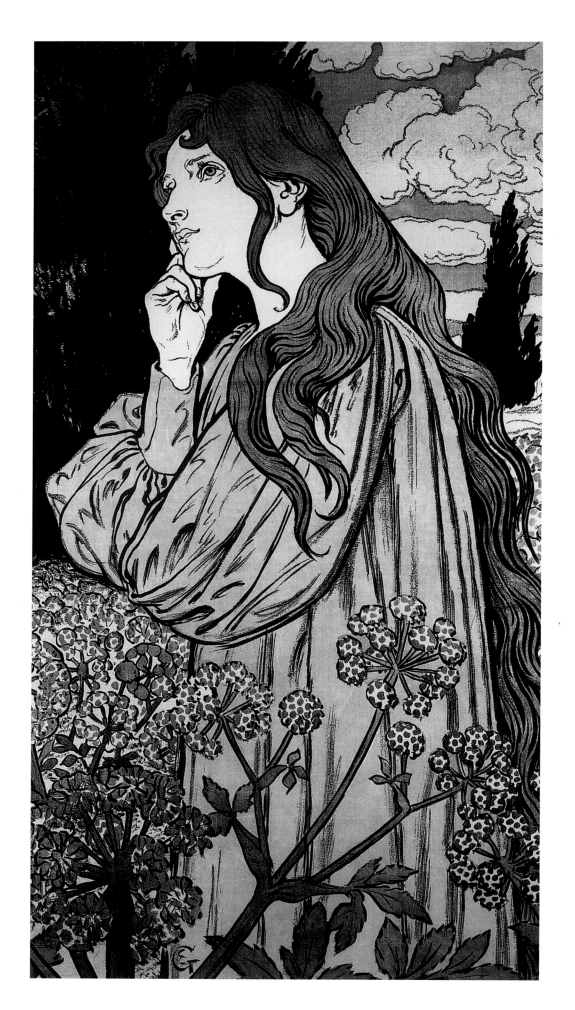

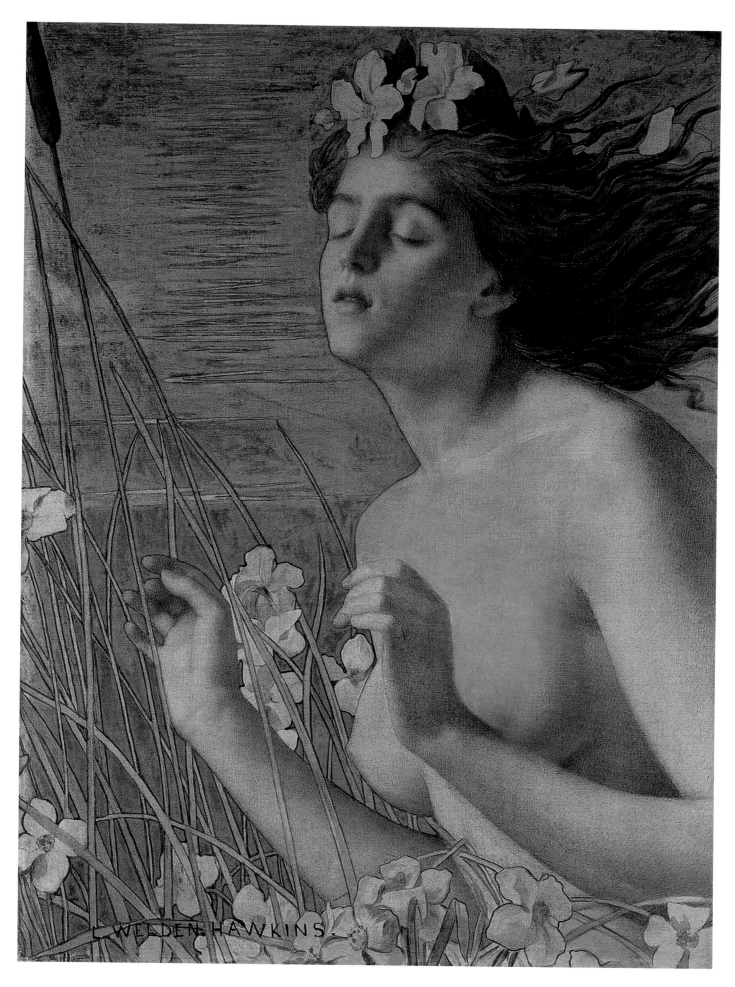

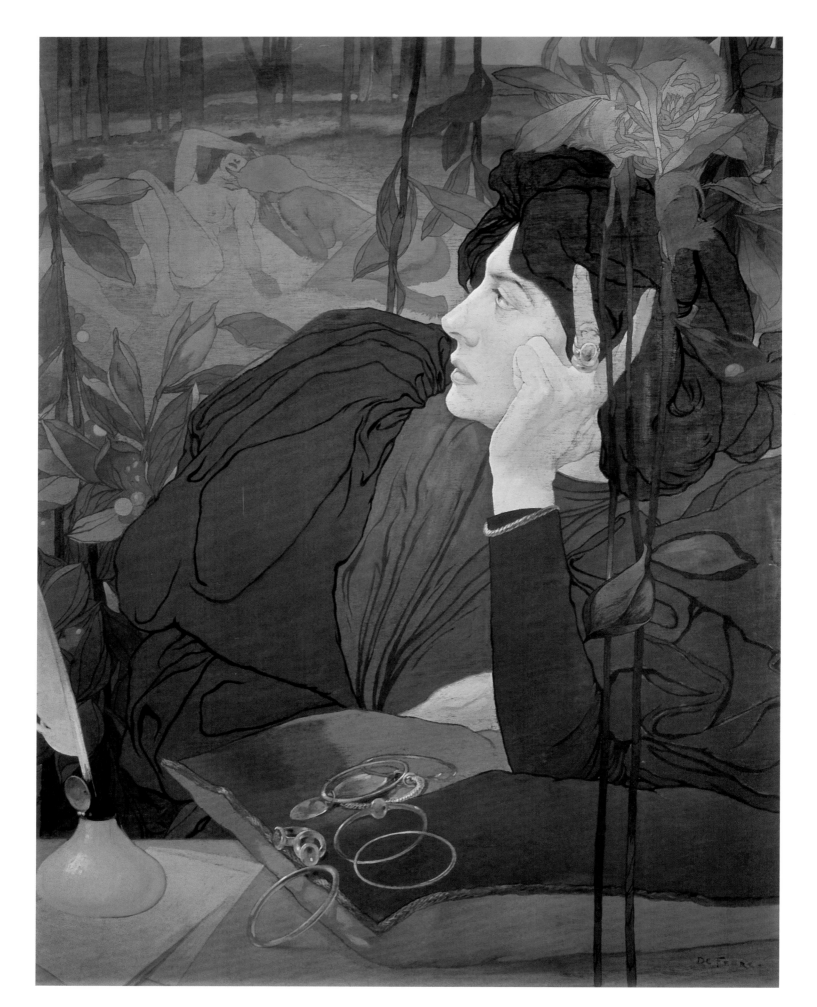

Two years later, Grasset created his feminine ideal, a truly timeless muse, in his design for the Encres Marquet (Marquet Inks) poster. Marked by symbolist, Pre-Raphaelite and Japanese influences, Grasset's posters are genuine testaments to the spirit of Art Nouveau. Their perfect union of woman, art and nature would considerably influence the work of Alphonse Mucha.

In 1894, Grasset, now internationally famous, designed advertisements for *The Century Magazine* and in this way introduced the Art Nouveau movement to the United States.

In 1896, his teaching led him to publish *La Plante et ses applications ornementales (The Plant and its Decorative Applications)*. Grasset henceforth confirmed his status as one of Art Nouveau's leading proponents and encouraged the abolition of the hierarchy between the minor and major arts.

The next year he collaborated on two new French magazines *Art et Décoration* and *l'Estampe et l'Affiche (Print and Poster)*.

In 1898, he designed his own typeface for the use of the Peignot type foundry, as well as the poster for the Salon des Cent.

In 1905, Grasset started teaching Typeface History and Design at the Ecole Estienne and published his *Méthode de composition ornementale (Method of Ornamental Typesetting)* in 1906.

Eugène Grasset died in Sceaux in 1917.

Georges de Feure (Paris, 1868 - 1943)

The son of a Dutch architect and a Belgian mother, Georges Joseph Van Sluyters, who used the pseudonym Georges de Feure, was born in Paris in 1868.

De Feure began working in Paris as an actor, costume designer and interior decorator.

In 1890, he worked in the studio of Jules Chéret, originator of the artistic poster. During this period he designed posters and produced many illustrations for various periodicals, including the *Figaro illustré* and the *Courrier français*.

De Feure participated in many exhibitions and salons, in particular the Salon of the Société Nationale des Beaux-Arts, the Salon des Cent, the Salon de la Rose-Croix, the Salon d'Automne and even in exhibitions of Impressionist and Symbolist painters. His work also appeared in several international exhibitions.

In 1894, the Galerie des Artistes Modernes held an exhibition devoted to his painting and watercolours, which were partly influenced by Symbolism and the work of Charles Baudelaire and Aubrey Beardsley. The scope of de Feure's work was henceforth defined and consisted of reinterpreting, with incomparable elegance, the essence and delicacy of feminine grace.

In 1900, the artist turned his attention to the decorative arts.

Art dealer and collector Siegfried Bing selected de Feure, who was making designs for Limoge porcelain, to produce two pieces for Bing's pavilion at the Universal Exposition, along with Eugène Gaillard and Edouard Colonna. De Feure also produced the paintings and glass panels that decorated the facades.

The next year he designed the decorative paintings for the dining room of the Restaurant Konss, then was named a Chevalier de la Légion d'honneur.

In 1902 and 1903, de Feure worked on producing various decorative objects, in particular vases and porcelain statuettes.

Georges de Feure,
The Voice of Evil, 1895.
Oil on canvas, 65 x 59 cm.
Private collection.

After Bing's death in 1905, de Feure pursued furniture design, in particular for bedrooms and bathrooms. As in his paintings and posters, the artist decorated these essentially feminine furnishings around themes associated with women, whom he continued to celebrate with delicate lines and elegant sensuality.

In 1909, de Feure founded an aircraft design company for which he designed the airplane models.

At the same time, the artist continued to design ceramics for Edmond Lachenal, the great French ceramicist and Art Nouveau master. A man of many talents, Georges de Feure also composed music and ballets.

In 1913, de Feure moved to England. In London he produced several theatrical productions, for which he was also designed the costumes and decor.

Upon returning to Paris, he produced new furniture in the nascent Art Deco style, as well as more costume and set designs for the theatre.

In 1923, de Feure oversaw the interior decoration of Madeleine Vionnet's couture house and then was promoted to Officier de la Légion d'honneur.

Two years later, for the first Decorative Arts Exposition, de Feure was responsible for the complete design of a pavilion. And in 1937, the Decorative Arts Division of the International Exposition invited him to design a bedroom.

Georges de Feure died in 1943.

De Feure was the perfect representative of the Art Nouveau movement, not only because of the themes he chose and the way he treated them, but also on account of his remarkable multi-disciplinary approach, which he demonstrated throughout his life.

Alphonse Mucha (Ivancice, 1860 – Prague, 1939)

Alphonse Mucha was born on 14 July 1860 in Moravia (present-day Czech Republic), in the town of Ivancice. The son of a marshal of the court, he was raised in a relatively modest environment. In spite of his family's limited means, Mucha's received a stimulating education and artistic encouragement. His first memorable aesthetic experience was no doubt connected with Saint Peter's baroque-style church located in the regional capital of Brno. The central European baroque style, with its sensual theatricality characterised by luxuriant curvilinear decoration derived from nature, surely nourished his imagination.

While working in an office to earn a living, Mucha gave free reign to his passion for drawing. In 1877, he submitted the results of his self-taught efforts as an amateur to Prague's Academy of Fine Arts, but failed to win admission. In 1879, he saw a notice for theatrical designers and artisans posted in a Viennese newspaper by the design firm Kautsky-Brioschi-Burghardt. Mucha sent the firm a few of his works and this time was successful, gaining employment. His stay in Vienna ended abruptly less than two years later when the Ringtheater was destroyed by fire on 10 December 1881.

Mucha left to live in the little town of Mikulov, where he met the first of two benefactors who would influence his career. Count Karl Khuen was a wealthy landowner who commissioned Mucha to design frescos for the dining room of Emmahof Castle. From this initial experience with mural painting arose Mucha's ambition (which he never abandoned) to realise large-scale decorative works. Even his posters from the 1890s (upon which his current reputation is primarily based)

Fernand Khnopff,
The Caresses
(also called *The Sphinx* or *Art*), 1896.
Oil on canvas, 50 x 150 cm.
Musées royaux des Beaux-Arts, Brussels.

may be considered as examples of his mural painting vocation. After completing a second series of murals for Emmahof Castle, the artist was able to continue his studies, thanks to the generosity of Count Khuen, who gave him a choice between Rome and Paris. Mucha chose Paris, a wise decision that would have major consequences.

Arriving in Paris in 1888, Mucha enrolled in the Académie Julian where he met Sérusier, Vuillard, Bonnard, Denis and other artists in the Nabis group.

Although Mucha's style and technique remained essentially academic until the mid 1890s, he was deeply influenced by the Symbolist movement and by the mysticism popular in Parisian literary and artistic circles during the second half of the 1880s.

In late 1889, Count Khuen suddenly ended Mucha's financial support without warning. The artist had to leave the Académie Colarossi and experienced lean years before he started to earn a modest living as an illustrator in the early 1890s.

It was the appearance of the Art Nouveau style during the 1890s that enabled Mucha to finally free himself from the grip of academicism and to give free reign to his natural talent and spirit of invention.

1895 was the year Art Nouveau exploded in Paris: the year during which Guimard built Castel Béranger and Bing opened his shop, had commenced with Mucha's poster of Sarah Bernhardt in the role Gismonda appearing on the streets of Paris. The theatre poster's enormous popularity instantly propelled Mucha to the pinnacle of artistic success in Paris. But Mucha's change in style was not only due to his discovery of Art Nouveau; it was also a response to the specific requirements of the advertisement as a new art form.

When it was plastered all over the walls of Paris in January 1895, the Gismonda poster caused a sensation. It not only gave Mucha an instant reputation, it also provided financial security in the form of a six-year contract to work for Sarah Bernhardt. Mucha created a succession of eye-catching posters (*La Dame aux camélias*, *Lorenzaccio*, *La Samaritaine*, *Médée*, *La Tosca*, and *Hamlet*) over the course of the next four years and also supervised nearly all the visual aspects of Bernhardt's theatrical productions, designing the decor, costumes and accessories, sometimes even jewellery.

The success of his work for Sarah Bernhardt earned Mucha a large number of orders for other posters. Following Chéret's example, Mucha created an immediately recognisable and idealised feminine type that he employed in all manner of advertisements, as well as for cigarette papers, soap, beer and bicycles. The figure had something of the carnal gaiety of Chéret's hedonistic blondes and red-heads, whose voluptuous silhouettes emerge from strict corsets; the morbid melancholy and refinement of the pre-Raphaelite muses; and the dangerous attraction of the fin-de-siecle's femme fatale – all elements that Mucha combined to various degrees.

During the late 1890s, Mucha applied his prodigious capacity for invention to the decorative arts: he could design furniture and place settings just as easily as shop windows, jewellery and biscuit tins. The sinuous and organic contours of his style were particularly suited to metal objects.

Mucha's Parisian career reached a peak with the frenzied activity of his preparations for the 1900 Universal Exposition in Paris. The artist had been invited to select the paintings for Austria's contribution to the Exposition. He was also asked to design a pavilion for the newly annexed provinces of Bosnia-Herzegovina.

In 1906, the artist no doubt fully understood that time was running out for the "Mucha style", as Paris was always hankering after the latest fashion. He embarked for the United States in

Germaine Boy,
The Wind from the Sea.
Gouache and watercolour.
Victor and Gretha Arwas collection.

Adria Gual-Queralt,
The Dew, 1897.
Oil on canvas, 72 x 130 cm.
Museo de Arte Moderno, Barcelona.

Georges de Feure,
The Gate to Dreams II, 1898.
Hand coloured etching.
Victor and Gretha Arwas collection.

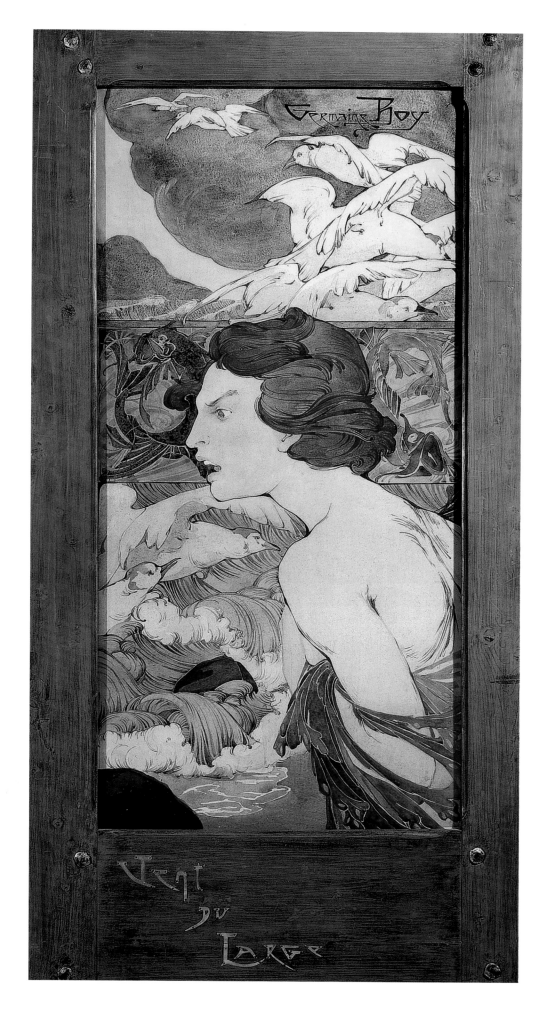

QVANT LA NIT FA PAS AL
JORN ·
JOIAS HE VISTAS ·
DE LAS PLANAS AL
ENTORN ·
VOLEJANT TRIS
TAS
SONIAS FI
LLAS DE LA
NIT ✳

· LA · R

Adrià Gual - 1898

MES · TARTFANVN
Y · VE · LA · MARINA

QV·OMPLENADAS·DE·
NECVIT·
SE·N·DESPEDEIXEN·
Y·AB·L·HVMITEIG·
DE·LLVRS·PLORS·
REBIFANAR·
BRES·FLORS·
Y·S·ESFV·
MEIXEN·

·DA·

PIR·D·ENAMORADA·

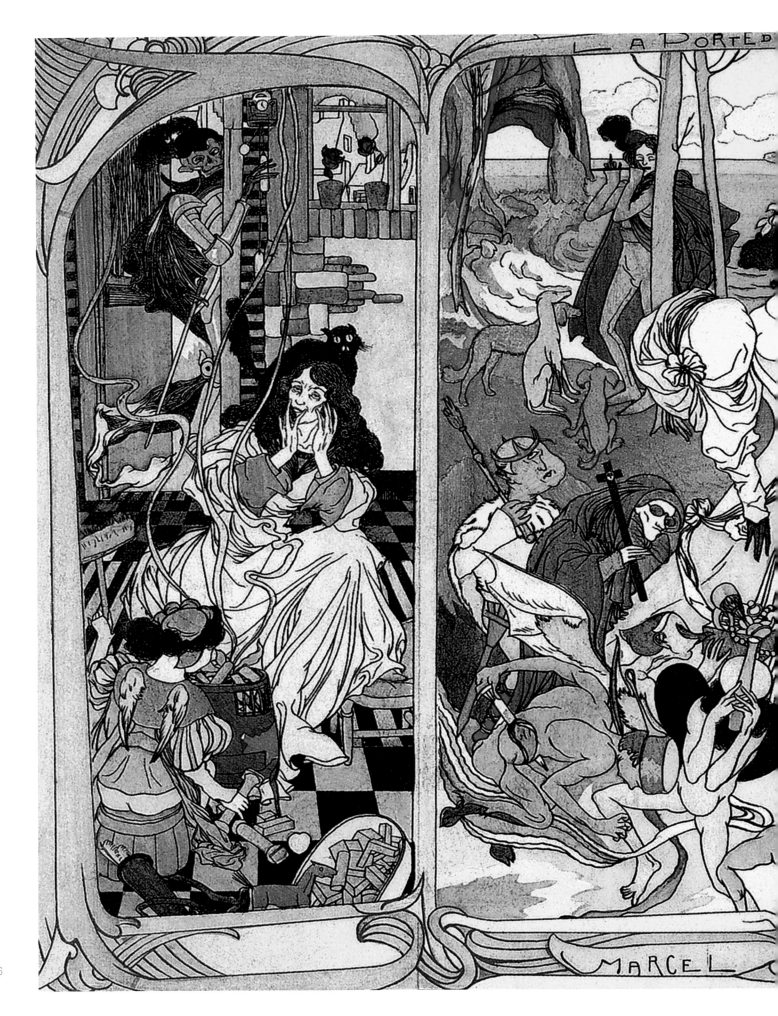

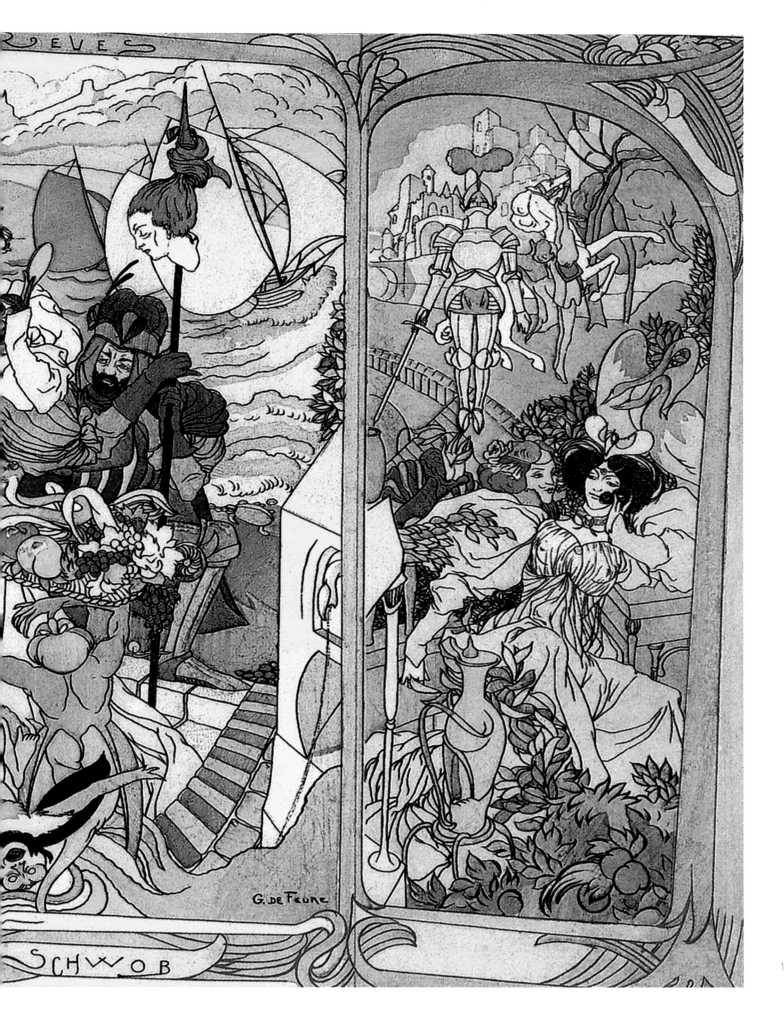

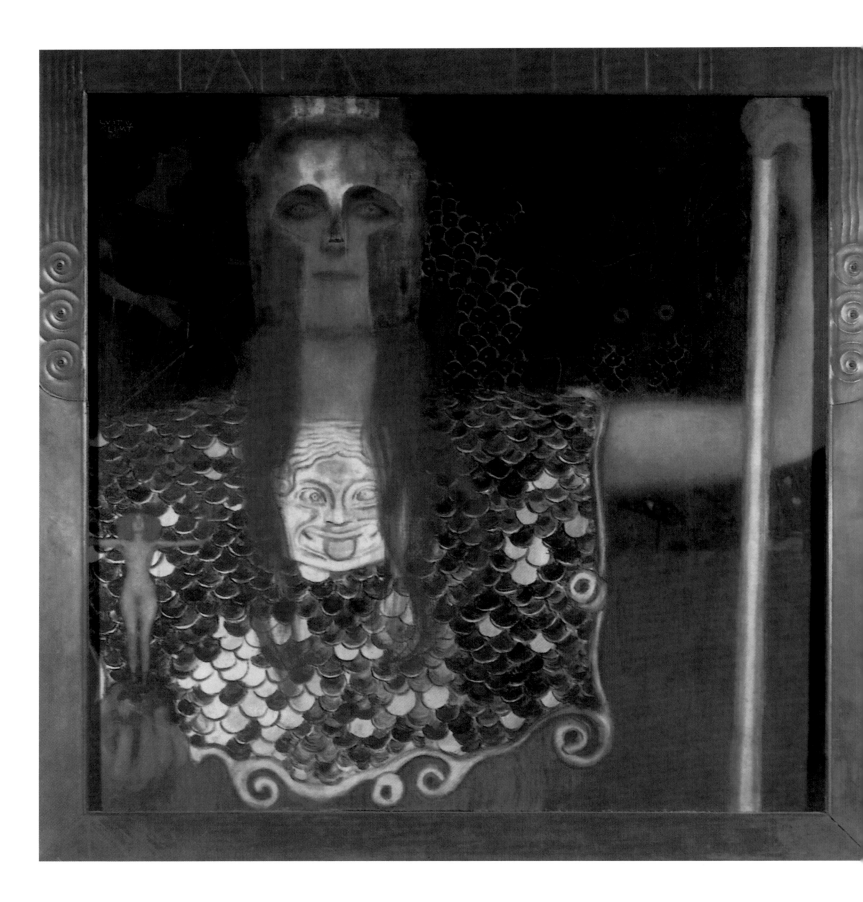

search of new, lucrative portrait commissions and teaching, but the years he spent in the United States just before the First World War were disappointing on professional and artistic levels. Mucha was still determined to paint the monumental canvases of his *Slav Epic* and after his final return to his native country in 1913, devoted the remainder of his career to this project.

Mucha died in 1939.

The irony of Mucha's career is that he created an eminently individual style in his Parisian posters by infusing them with an elusive, yet undeniable Slavic charm, in spite of his cosmopolitan roots.

Gustav Klimt (Vienna, 1862 - 1918)

"I'm not interested in doing a self-portrait. What painting subjects interest me? Other things, women in particular…"

No reference to the external world would disturb the charm of the allegories, portraits, landscapes and other figurative works painted by Gustav Klimt. In order to create his seductive œuvre, in which the female body revealed its full sensuality, the artist relied on colours and motifs inspired by the East (Klimt was deeply influenced by Japan, ancient Egypt, and Byzantine Ravenna), a flat, two-dimensional space and a stylised image quality.

At the age of fourteen, Klimt received a government scholarship to attend Vienna's Kunstgewerbeschule (School of Arts and Crafts), where his talents as a painter and draftsman were quickly confirmed. The artist's earliest works made him an unusually precocious success.

His first important initiative dates to 1879, when he created the company of artists known as the Künstlerkompagnie with his brother Ernst and Franz Matsch. Late nineteenth-century Vienna was undergoing a period of architectural ferment, due to the fact that in 1857, the Emperor Franz-Joseph had decided to tear down the ramparts surrounding the medieval centre of the town to build the Ring with taxpayer money. As the Ring was a series of magnificent residences bordered by beautiful parks, Klimt and his partners benefited from Vienna's changes, which provided them with many opportunities to exercise their talents.

In 1897, Klimt left the highly conservative Künstlerhausgenossenschaft (Cooperative Society of Austrian Artists) and along with several close friends founded the Secession movement, for which he served as president. There was immediate recognition. Above the entrance porch of the Secession building (designed by Joseph Maria Olbrich) was inscribed the movement's motto: "To each age its art, to art its freedom."

Beginning in 1897, Klimt spent almost every summer on the Attersee Lake in Austria with the Flöge family. These periods of peace and tranquillity provided him the opportunity to paint the many landscapes that make up a quarter of his entire output. Klimt executed preparatory sketches for most of his works, sometimes producing over one hundred studies for a single painting.

The exceptional character of Klimt's œuvre is perhaps due to the absence of predecessors and any real followers. He admired Rodin and Whistler without slavishly copying them. Klimt, in turn, was admired by the younger generation of Viennese painters, such as Egon Schiele and Oskar Kokoschka.

Gustav Klimt,
Pallas Athena, 1898.
Oil on canvas, 75 x 75 cm.
Wien Museum, Vienna.

Koloman Moser (Vienna, 1868 - 1918)

Koloman Moser was born in Vienna in 1868.

In Vienna Moser studied painting at the Academy of Fine Arts, where the architect Otto Wagner was his teacher. He was later trained in decorative art at the Vienna School of Arts and Crafts where he attended classes taught by Franz Matsch with Gustav Klimt.

During this period Moser also met the architects and decorators Joseph Maria Olbrich and Josef Hoffmann.

In the early 1890s, Moser started to develop an innovative and highly individual Art Nouveau style while working as an illustrator.

In 1897, Moser joined Klimt, Olbrich, and Hoffmann in forming a new alliance of artists and architects who were uniting to promote new aesthetic ideals that they hoped would revolutionise art: thus was born the Viennese Succession, Art Nouveau's proud Austrian representative. For Olbrich's building that served as their home, Moser designed the window glass and textiles, and produced furniture and various decorative objects, in particular of glass.

In 1900, Moser organised the sixth Secession exhibition (held 20 January - 15 February) as a solid Art Nouveau offshoot and subsequently participated as sometime scenic designer for the group's exhibitions.

Beginning in 1900, Moser started to paint increasingly monumental paintings notable for their brilliant use of colour and taught classes at the Vienna School of Arts and Crafts where he had once been a student. He continued teaching up until 1918.

Moser also worked on the co-publication of the journals *Die Fläche* and *Hohe Warte* and on poster design and illustrations.

In 1903, he founded another important group, the Wiener Werkstätte. A German arts and crafts society, the Wiener Werkstätte, offered graduate art students a place to work and conduct research. Its studios produced various decorative objects, jewellery, tapestries and other furnishings that Hoffmann frequently included in his own architectural works.

Moser later worked in various countries (France, Germany, Switzerland, the Netherlands and Belgium) and in particular the cities of Paris, Hamburg, and Berne.

In 1905, Moser participated, along with Gustav Klimt and Josef Hoffmann, in the acclaimed project of the since famous Palais Stoclet in Brussels. He left the Secession that year and the Wiener Werkstätte two years later.

The artist's style changed rapidly from a French and Belgian-inspired Art Nouveau, where curves danced ceaselessly, to a more sober Art Nouveau of elongated and geometric forms.

Beginning in 1907, Moser devoted himself exclusively to painting.

He died as a result of cancer of the larynx in October 1918, at the age of fifty.

Moser was always drawn to diverse aspects of the major and minor arts – to painting as much as interior decoration; and to drawing as much as the production of furniture and other objects – and is therefore linked to the concept of unified artistic production that was Art Nouveau's guiding principle and was always able to create rhythmic spaces within his works through the use of colour and striking contrasts.

Koloman Moser,
Cover for the Secession magazine named Ver Sacrum, 1899.
Private collection, Vienna.

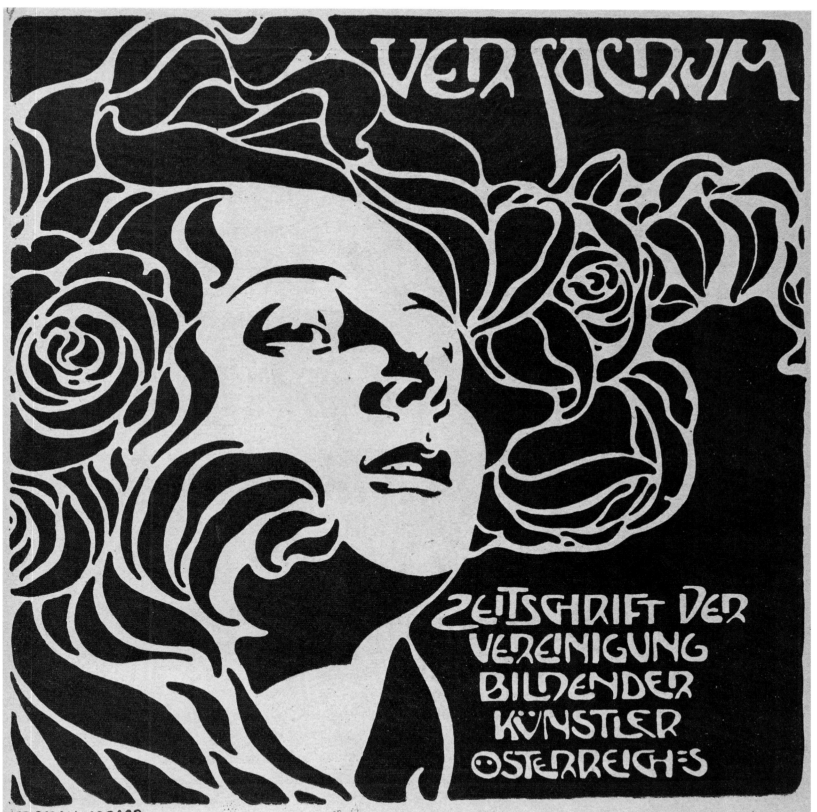

VER SACRUM

ZEITSCHRIFT DER VEREINIGUNG BILDENDER KÜNSTLER ÖSTERREICHS

·KOLOMAN·MOSER·

JÄHRLICH 12 HEFTE. IM ABONNEMENT 9 FL. = 15 M. II. JAHRG. HEFT 4.

VERLAG VON E. A. SEEMANN, LEIPZIG.

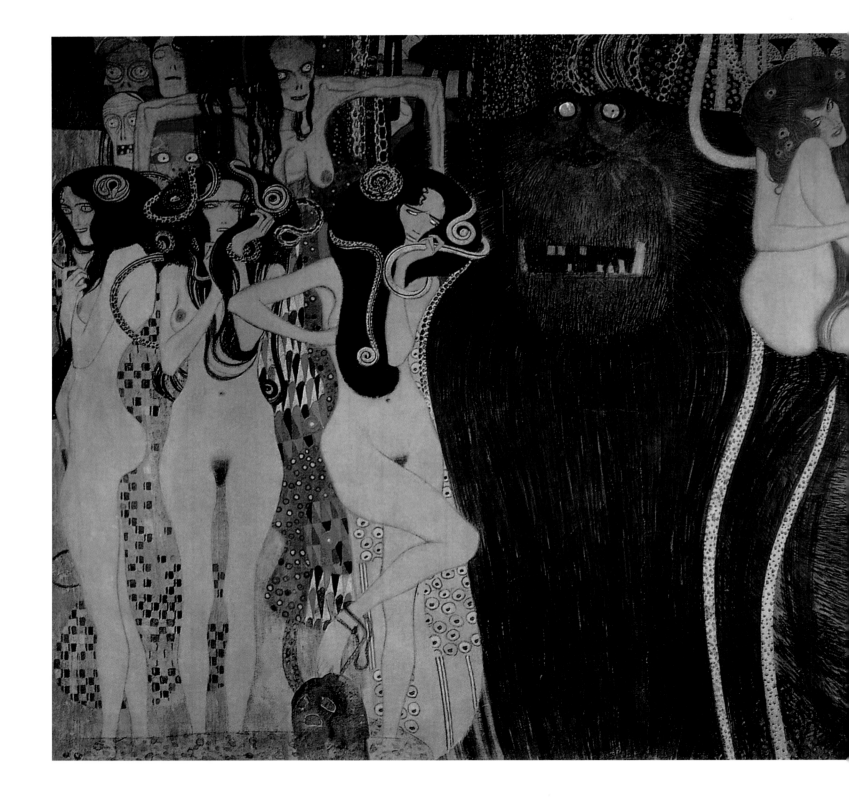

Gustav Klimt,
The Beethoven Frieze (detail), 1902.
Casein on plaster, h: 220 cm.
Secession, Vienna.

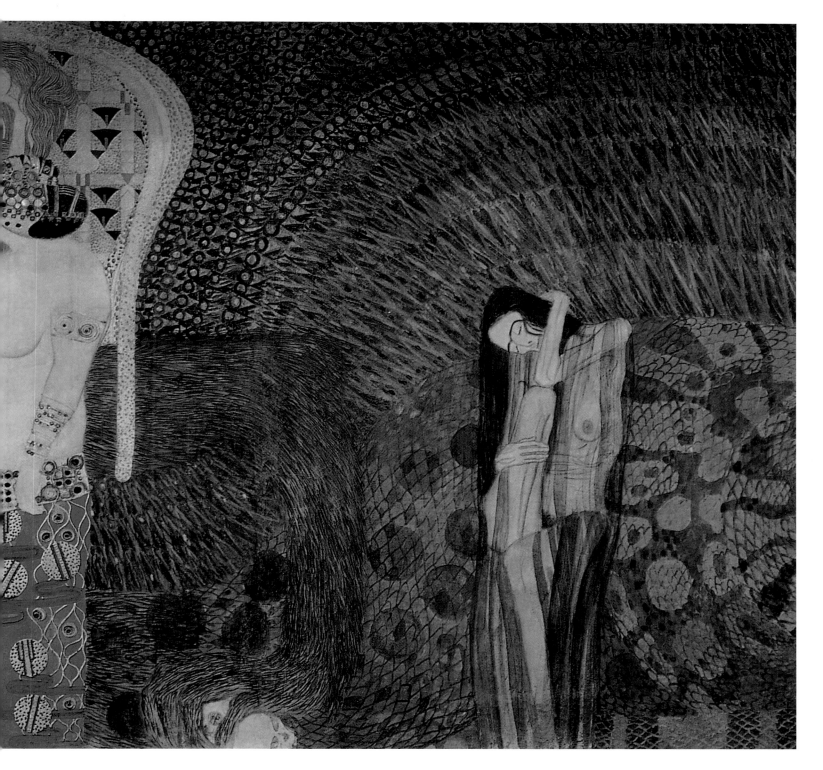

Henri de Toulouse-Lautrec,
Loïe Fuller, 1892-1893.
Colour lithograph.
Private collection.

Jean Delville,
Soul Love, 1900.
Egg tempera on canvas, 238 x 150 cm.
Musée d'Ixelles, Brussels.

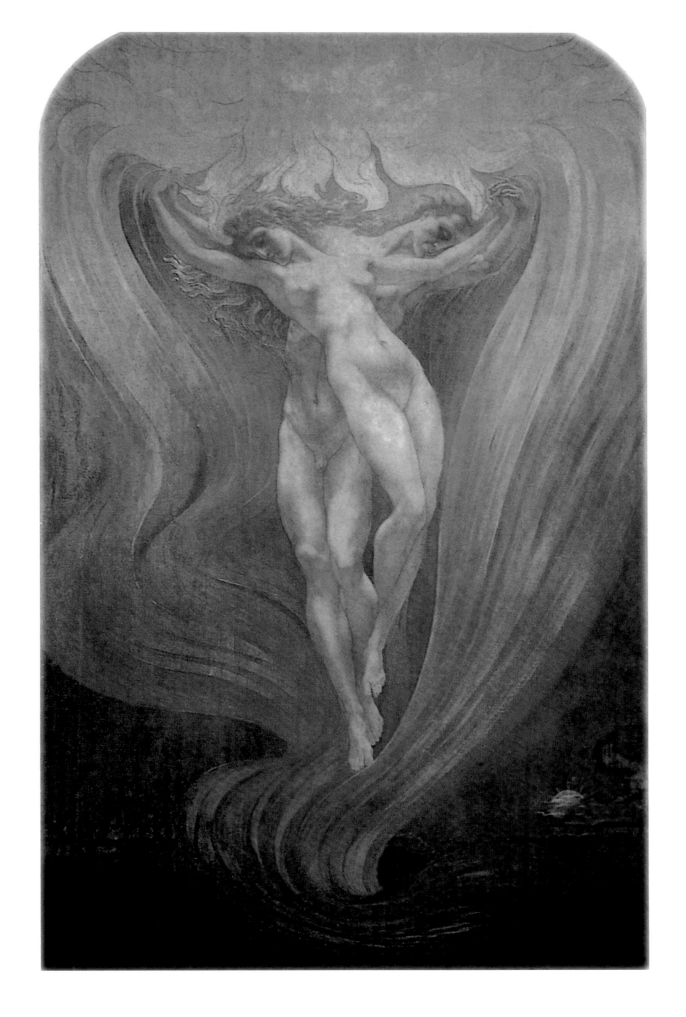

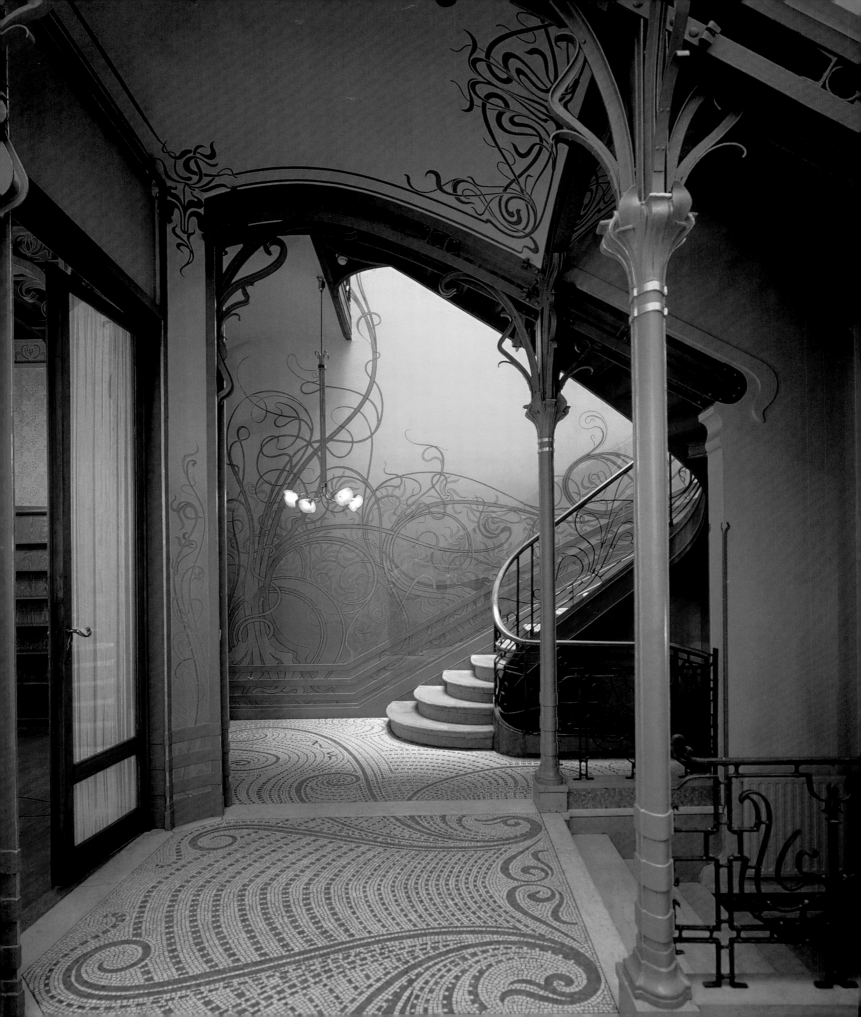

Architecture

Victor Horta (Gand, 1861 – Brussels, 1947)

Victor Horta was born in Gand, Belgium in 1861.

The son of cobbler, he enrolled in the Académie des beaux-arts in his native town, then attended public secondary school from 1874 to 1877.

In 1878, he made his first trip to Paris for the Universal Exposition and completed a period of training with the architect and decorator Jules Debuysson.

In 1880, fate led him back to Belgium right after his father died.

Married the next year, he moved to Brussels and enrolled in the Académie Royale. During this period he commenced training under Alphonse Balat, the official architect of Leopold II.

In 1884, Horta submitted a plan for Parliament that earned him the first place in the Godecharle architecture competition. The next year he built three houses in Gand. In 1887, his plan for the Museum of Natural History won the triennial alumni competition launched by the Académie des beaux-arts in Brussels.

In 1889, Horta returned to Paris to attend the new Universal Exposition.

Upon his return to Belgium, his wife gave birth to a daughter Simone and in 1892 he was hired to teach at the Faculté Polytechnique of the Université Libre of Brussels where he was appointed professor in 1899.

The next year, Horta designed a private residence for the physicist-chemist Emile Tassel. Today, Tassel House remains a key Art Nouveau monument. Set on a deep and narrow lot, the structure's principle element is a central staircase covered by a frosted lantern. Bathed in light, supported by thin cast-iron columns sprouting botanical arabesques that are continued in the paintings and mosaics that cover the walls and floors, the staircase is townhouse's principal architectural feature.

Horta's nod to architecture marked the beginning of a lengthy series of commissions that continued until the first decade of the twentieth century, among which the majority were for townhouses, mainly in the Belgian capital.

The following private residences are among Horta's most famous: Tassel (1893), Solvay (1894), Van Ettvelde (1895), Aubecq (1899) and Max Hallet (1902). In 1898 Horta also completed a house and studio for his own use on the rue Américaine.

Victor Horta lent his talent to public projects, as well. In 1895, he built the Maison du Peuple for the Belgian Socialist Party, largely with Solvay's financing. He also worked on department stores: the Brussels department store chain called A l'innovation (1900); the Anspach stores (1903); Magasins Waucquez (1906) and Magasins Wolfers (1909).

In 1906, he divorced his wife; two years later, he remarried.

In 1912, Horta was entrusted with the reorganisation of the Académie des beaux-arts of Brussels. The next year he agreed to serve as the institution's director for three years.

At the end of his term directing the Académie des beaux-arts, Horta was forced to exile himself to the United States until 1919.

Upon his return, he sold his premises on the rue Américaine and started working on plans for the Palais des Beaux-Arts in Brussels.

Victor Horta,
Tassel House, grand hall on main floor,
1893.
Brussels.
© 2007 – Victor Horta/Droits SOFAM – Belgique

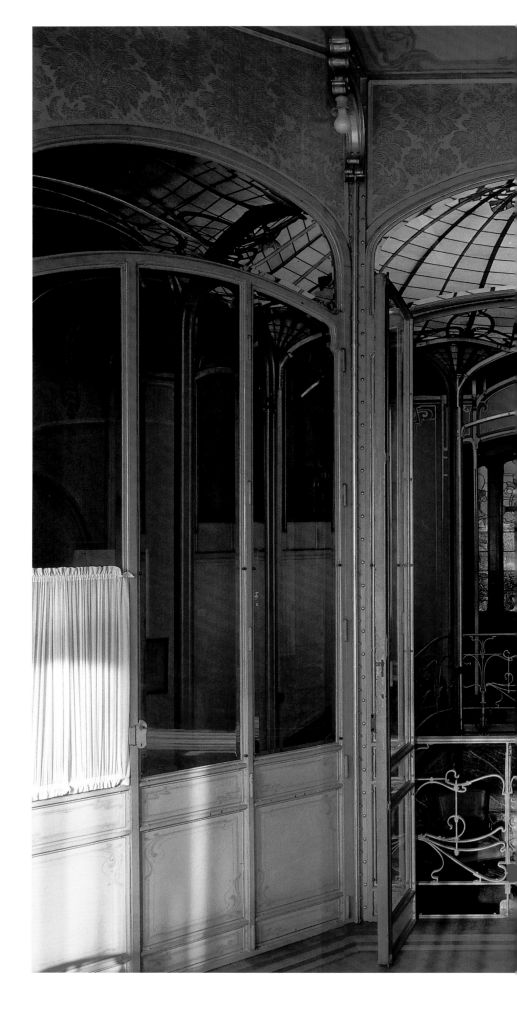

Victor Horta,
Van Eetvelde House, view from living room, 1895.
Brussels.
© 2007 – Victor Horta/Droits SOFAM –
Belgique

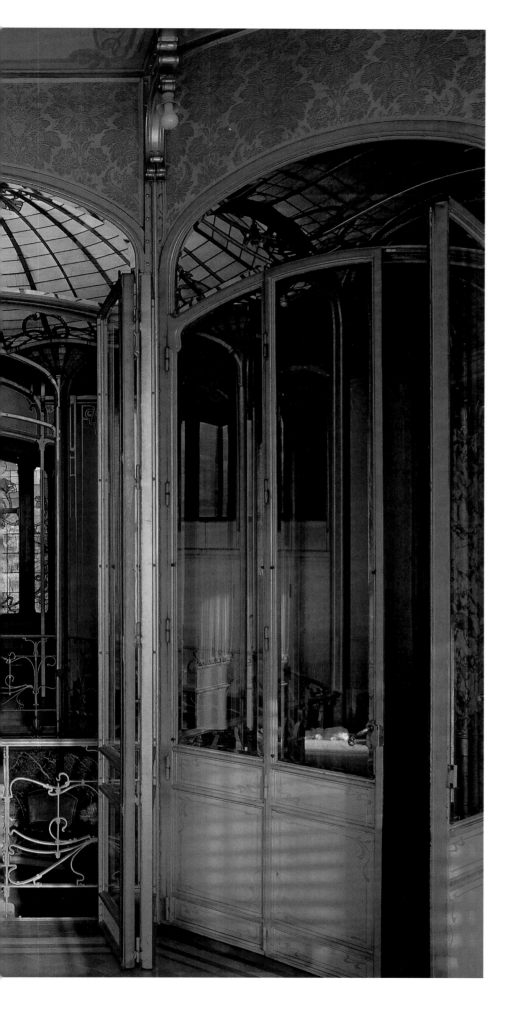

Victor Horta,
Van Eetvelde House, facade, 1895.
Brussels.
© 2007 – Victor Horta/Droits SOFAM –
Belgique

Emile André,
Huot House, 1903.
Nancy.

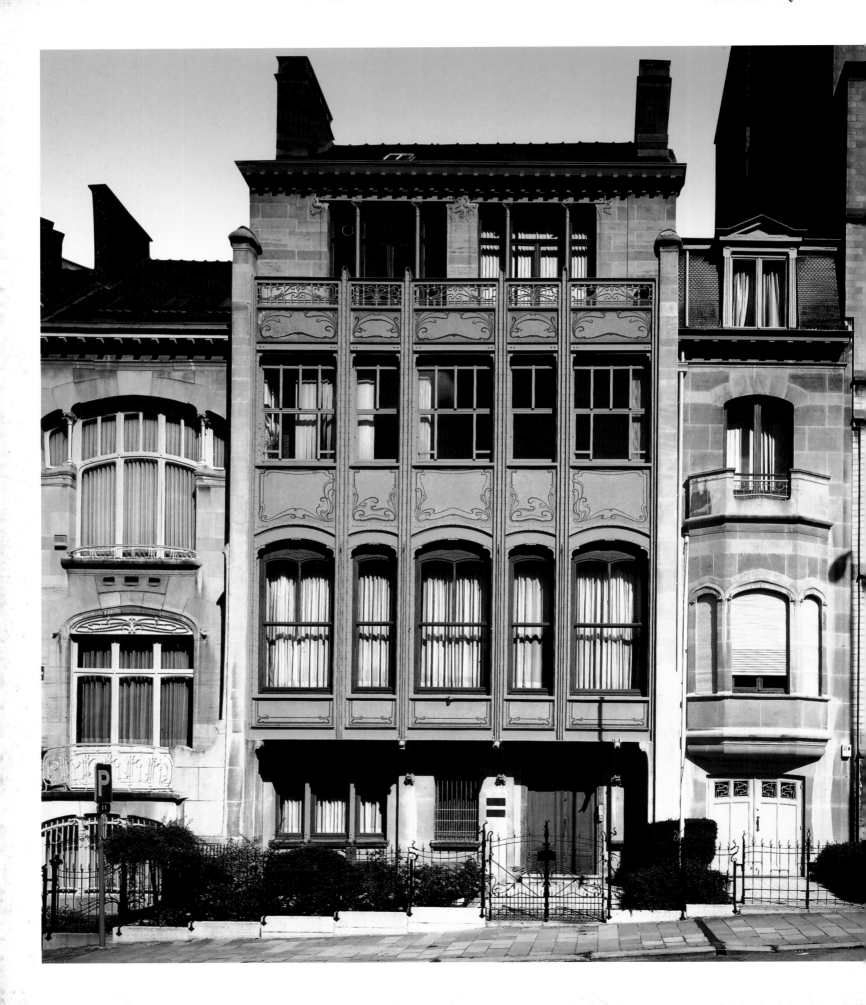

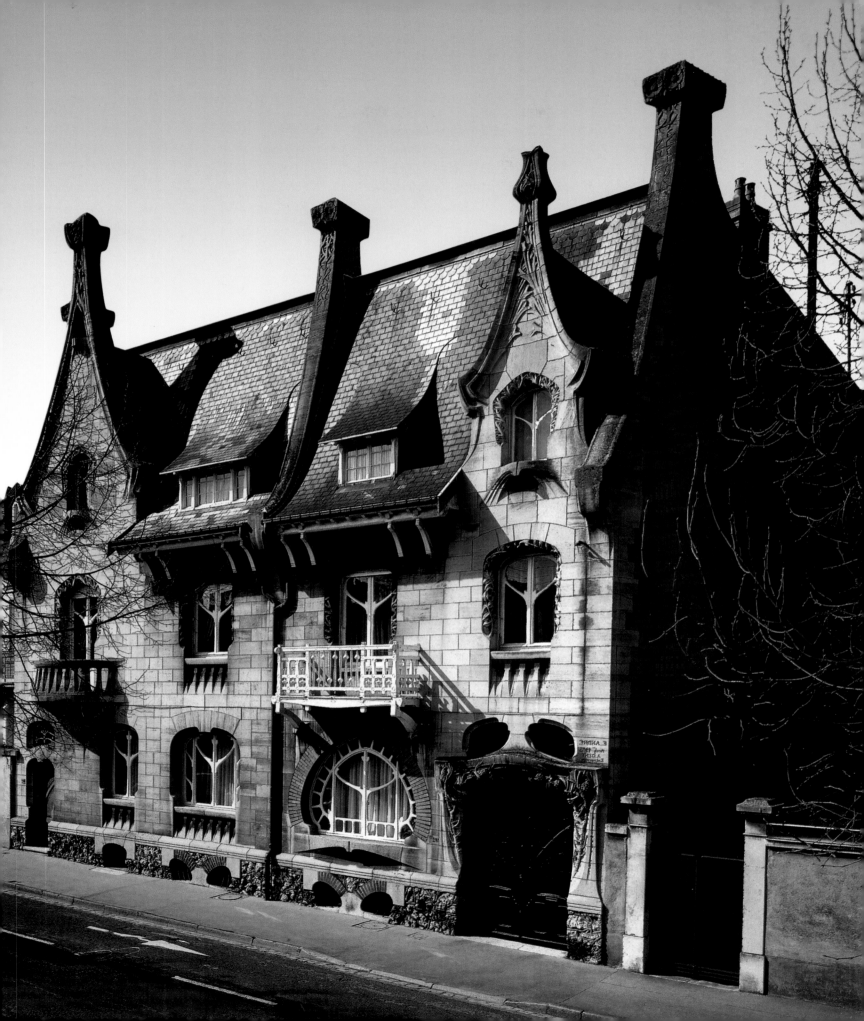

In 1925, Horta completed the *Pavillon d'honneur* for the first International Exposition of Decorative and Industrial Modern Arts in Paris and became the Principal of the Fine Arts class at the Académie Royale de Belgique.

Horta was elevated to the title of Baron in 1932. Five years later, he submitted his final project: the Gare Centrale de Bruxelles (Brussels Central Train Station).

Horta died in 1947, at age eighty-six.

Horta built a great deal. Fortunately, he died without having to witness the destruction of his works, such as the Magasins Anspach and the Maison du Peuple, which were demolished in 1965-1966. In 1969, his house and studio on the rue Américaine were turned into the Musée Horta, in the end serving to consecrate his work as an artist.

Henry Van de Velde (Anvers, 1863 - Zurich, 1957)

Henry Clément Van de Velde was born in 1863, in Anvers.

From 1880 to 1883, Van de Velde studied painting at the Académie des beaux-arts in Anvers. During the following two years, he completed his training in Paris in the studio of the painter Carolus-Durant and afterwards among the Impressionists.

Van de Velde's first contact with the French capital was not at the top of his experiences as a young artist: an entrepreneur architect forced him out of a theatre construction project for which he had been hired.

Skilled at neo-Impressionist painting, Van de Velde discovered the work of Seurat and after returning to Anvers in 1886, joined Les Vingt in 1888. He proceeded to paint a few pointillist works without any real success and in 1892 he abandoned painting in order to devote himself to the decorative arts.

In 1895, Van de Velde married and settled in Uccle where he built Bloemenwerf, his house inspired by the English Arts and Crafts movement. As a non-specialist in architecture, Van de Velde worked in consultation with a professional and the project consequently emerged as a true manifesto, as well as the springboard for his architectural career. Based on a hexagonal plan, the house, which tended towards irregularly formed (and therefore impractical) rooms, resembled a cottage as much as a suburban or country home. Bloemenwerf quickly became a showcase within which potential clients could admire the handiwork of the artist, who went so far as to design his wife's wardrobe as an expression of the unifying principle so dear to Art Nouveau practitioners.

The same year, Van de Velde designed the interiors and furniture for Bing's Art Nouveau exhibit in Paris and henceforth became recognised as a decorator.

In 1897, he participated in the Exposition of Decorative Arts in Dresden.

The following year, Van de Velde established his own company. With his fame as an artist rising, he opened a branch in Berlin, closing the Belgian workshops in favour of the German ones in 1900. Van de Velde carried out a number of projects in Germany up until 1914, including in particular department stores and apartments, and the Folkwang Museum in Hagen. But the First World War forced him to leave the Germany and, because he was considered a traitor in Belgium, he had to exile himself to Switzerland.

An influential group of patrons rehabilitated Van de Velde's reputation in Belgium during the 1920s, obtaining a teaching position for him at the University of Gand in 1925. He then took over the

management of the new Institut Supérieur des Arts Décoratifs in Brussels, continuing at the same time to build private residences.

In 1933, the Belgian government commissioned Van de Velde to build the new University of Gand. He also designed new rail cars for the Belgian National Railroad and furnishings for ocean liners.

After 1936, Van de Velde gave up his various institutional positions and worked on the Belgian Pavilions for the Universal Expositions in Paris (1937) and New York (1939).

During the Second World War, Van de Velde served as "aesthetic advisor on reconstruction to the General Committee for the Restoration of the Country". But under suspicion of having collaborated with the enemy, the architect was asked to leave Belgium at the end of the war.

Van de Velde spent the last ten years of his life in the Swiss Alps and died in Zurich in 1957.

Henry Van de Velde, *Bloemenwerf*, 1895. Brussels.

Josef Maria Olbrich,
Vienna Secession Building, 1897-1898.
Vienna.

Hector Guimard,
Kiosk at the Porte Dauphine Station,
c. 1900.
Paris.

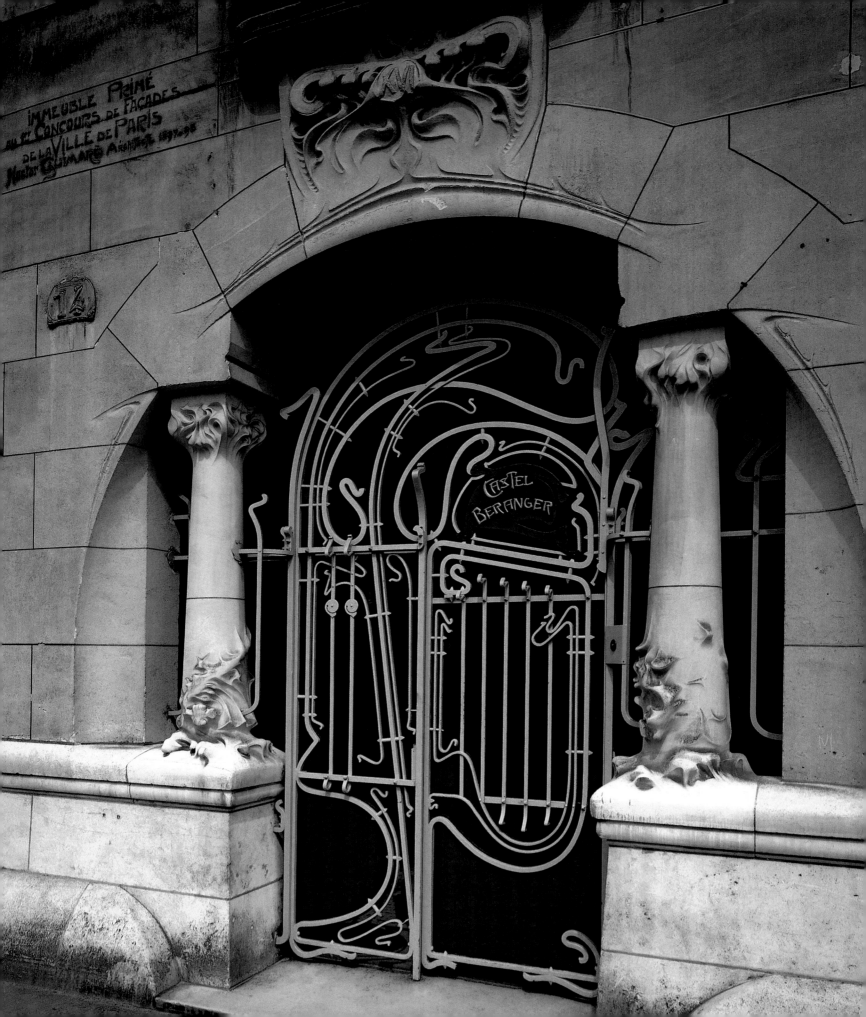

Hector Guimard (Lyon, 1867 - New York, 1942)

Hector Germain Guimard was born in Lyon in 1867.

He entered the Ecole des arts décoratifs in Paris at age fifteen; three years later he entered the Ecole des beaux-arts.

In 1888, Guimard was commissioned to build a café featuring live music on the banks of the Seine (sadly swept away by the floods of 1910) and also built a townhouse, designing its furniture, as well. These early works already evidenced the architect's style, which effortlessly combined expensive with inexpensive materials and asymmetrical compositions with varied forms.

In 1889, Guimard was asked to create the Universal Exhibition's electricity pavilion and was busy constructing the Sacré-Cœur school.

Between 1891 and 1893, Guimard built various private residences.

Guimard spent the next year travelling, in particular in England and in Belgium, where he met Victor Horta and commenced a dialogue with Art Nouveau.

Upon his return to France in 1895, Guimard devoted three years to the construction of the Castel Béranger. This private residence, a true masterpiece entirely conceived by Guimard, who even designed the doorknobs, received first prize for the most beautiful façade in Paris in 1899.

In 1898, Guimard also participated in the competition launched for the Paris Metro and focused on the kiosks intended to shelter the stations' entries. In the end, Guimard was awarded the job of designing the entrances, having been imposed upon the jury by the project's financier, Baron Empain. But not everyone appreciated Guimard's style; the overly cautious were quick to label it *style nouille*. Thus it was decided in 1902, after a major press campaign, that the opening of the entrance of the Place de l'Opéra station would not be in the Art Nouveau style. The decision represented a lost opportunity for a juxtaposition of two styles (Garnier's historicism and Guimard's Art Nouveau). Because each style was revolutionary in its time, such a comparison would have formed an excellent and accurate testament to historical change and evolution. Moreover, in 1925, Guimard's entrance to the Metro at the Place de la Concorde was demolished and replaced by a "classic" entrance.

In 1903, Guimard participated in the International Housing Exposition at the Grand Palais and designed a pavilion.

The architect continued to build a large number works up until the late 1920s, but not all of them represented Art Nouveau architecture.

After the Second World War, Guimard became interested in new industrial construction methods. A modernist, he considered the material and economic hardships stemming from the war: reconstruction had to be quick and inexpensive. The Parisian townhouse at 3 Jasmin Square (sixteenth arrondissement), completed in 1922, shows Guimard's response to these concerns. Most of the house's architectural elements were factory-made before assembly. Guimard was pioneering when he made the façade in concrete bricks and moulded cement coated in white plaster; cast-iron was used for the windowsills, whereas tin was used for the building's roofing.

In 1930, he built a country home called La Guimardière, utilising pipes as supportive and decorative elements. The home was destroyed in 1969.

When war came to Europe in the late 1930s, Guimard, who was ill at the time, exiled himself to the United States.

Hector Guimard died in New York in 1942.

Hector Guimard,
Castel Béranger, main entrance,
1895-1898.
Paris.

Henri Sauvage,
Villa Jika, 1898.
Nancy.

Hector Guimard,
Castel d'Orgeval, view of the left lateral facade, 1904.
Villemoisson-sur-Orge.

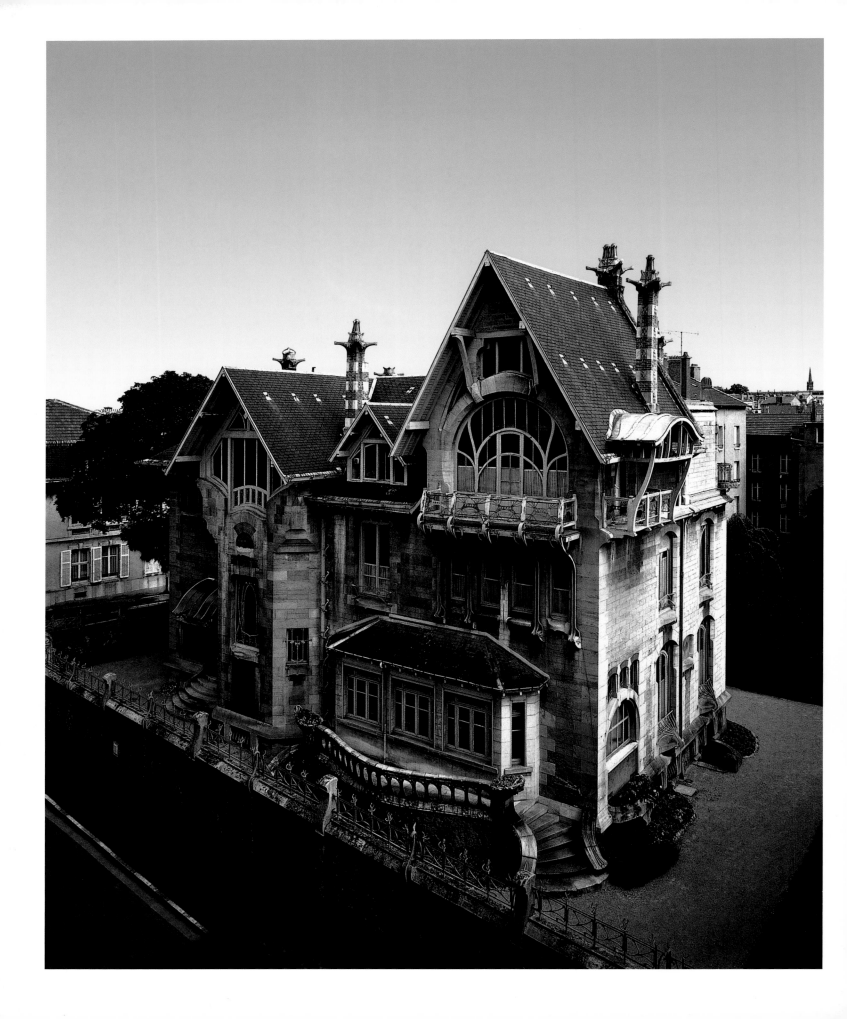

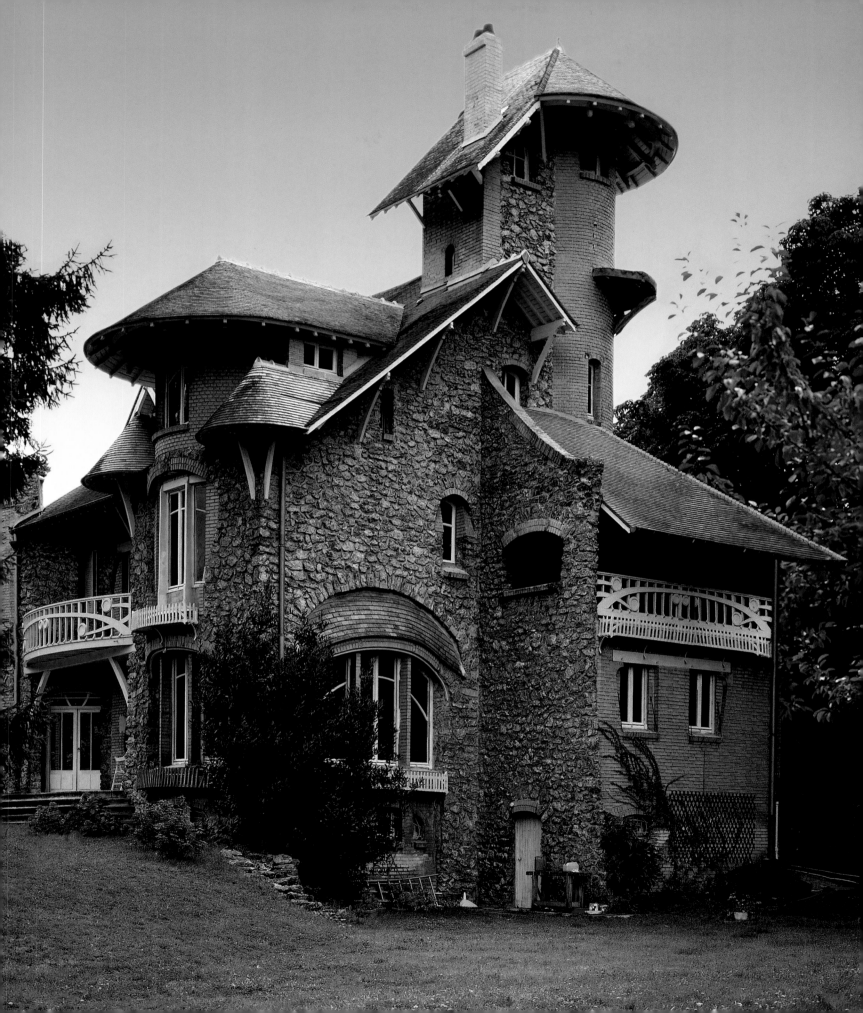

Antoni Gaudí (Riudoms, 1852 - Barcelona, 1926)

Antoni Gaudí I Cornet was born in the Spanish province of Tarragone, at Mas de la Caldera, his family's home in the town of Riudoms, in June of 1852.

In 1870, he entered the architecture school in Barcelona, where he settled.

In 1876 and 1877, Gaudí collaborated with Francisco de Paula del Villar to restore the chapel of the Montserrat monastery church and published his first writings on architecture.

The following year he obtained his diploma in architecture and designed two street lights for the Plaza Real.

As a young architect Gaudí was inspired by Viollet-le-Duc's neo-Gothic work, but quickly separated himself from this rather rigid style and developed greater originality and fantasy. Henceforth placing himself within the Art Nouveau movement, Gaudí unified architecture and furniture and would originate Art Nouveau's Spanish variant known as Modernista.

Work on Barcelona's Sagrada de la Familia began in 1882, when Joseph M. Bocabella purchased the land to build a temple dedicated to the Holy Family. When disputes with the architect in charge of construction erupted, the commission was entrusted to Gaudí, who modified the original project and would continue throughout his life making it ever more ambitious.

In 1883, Gaudí was charged with building the Casa Vicens. A private commission from the industrialist and ceramist Manuel Vicens Montaner, this project already presaged Gaudí's style, highlighting the Oriental, baroque, and Art Nouveau influences in his materials, *trompe-l'œil* effects and arabesques.

Two years later, the architect collaborated with textile manufacturer Eusebio Güell, for whom he built a palace and gardens. Afterwards, the wealthy industrialist would continue to support and finance Gaudí.

Gaudí continued to undertake various private and public architectural commissions up until the early twentieth century.

In 1900, he started work on a commission from Güell for a city garden on a hillside in Barcelona, the present-day Güell Park. The industrialist's original pharaonic plan called for residences, studios, a chapel, and park – in other words, a small village within the Catalan capital. When it came to making the project a reality, skyrocketing costs only allowed for two houses and the park to be built. The project nevertheless allowed Gaudí to give free reign to his creativity and to his originality, which meant respecting the landscape's natural form. He used his characteristic serpentine curves to develop his structures, totally integrating them within the environment in which he was composing, in particular by adhering to a principle of analogy of forms. Seven years after the work came to an end, the city of Barcelona acquired the project. Today Güell Park ranks as one of Barcelona's most popular destinations.

In 1926, Antoni Gaudí was run over by a streetcar and died as a result of his injuries. He was buried in the crypt of the Sagrada Familia, which he had left unfinished, although he had devoted twelve years of his life to it. To this day the last stones of the cathedral have yet to be placed; its completion is anticipated for the centenary of the architect's death.

Antoni Gaudí,
Casa Batlló, upper facade, 1904.
Barcelona.

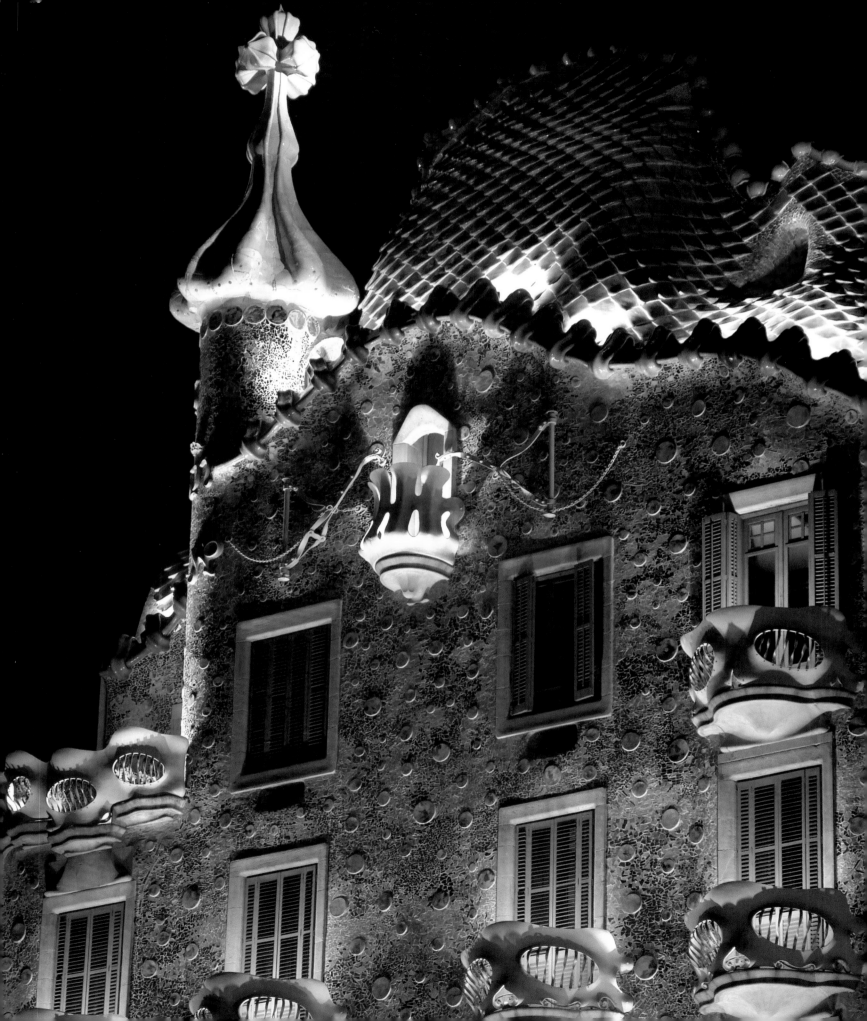

Antoni Gaudí,
La Pedrera, entrance, 1905.
Barcelona.

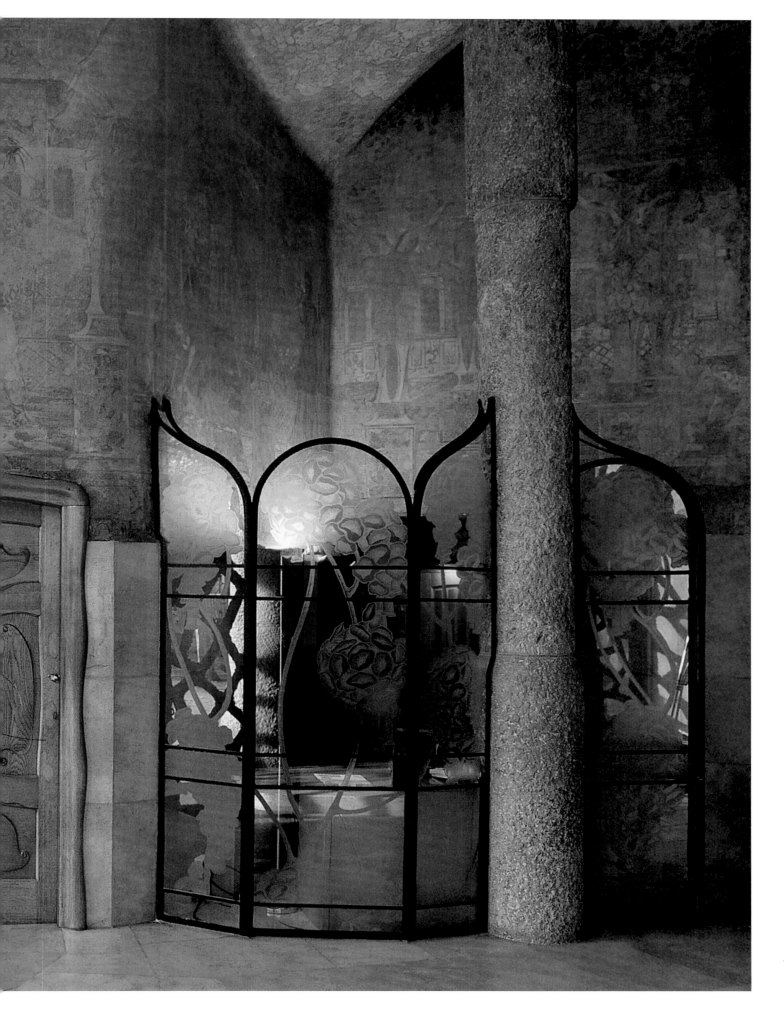

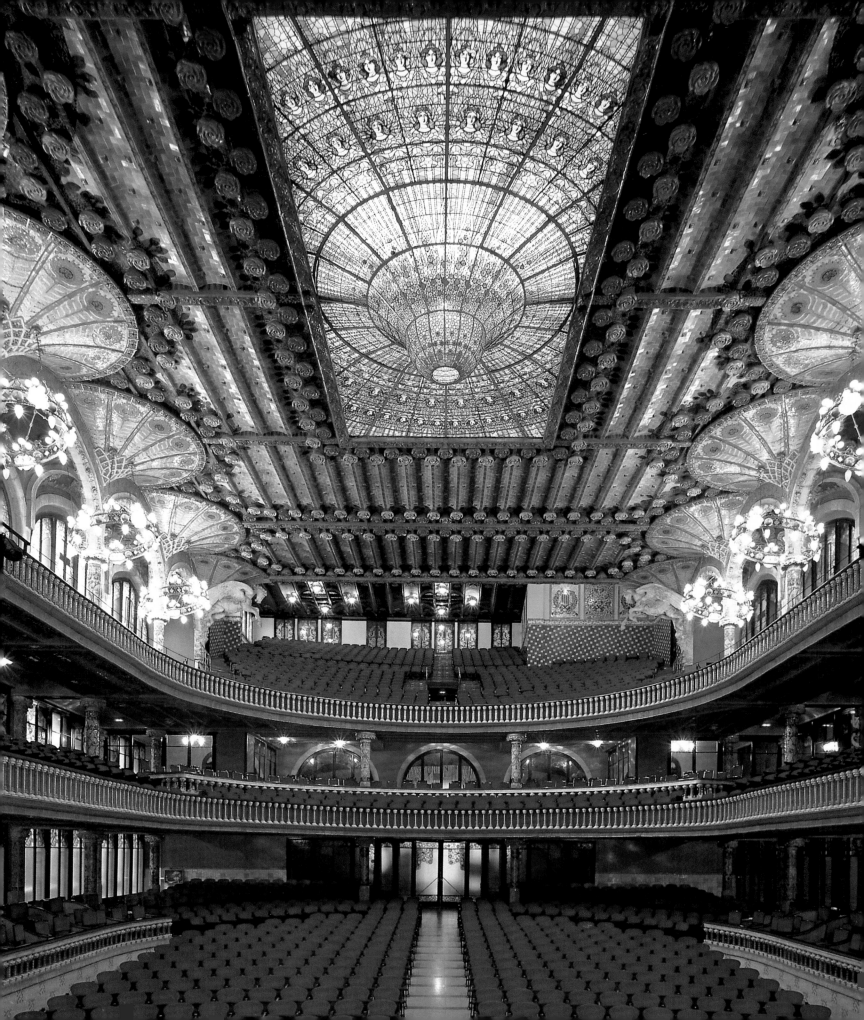

A worthy representative of Art Nouveau, Gaudí is undoubtedly among those artists who made the most radical break with the past. His work, now under the protection of the UNESCO international heritage program, was greatly criticised during his time. Contemporaries dubbed the Casa Milà that Gaudí designed in 1905 *La Pedrera* (the Quarry), due to its overly organic appearance that seemed devoid of any rational architectural principle. The enveloping organic architecture of this man, who was then considered too eccentric to be an architect, was thought to be devouring the soul of beautiful Barcelona – the same Barcelona as today, whose soul everyone believes is the work of Antoni Gaudí.

Lluis Domènech i Montaner,
Auditorium of the Palau de la Música Catalana, 1905-1908.
Barcelona.

Friedrich Ohmann,
Hotel Central, 1899-1901.
Prague.

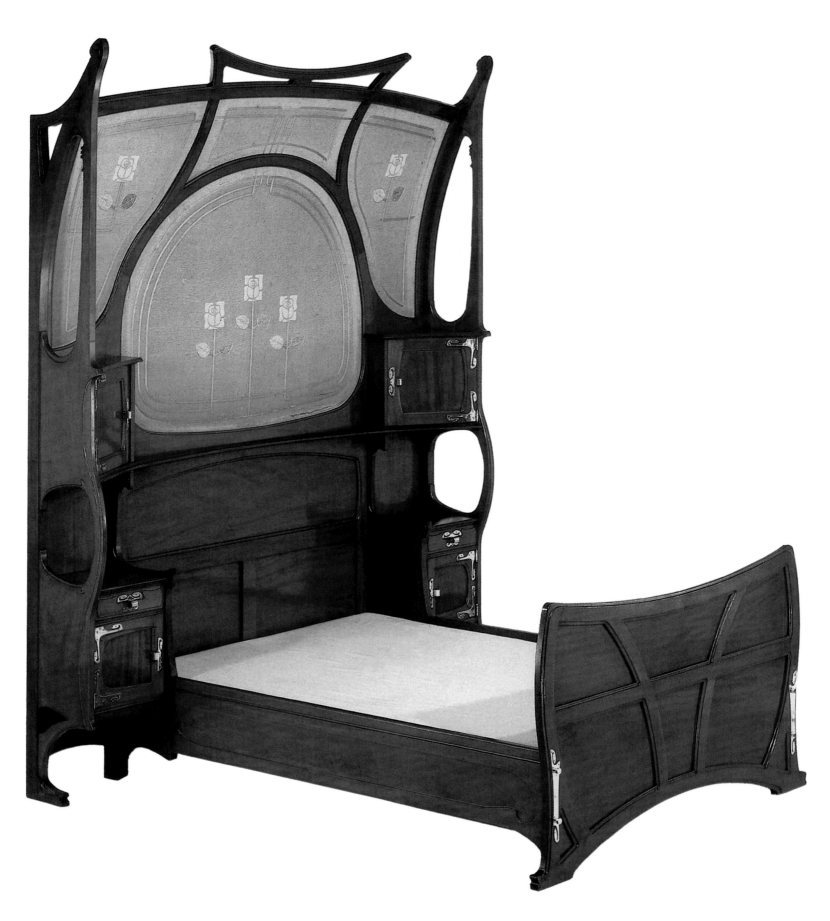

Decorative Arts

Gustave Serrurier-Bovy (Liège, 1858 - Anvers, 1910)

Gustave Serrurier-Bovy was born in Belgium in the town of Liège in 1858.

The son of a woodworking contractor, he attended the public secondary school in his native town and completed his training at the Ecole des beaux-arts.

Serrurier-Bovy was quickly seduced by the ideas advanced by William Morris, the founder of the English Arts and Crafts movement. He consequently travelled to London and worked as a furniture designer in the Modern Style, an outgrowth of Arts and Crafts.

Upon his return to Belgium in 1884, the artist married Maria Bovy. The same year he opened his own workshop in Liège and in this way founded the firm Serrurier-Bovy. Branches were later opened in Brussels and Paris.

Initially the business imported furniture and decorative items from Great Britain, offering Liberty items in particular at the Liège boutique. But in response to contemporary taste, which was increasingly turning towards Japan, Serrurier-Bovy also started offering Japanese items.

Serrurier-Bovy was also a founder of the Brussels Salon de l'Esthétique and devoted himself to furniture design from 1894.

Removing any indication of period styles from his designs, Serrurier-Bovy offered the public modernised furnishings that commanded respect for their bold innovation and quality. Acknowledged by European critics, the cabinetmaker was henceforth able to exhibit abroad. He thus participated in large-scale international exhibitions in Saint Louis, Paris and London and established relationships with the Darmstadt artist colony in Germany where Jugendstil was developing.

Within the Art Nouveau trend then making itself felt, the vegetal lines of Serrurier-Bovy furniture assumed forms of astonishing sobriety, which became almost geometric in the early twentieth century.

For the 1900 Universal Exposition in Paris, Serrurier-Bovy worked alongside architect René Dulong in the construction of the Blue Pavilion, a restaurant whose exuberant Art Nouveau decor was attractively co-ordinated with restrained white lacquer furniture.

The grand piano that Serrurier-Bovy made for the Château de la Chapelle in Serval (near Compiègne) in 1901 is a remarkable example of how bold and innovative he could be. Radically departing from the musical instrument's classical form, he nevertheless designed it as a true piece of architecture. The legs are replaced by side panels and a crosspiece, allowing for an immediate reading of the work. In this way the construction responds to the master's passionate belief in the principle of simplicity.

In 1902, René Dulong was commissioned to expand and modernise the Château de la Cheyrelle in the heart of the Cantal region and the interior furnishings were entrusted to Serrurier-Bovy.

During the three-year renovation project, the artist applied his individual ideas on architecture and decoration to the premises, in the creation of a "domestic manifesto". The house henceforth became light, functional and rational and the decor, which consisted of stylised and geometric forms, picked up floral motifs and a multi-colour scheme from Art Nouveau.

Gustave Serrurier-Bovy,
Bed, c. 1898-1899.
Mahogany and copper.
Musée d'Orsay, Paris.

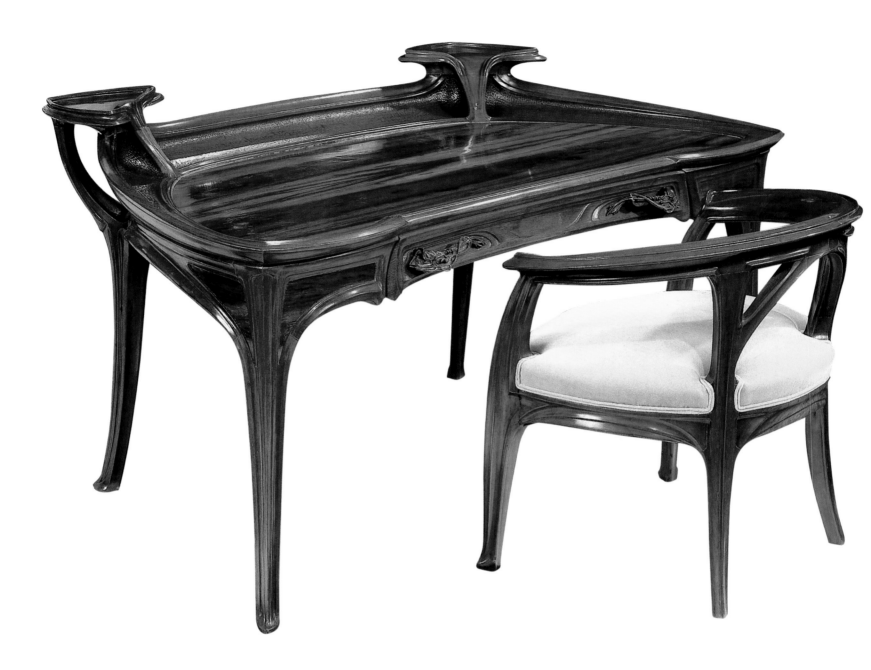

Jacques Gruber,
Desk and Chair.
Wood and ormolu.
Macklowe Gallery, New York.

Eugène Gaillard,
Vitrine, 1900. Walnut.
Kunstindustrimuseet, Copenhagen.

The chateau, which was built in 1866 in a style at once neo-medieval and picturesque, and which today still preserves most of the Serrurier-Bovy furnishings, is last French remnant of Serrurier-Bovy's work. It was decreed a registered national heritage site in 1994 and was restored in 1996.

At the 1905 Universal Exposition in Liège, Serrurier-Bovy introduced the public to his "Silex" furniture, that he had already tried out at the Château de la Cheyrelle.

Simple wood furniture decorated with stencils and packaged in a kit, these works represented a fundamental stage in the history of design and one of the few actually successful outcomes of Art Nouveau philosophy: art accessible to everyone. Due to its lower production costs, the same Silex furniture that furnished the rooms of a French chateau in the Cantal region could henceforth furnish workers' interiors. Serrurier-Bovy broke barriers between the different social classes, at least in the realm of furniture.

In this way successfully achieving the goals that he had set for himself, Gustave Serrurier-Bovy died in Anvers in 1910. He was fifty-two years old.

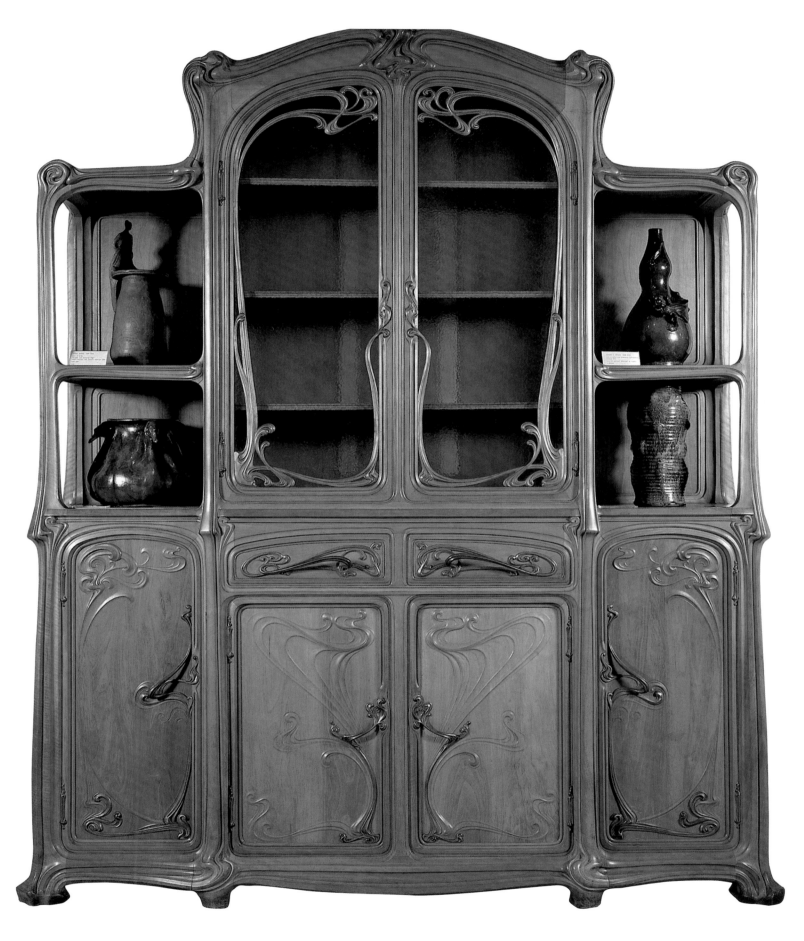

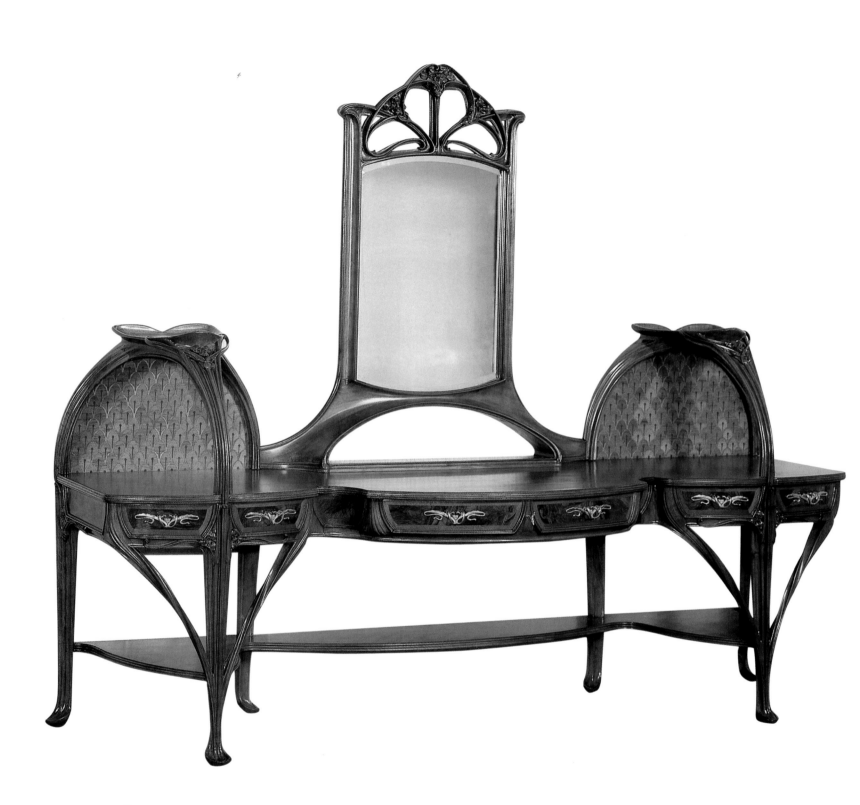

Louis Majorelle,
Dressing table. Marquetry and ormolu.
Macklowe Gallery, New York.

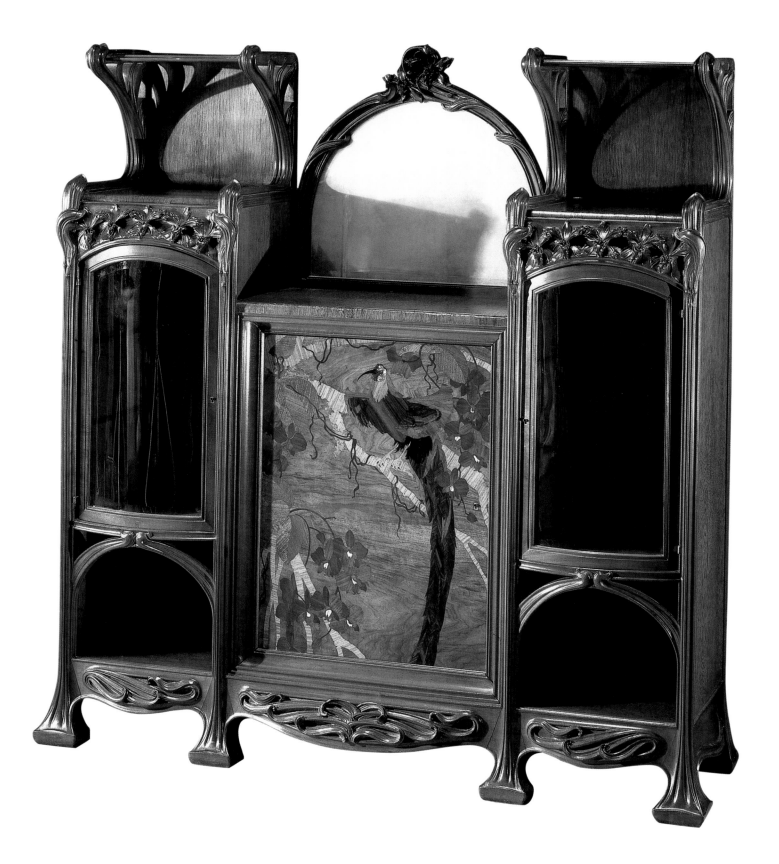

Louis Majorelle,
Cabinet. Marquetry and mother-of-pearl.
Macklowe Gallery, New York.

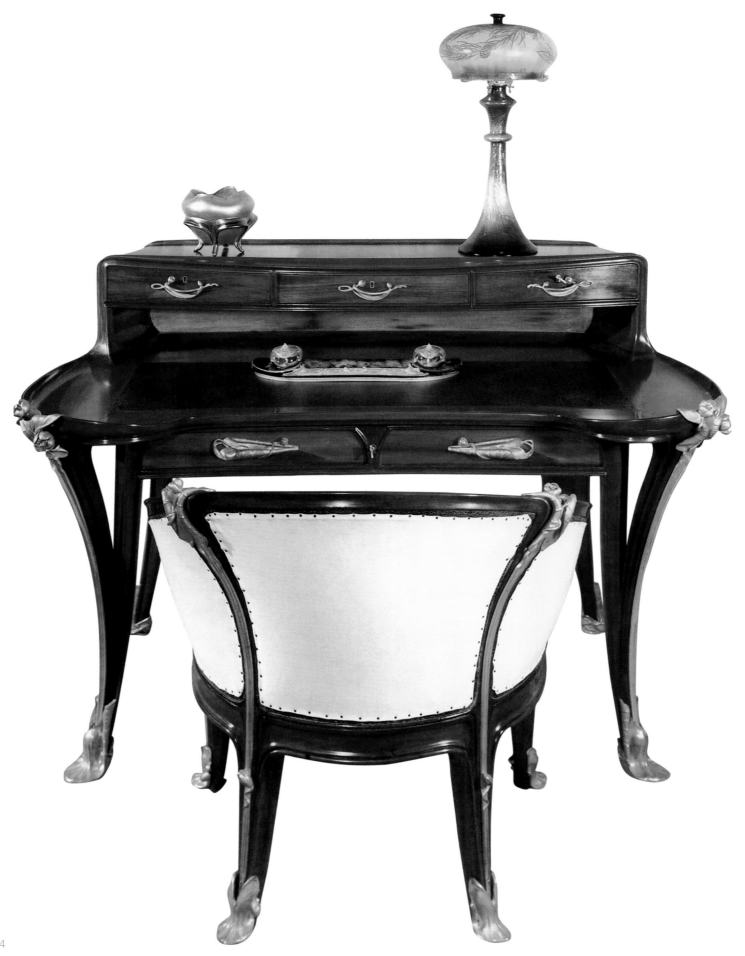

Louis Majorelle (Toul, 1859 - Nancy, 1926)

Louis Majorelle was born in Toul (Meurthe-et-Moselle), France in 1859.

He began his artistic training at the Ecole des beaux-arts of Nancy where he was a student of Théodore Devilly and Charles Pêtre. In 1877, he continued his education at the Ecole des beaux-arts in Paris under the direction of the sculptor Aimé Millet.

Two years later Majorelle returned to Nancy when his father was dying.

There, along with his brother, he took up the family business: furniture and porcelain production.

There is scant documentation regarding the activities of Majorelle's father Auguste, but apparently he was already involved in artistic endeavours. Beginning in 1860, he set up shop dealing in art objects first in Toul, then in Nancy. In 1868 and 1874, Auguste Majorelle appeared in the Salon de la Société des amis des arts and exhibited his furniture and his first ceramics.

Initially, Louis Majorelle continued in his father's footsteps by producing rococo and historically based furniture for sale in France and its colonies.

Converted to Art Nouveau in 1894, by Emile Gallé, Majorelle went on to become one of the most important representatives of the School of Nancy.

Henceforth inspired by the era's prevailing naturalism and Symbolism, Majorelle made his reputation primarily through inlay furniture, where water lilies with sober lines replaced traditional chair legs and headboards. In his hands, the lacquered decor of rocaille and Japanese furniture gave way to refined marquetry work filled with contemporary ambiance.

At the same time Majorelle began working in metal and bronze, which he used to decorate the furniture in order to emphasise its architectural lines or certain decorative elements.

In 1898, he asked the architect Henri Sauvage to design his personal villa in Nancy. The "Villa Majorelle" or villa "Jika" (representing the initials of his wife Jeanne Kretz) was a work by one artist for another that immediately demonstrated, both in its exterior and interior architecture and in its decorative elements, the concept of the unitary work advocated by Art Nouveau artists. In 1996, the villa was classified as a historic monument and partially restored three years later.

Additionally, Majorelle's collaboration with Daum brothers' glass works resulted in original lighting creations combining the forms and colours of the young Art Nouveau trend, and his presence at the 1900 Universal Exposition in Paris was a real success.

In 1901, he was a vice-president of the School of Nancy.

His work later evolved towards more pure and simple lines that, while thoroughly Art Nouveau, already prefigured the evolution towards the Art Deco style of the 1920s.

Responding to economic considerations, as well, Majorelle divided his production into two divisions: one for luxury furniture (produced in Nancy) and beginning in 1905, one for mass-produced furniture designed in the workshops of Bouxières.

Still producing ceramics in various workshops located in Lorraine, Majorelle's different activities enabled him to open numerous showrooms, in particular in Paris and Lyon.

Louis Majorelle had become one of the most significant and famous Art Nouveau furniture makers when he died in Nancy in 1926, leaving behind the legacy of a style at once elegant and original in precious wood undulating to the rhythm of Nature.

Louis Majorelle,
"Water Lilies" Desk and Chair.
Wood and bronze.
Galerie Maria de Beyrie, Paris.

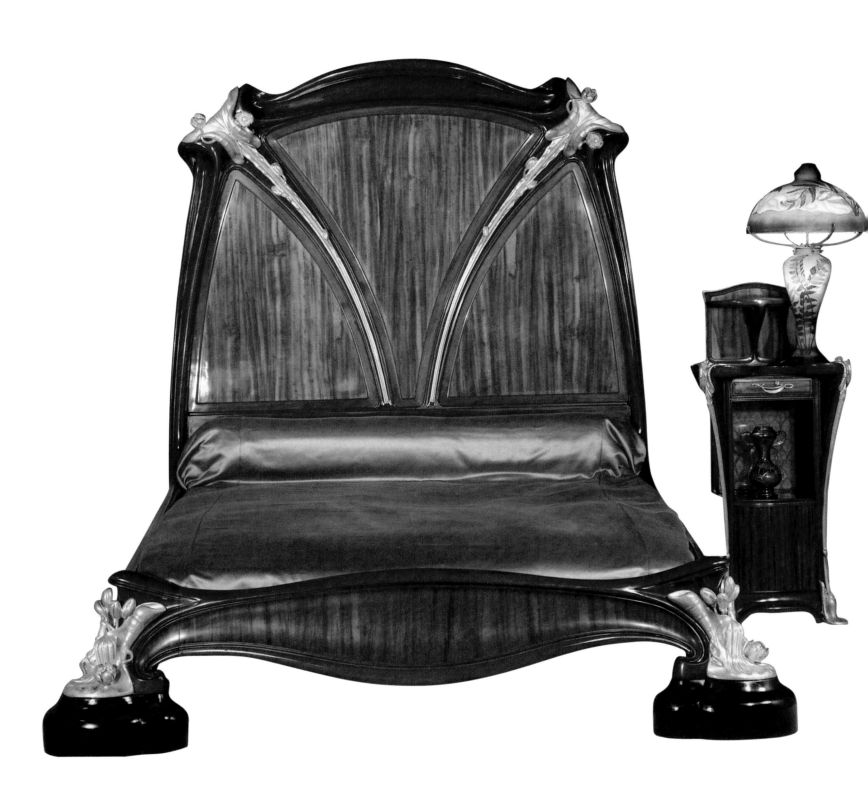

Louis Majorelle,
"Water Lilies" Bed and Night Table,
1905-1909. Wood and bronze.
Musée d'Orsay, Paris.

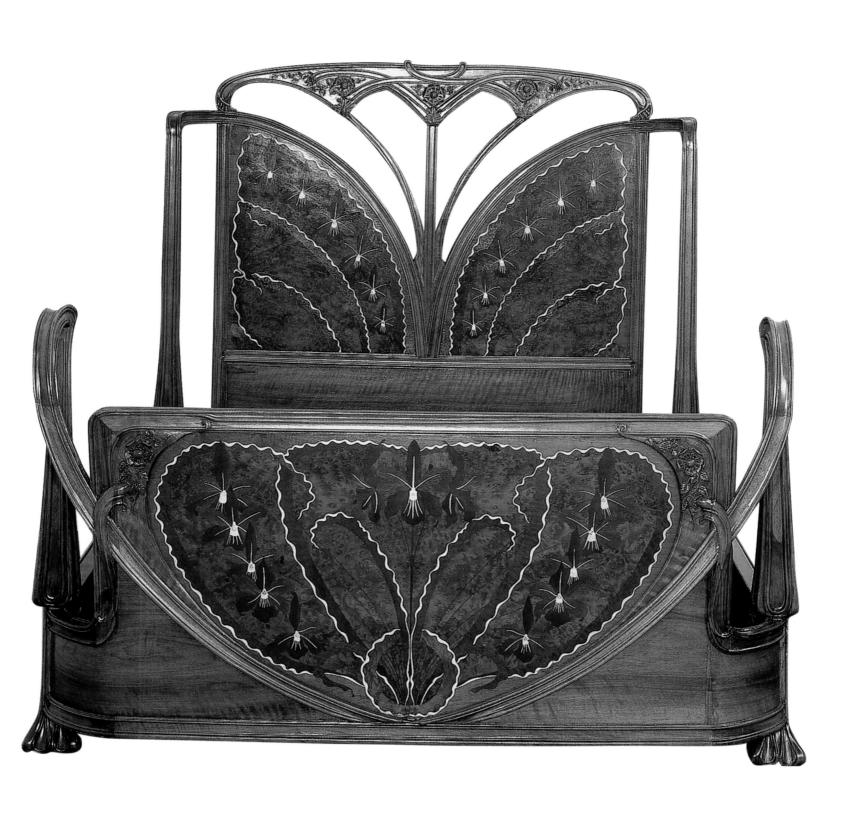

Louis Majorelle,
Bed. Wood and metal.
Macklowe Gallery, New York.

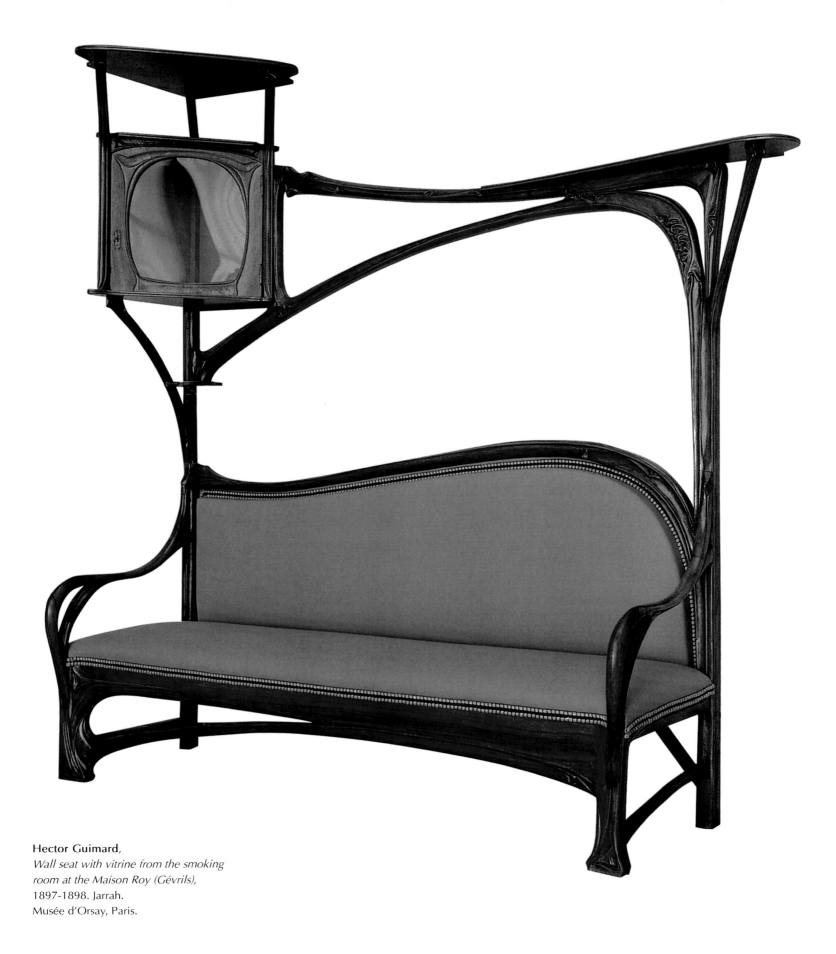

Hector Guimard,
Wall seat with vitrine from the smoking room at the Maison Roy (Gévrils),
1897-1898. Jarrah.
Musée d'Orsay, Paris.

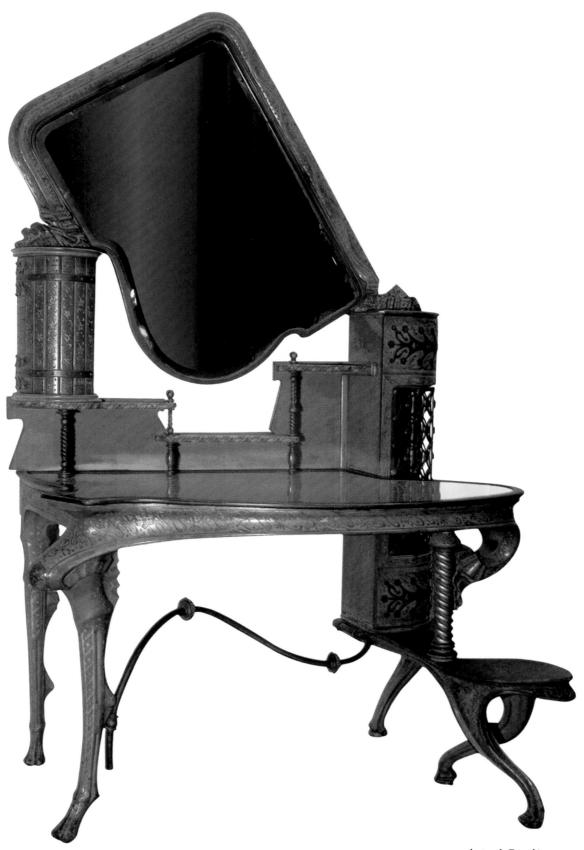

Antoni Gaudí,
Dressing Table, c. 1895. Wood.
Güell family collection, Barcelona.

Charles Rennie Mackintosh (Glasgow, 1868 – London, 1928)

Charles Rennie Mackintosh was born in Glasgow, Scotland in 1868.

He pursued architectural training in his native city in the offices of John Hutchinson and took evening classes in art and design at the Glasgow School of Art.

From that time on he was the recipient of numerous prizes in drawing, painting, and architecture.

During the course of his studies, he met Herbert McNair and the MacDonald sisters, Margaret (whom he would marry in 1900) and Frances.

In 1889, he joined the architectural firm Honeyman & Keppie.

The next year he established his own architectural office. Four years later, along with the MacDonald sisters and McNair, he established a group known as "The Four". The group would end when McNair married Frances and they left to live in Liverpool.

The Four soon began participating in international exhibitions, beginning with Liège in 1895 and followed by showings in Glasgow, London, Vienna and Turin. There they exhibited works inspired by continental European Art Nouveau, Japanese art, Symbolism and neo-Gothic. Thanks to these exhibitions, Mackintosh started to develop a reputation and the style of The Four was quickly baptised the "Glasgow" style. It was Mackintosh in particular who inspired Viennese Art Nouveau movement known as the Secession.

In 1894, Mackintosh designed his first architectural work, the corner tower of the Glasgow Herald building. From then on he repudiated academic tradition in favour of designing buildings with modern forms.

In 1897, Mackintosh was entrusted with the alteration of the Glasgow School of Art building. This project, which was one of his major works, helping to establish his international reputation, was executed in two phases: the first part was completed in 1899 and the second in 1909. Mackintosh asserted his style in the architecture of the school and that of the adjacent library. Confirming his opposition to historicism, he sought in the concept of the unified work to establish a proper synthesis between exterior and interior architecture and furnishings, already presaging the rational architectural of the twentieth century.

Thus, with the utmost sensitivity, he exploited the play of natural and artificial light in his buildings and enhanced his interiors with furniture of stunning restraint, often decorated with the famous stylised flower known as the Glasgow Rose.

In 1900, his work was shown as part of the Secession exhibit in Vienna. The same year he participated in the competition launched for Liverpool Cathedral, but was not selected.

Immersed in a decade of intense creativity until the early twentieth century, Mackintosh is known for various architectural designs, mostly for public buildings, but also private villas and tea salons.

As a decorator Mackintosh also created innovative designs for furniture, textiles and ironwork. He always worked in collaboration with his wife and the work reflects their partnership: his formal rectilinear style is enhanced by her undulating floral forms. The couple thus created an individual style whose primary characteristic became a strong contrast between right angles and the gentle curves of floral decoration.

Popular in his native country and highly productive, Mackintosh was only relatively successful outside the United Kingdom.

Much later, discouraged with architecture, he worked as a landscape painter and studied flowers with Margaret in the village of Walberswick where they lived.

Charles Rennie Mackintosh,
Chair, 1904. Oak.
Glasgow School of Art, Glasgow.

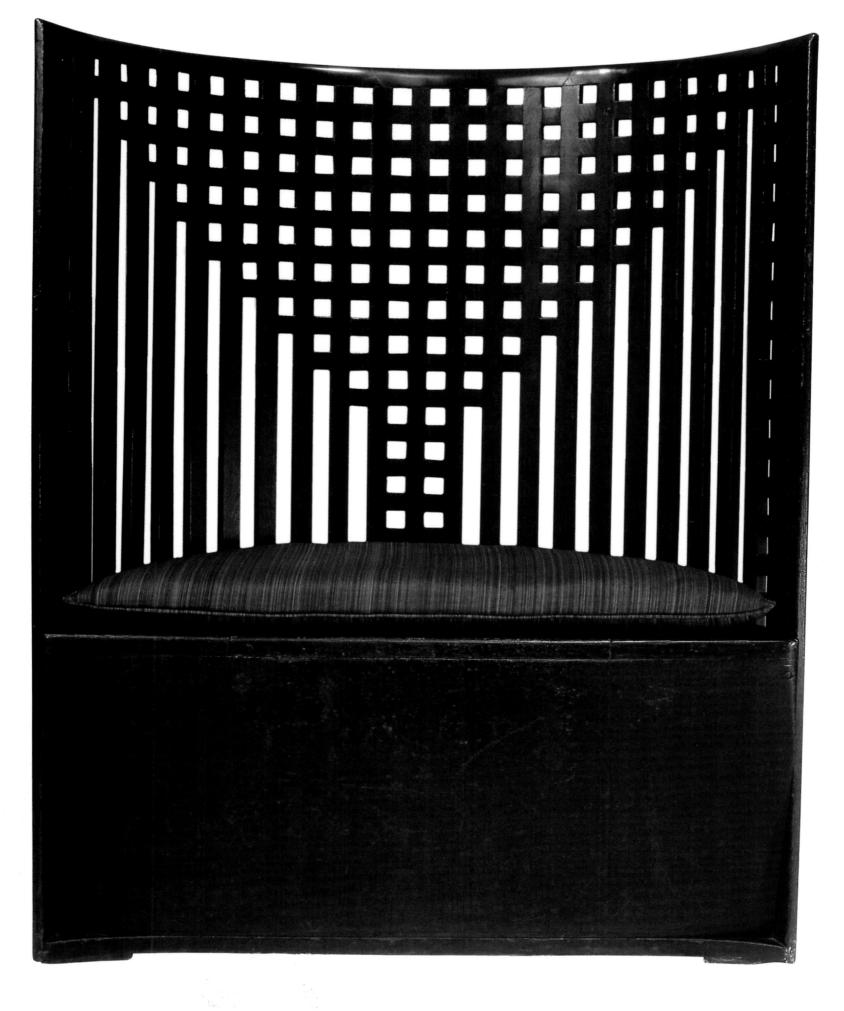

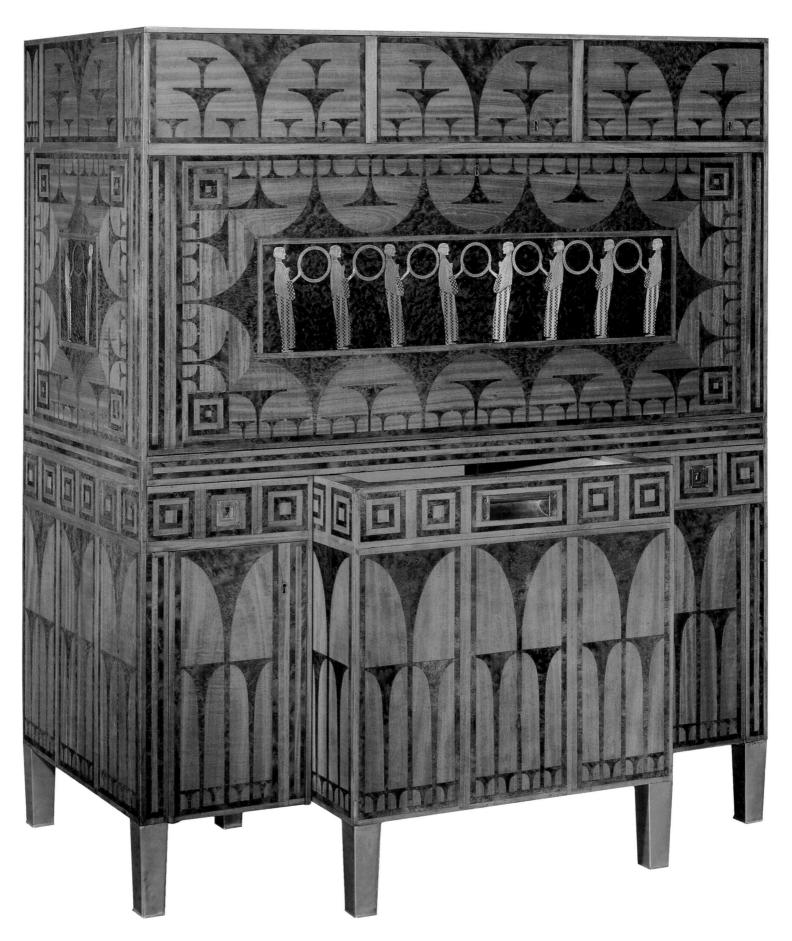

Reduced to a state of ruin, Charles Rennie Mackintosh died in 1928.

The artist's work, however, became very popular in the decades after his passing. Today the Glasgow School of Art building is regarded by architectural critics as the one of the most elegant buildings in the United Kingdom and has since been renamed the Mackintosh Building, thereby giving the architect the glory that his own era refused him. Meanwhile the Charles Rennie Mackintosh Society promotes a greater awareness of his work as architect, artist, designer and early twentieth-century creative force to be reckoned with.

Koloman Moser,
Woman's Writing Desk and Chair, 1903.
Thuja, marquetry, copper and gilt.
Victoria and Albert Museum, London.

Gustave Serrurier-Bovy,
Clock, 1900-1910.
Oak, brass, iron and other materials.
Collection Marsh and Jeffrey Miro.

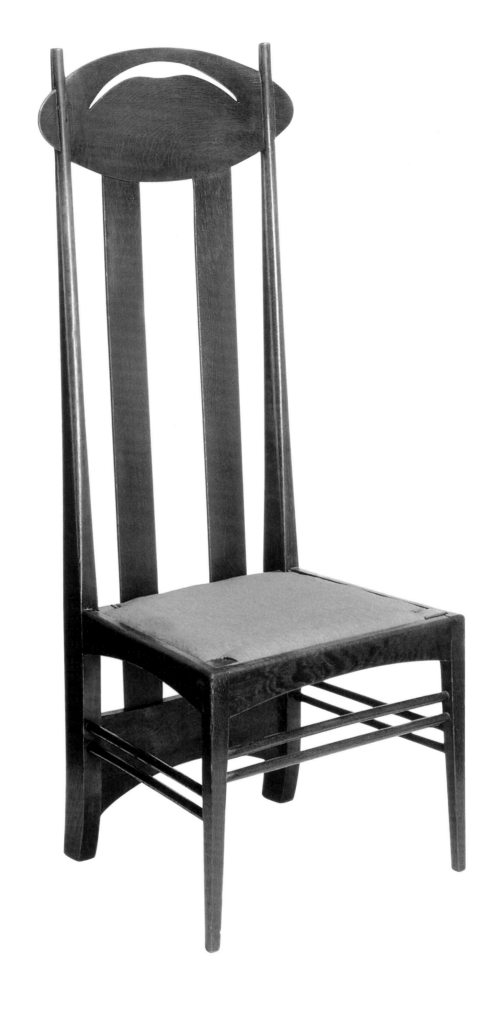

Charles Rennie Mackintosh,
Chair, 1897-1900. Oak.
Victoria and Albert Museum, London.

Josef Hoffmann,
Three-Panel Screen, 1889-1900.
The Royal Pavilion, Brighton.

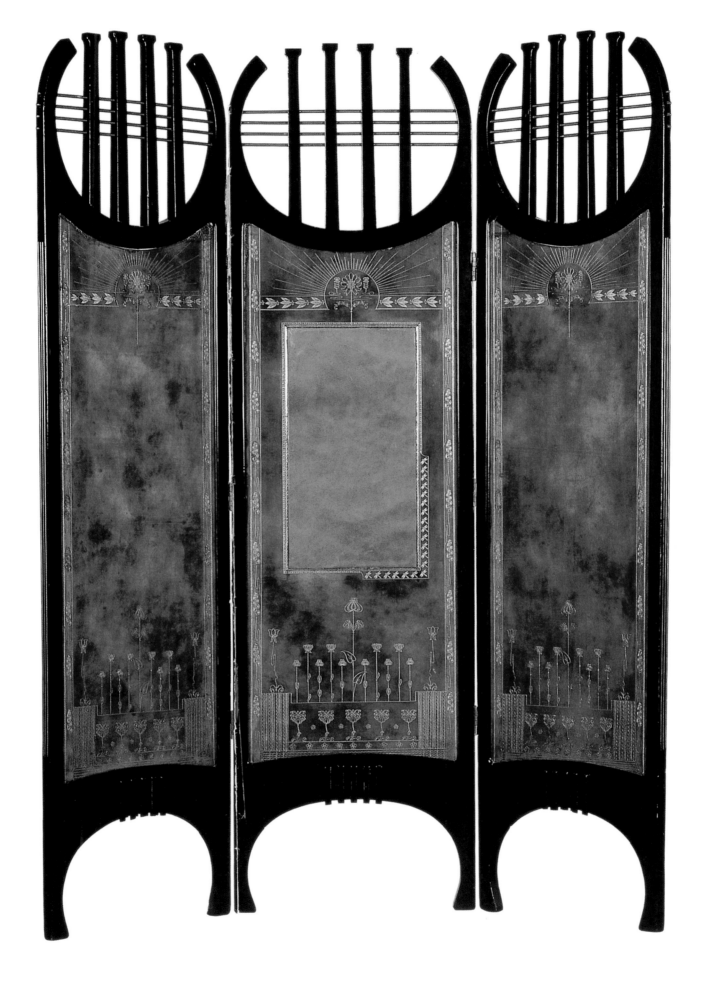

Louis Comfort Tiffany (New York, 1848 - 1933)

The son of Harriet and Charles Lewis Tiffany, the founder of a company specialising in luxury items, jewellery and stationary articles, Louis Comfort was born in the United States in 1848.

Charles Tiffany had established his company with John B. Young in September 1838; Tiffany & Young establishments were renamed Tiffany & Co. in 1853 when Charles took over sole management.

The firm already enjoyed great renown when it was appointed to design a presentation urn for Abraham Lincoln's Presidential inauguration in 1861.

In 1866, Louis Comfort studied at the National Academy of Design in New York, today called the National Academy, comprising an honorary group of American artists, a museum, and a School of Fine Arts.

The following year, Tiffany studied under the New York painter George Inness and completed his first creation: a painting. This was also the year his father's company won an award of excellence for its silverware, becoming the first American company to be so decorated.

Tiffany first became interested in working with glass in 1872, at the age of twenty-four. On 15 May 1872, he married Mary Woodbridge Goddard and ten years passed before he started designing his glass works at age thirty-four.

From that point on, and with extraordinary taste and artistry, he composed with glass in unlikely forms and colours, creating glass windows, lamps, and lampshades in an Art Nouveau style of exquisite beauty.

In 1885, while Tiffany & Co. was increasing in popularity, Louis Comfort established his own firm specialising in glass works. There he developed new technical processes that enabled him in particular to produce opalescent glass (at a time when most artists still preferred clear coloured glass) and became part of Arts and Crafts Movement initiated in Great Britain by William Morris.

In 1893, Tiffany perfected a new process for making glass vases and bowls: the Favrile technique, an artisan method of glass blowing that permitted numerous effects. Tiffany was also making stained glass windows, while his company designed a complete line of interior decorations.

In 1895, Tiffany's works in glass were exhibited in Bing's Art Nouveau gallery in Paris.

In 1902, Louis Comfort Tiffany succeeded his father as head of Tiffany & Co., but still continued his work with glass.

Thomas Edison later encouraged Tiffany to focus on producing electric lamps. From then on Tiffany lamps were finely wrought in the family tradition, like actual pieces of jewellery. The works took up the organic themes of the naturalist: foliage, flowers, butterflies and dragonflies. Ever faithful to the Art Nouveau approach, Tiffany sought to elevate the decorative arts to the level of fine arts and to make them accessible to more people. He therefore produced multiple editions of the lamps and lampshades that combined multi-coloured glass with bronze and sculpted lead frames and decorative mosaic.

In 1904, he applied his decorative talents to the total design of Laurelton Hall, his own home in Oyster Bay, New York.

He continued to produce high quality exotic works influenced in particular by North African and Japanese aesthetics.

Louis Comfort Tiffany died in New York in January 1933.

Tiffany & Co.,
At the New Circus, Father Chrysanthemum, 1895.
Mottled, printed and superimposed glass,
120 x 85 cm.
Musée d'Orsay, Paris.

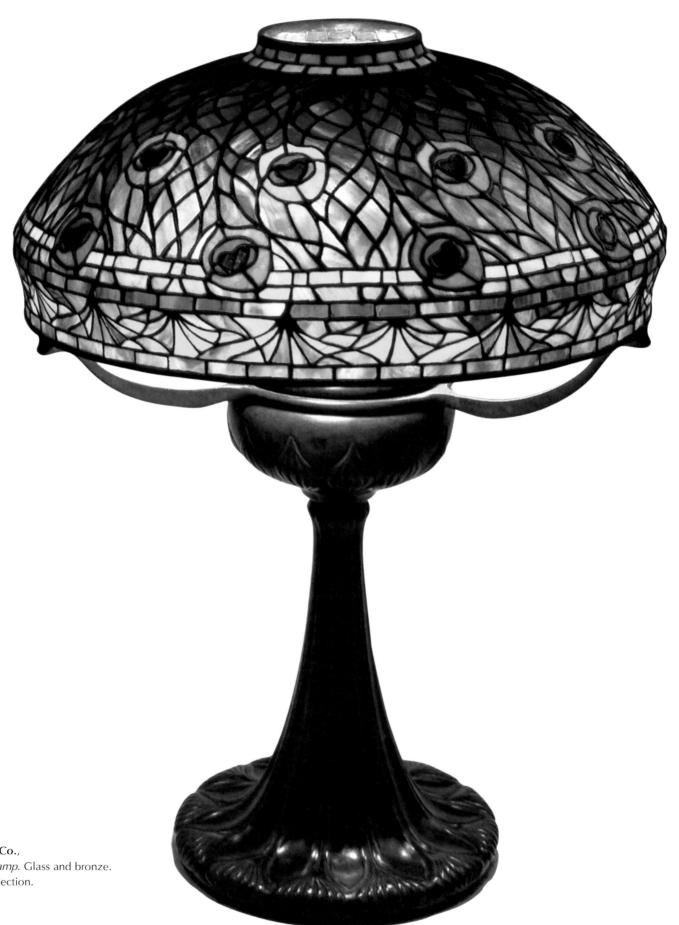

Tiffany & Co.,
Peacock Lamp. Glass and bronze.
Private collection.

168

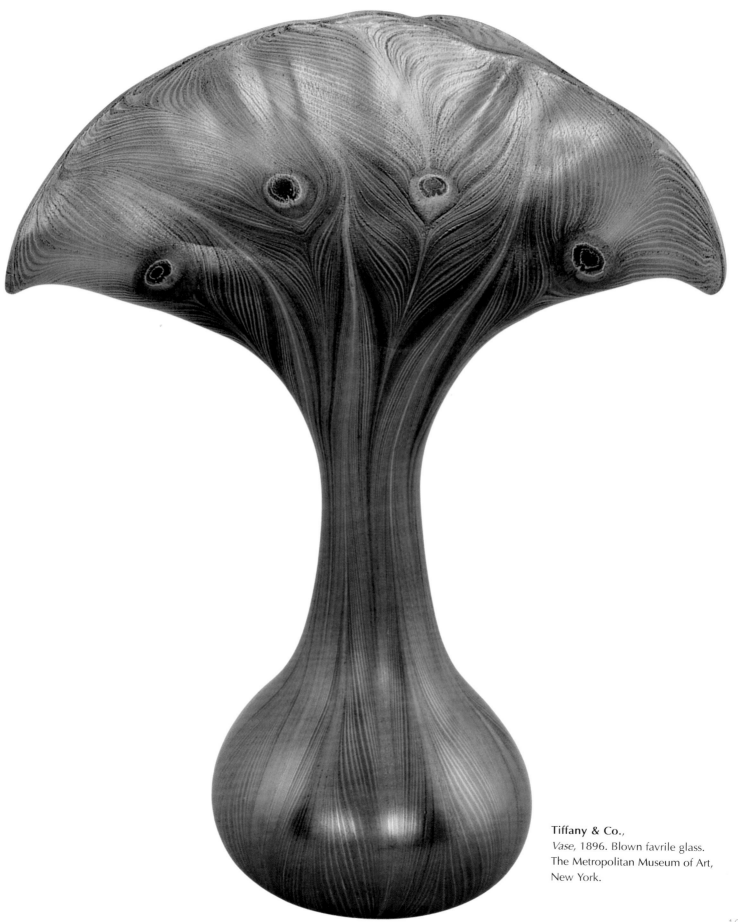

Tiffany & Co.,
Vase, 1896. Blown favrile glass.
The Metropolitan Museum of Art,
New York.

Tiffany & Co.,
Table Lamp.
Private collection.

Tiffany & Co.,
Crested Cockatoos, c. 1900.
Glass, 76 x 56 cm.
Haworth Art Gallery, Accrington.

Tiffany & Co. still exists. In the world of jewellery it remains an undisputed paragon. The works of Louis Comfort Tiffany remain extremely popular and sought after by collectors. The Metropolitan Museum of Art in New York possesses several whose unique style is characteristic of the Art Nouveau period.

Emile Gallé (Nancy, 1846 – 1904)

Emile Gallé was born in the French town of Nancy in May 1846. His father was Charles Gallé, an artist painter and a master enamellist who produced refined work; his mother Fanny was the daughter of a crystal and porcelain merchant named Reinemer. When he married Emile's mother, the elder Gallé joined her family's business.

Emile was educated in Nancy, where he obtained his baccalaureate.

At age nineteen, he travelled to Weimar, where he studied music and German art, before going to Meisenthal. He then worked in the glass factory of Lorraine Burgun, Schewerer & Cie, where he improved his knowledge of glass chemicals, techniques and forms. Inquisitive by nature, Gallé went beyond the standard theoretical approach to new processes that he was learning and taught himself glass blowing. He later travelled to London, where he spent time contemplating the collections of the South Kensington Museum (now the Victoria and Albert Museum) then on to Paris.

Gallé was fascinated by botany and throughout his travels he studied plants, animals, and insects in nature, making detailed reproductions that would later serve as references for his decorative work.

Gallé returned to Nancy and in 1867 started working with his father, for whom he designed new ceramics, furniture, and jewellery.

In 1873, Gallé established his own glass studio within the family factory and was henceforth able to employ the processes he had previously learned.

Two years later he married Henriette Grimm; in 1877, he assumed management of the Gallé establishments. The following year, ceramic production studios (then located in Saint-Clément) were set up in Raon-L'Etape. At the same time, Gallé considerably expanded the premises for glass works within the family business, which for a decade had relied on the firm Burgun, Schewerer & Cie for their production.

In 1878, while participating in the Universal Exposition in Paris, Gallé was quite impressed with the work of some of his contemporaries and actually fell under their influence. That was how he came to submit the artistic, individual and original glass creations that earned him Grand Prize at the 1889 Exposition. Gallé was utilising innovative materials, such as carved and etched glass and pâte de verre, and had also developed new forms of glass vases in colours never seen before. It was now official: Gallé was working in a pioneering Art Nouveau style.

To create his works, he submitted his designs to artisans who were responsible for their production and who, after receiving the master's approval, fixed their signature on the piece. During the last ten years of the nineteenth century, he designed crystal ware in this manner, producing a number of important and unusual works.

Gallé's creations met with immediate success and he received several awards. He was named Officier de la Légion d'honneur, then Commandeur in 1900.

In 1901, he founded the School of Nancy (with other artists, including Majorelle and Daum) and served as its President. The following year he participated in the Exposition of Decorative Arts in Turin, Italy.

Emile Gallé,
Vitrine with Artistic Vases.
Marquetry and glass.
Macklowe Gallery, New York.

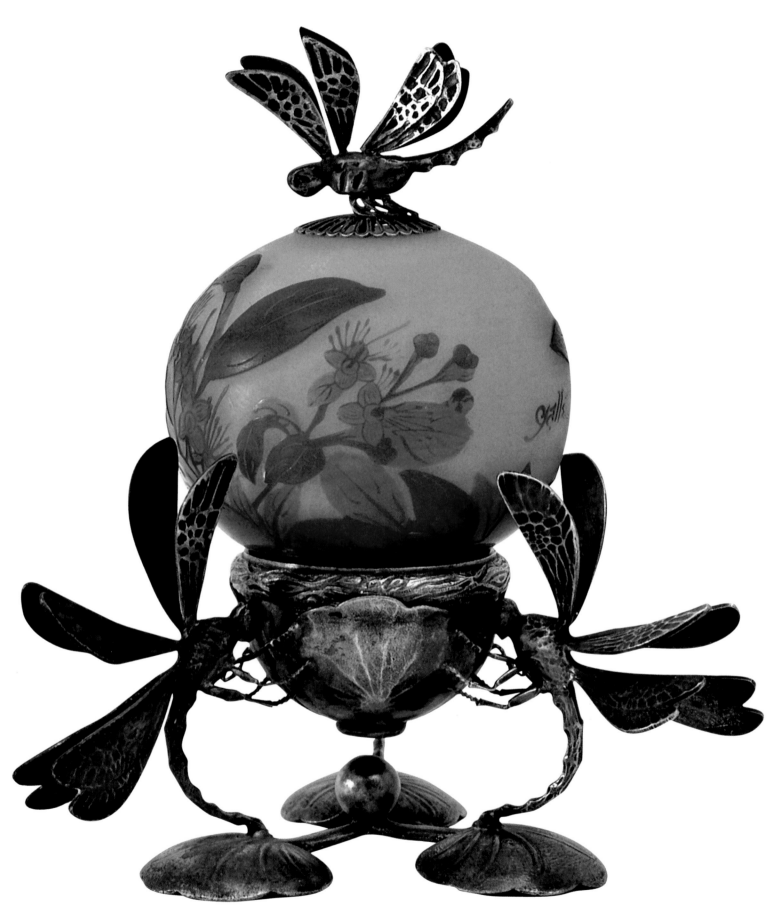

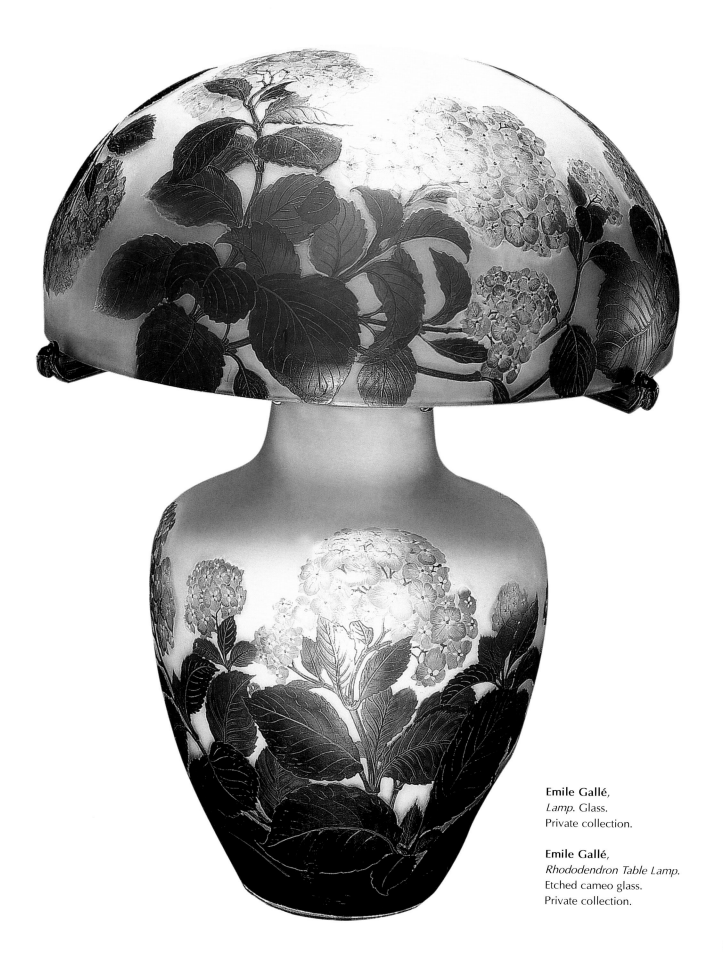

Emile Gallé,
Lamp. Glass.
Private collection.

Emile Gallé,
Rhododendron Table Lamp.
Etched cameo glass.
Private collection.

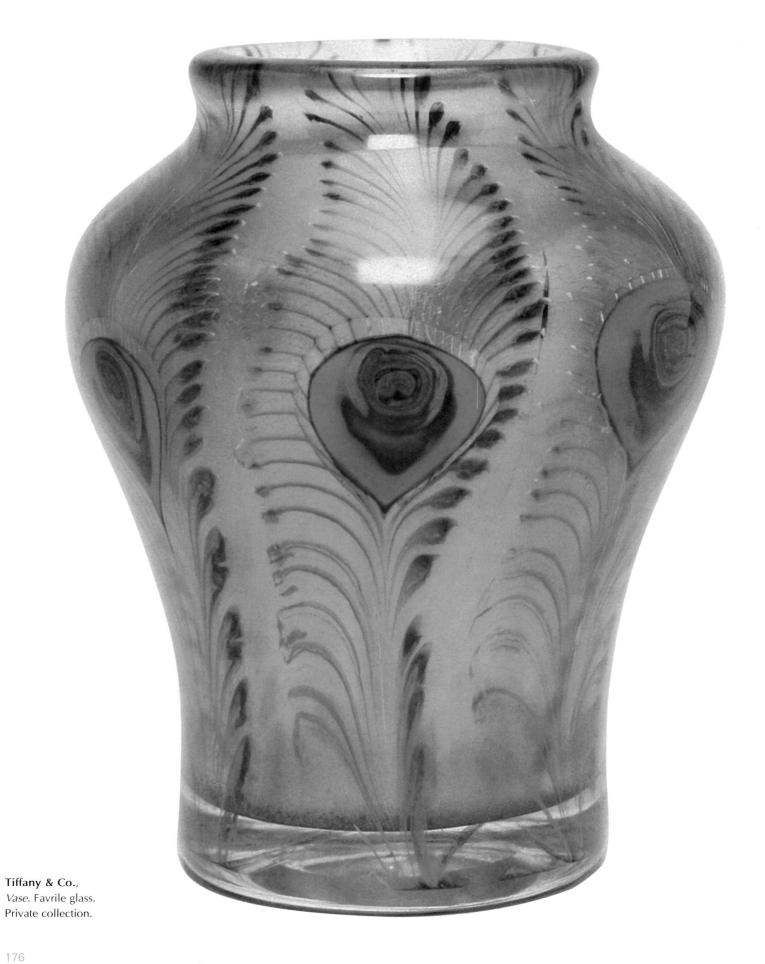

Tiffany & Co.,
Vase. Favrile glass.
Private collection.

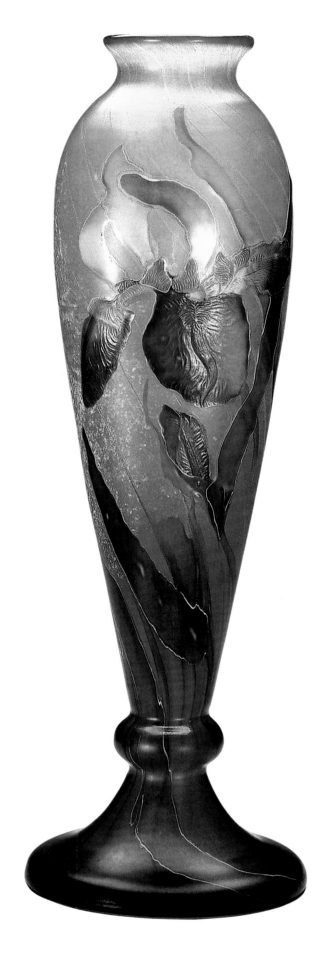

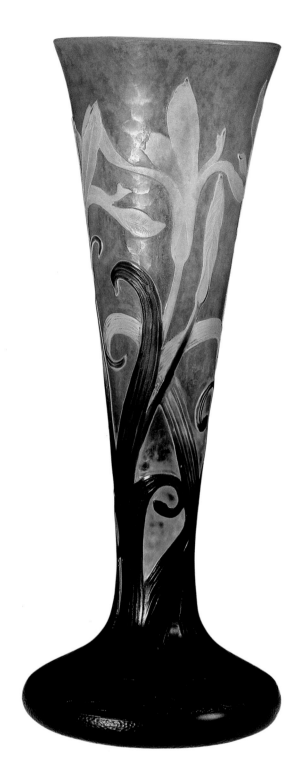

Emile Gallé,
Iris Vase. Wheel etched glass.
Private collection, Japan.

Daum,
Vase with Irises and Leaves.
Wheel carved cameo glass and
hammered background.
Cicko Kusaba collection, Japan.

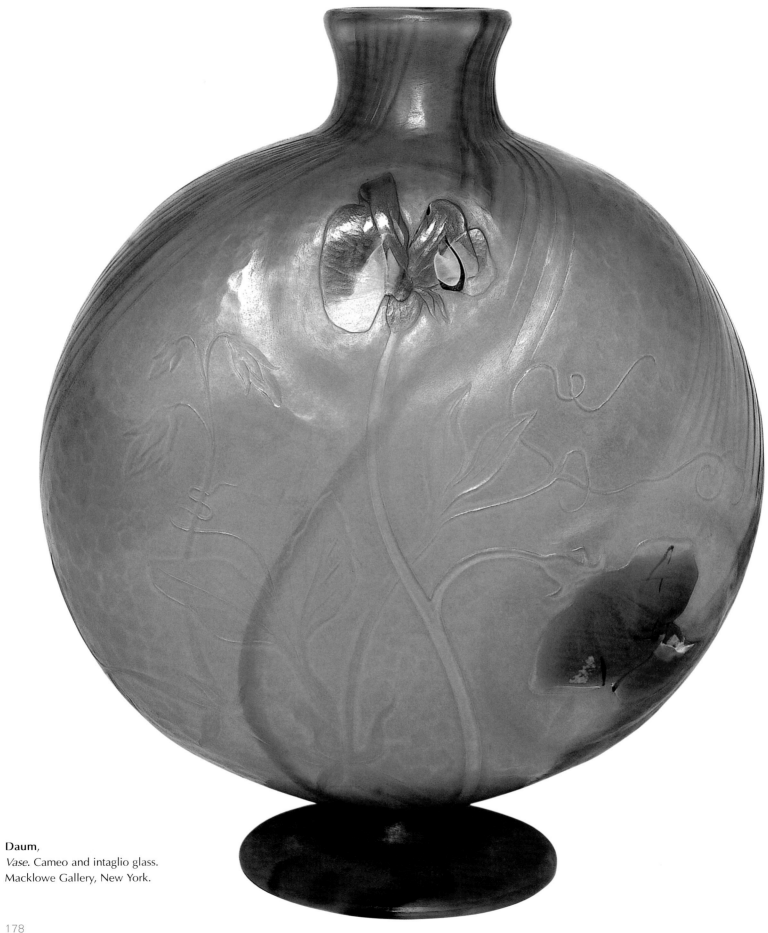

Daum,
Vase. Cameo and intaglio glass.
Macklowe Gallery, New York.

Emile Gallé outlived his father by a mere two years, dying prematurely of leukaemia in 1904. After his passing, Gallé's widow assumed management of the glass works until the First World War. Glass from this period is recognisable by the presence of an engraved star after the master's signature.

Gallé's works were produced until 1933. In 1935 the factory closed permanently.

The Daum brothers: Auguste (Bitche, 1853 - Nancy, 1909) and Antonin (Bitche, 1864 - Nancy, 1930)

The story of the Daum dynasty begins in France, in the town of Bitche (Lorraine).

Auguste and Antonin were born there in 1853 and 1864, respectively, the sons of Jean Daum. In 1871, when the town was annexed to Germany after the war of 1870, and while Auguste was studying Greek and Latin, the elder Daum decided to sell his practice and move his family to Nancy.

In France, Auguste trained in law in Metz, Nancy, and Paris, where he obtained his law degree.

The younger son Antonin attended school at Lunéville, then secondary school in Nancy.

In 1875, Jean Daum invested enough money in the Sainte-Catherine glass works in Nancy to take it over and changed the name *Daum et fils* (Daum and Sons).

In 1879, the company was in poor financial health and Auguste abandoned the subsidiary that he was focusing on in order to assume management of the firm.

The elder Daum died in 1885.

In 1887, Antonin graduated from the Ecole Centrale de Paris. An engineer, he joined the art glass division opened two years earlier by his brother and henceforth began to devote himself to revitalising the forms and decoration of the company's creations. In 1891, Auguste turned full management of the firm over to Antonin.

Fascinated and won over to Art Nouveau through the works of Emile Gallé, Auguste gave his younger brother all the necessary means to follow the trend that was already being promoted by the Frenchman from Nancy.

Auguste's management style and Antonin's creative ability gave a new dimension to glassmaking, one that was equally commercial and artistic.

Daum glassmakers were the greatest masters of all the techniques of their art, including furnace work, acid etching, wheel engraving, hammered glass, and painting with gold leaf and enamel. But Daum also rapidly implemented new methods for glasswork and for which they held patents.

The arrival of Almaric Walter in 1904 had a significant impact on these developments. Trained at the National Porcelain Factory in Sèvre, Walter contributed to the spread of the glass paste technique within the firm, by giving his apprentices original ideas for glass designs and forms. In this way, guided through the evolution of an artistic époque and its own taste, Daum expanded its vase vitrification and casting processes, but also created new processes that enabled it to decorate its works. Ornamentation henceforth took new forms and colours, in particular thanks to new vitrification processes, inserted decorations, and motifs in relief. By partnering with Majorelle, the Daum firm also produced beautiful decorative covers for electric lights.

Daum,
The Grape Vine. French *pâte de verre*,
applications in relief and wood. First
pâte de verre made by Almaric Walter.
Private collection, Japan.

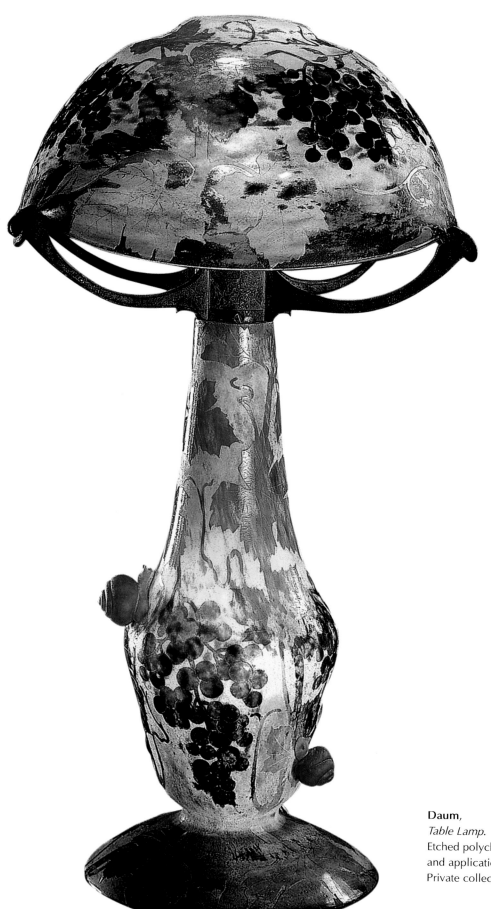

Daum,
Table Lamp.
Etched polychrome cameo glass
and applications in relief.
Private collection.

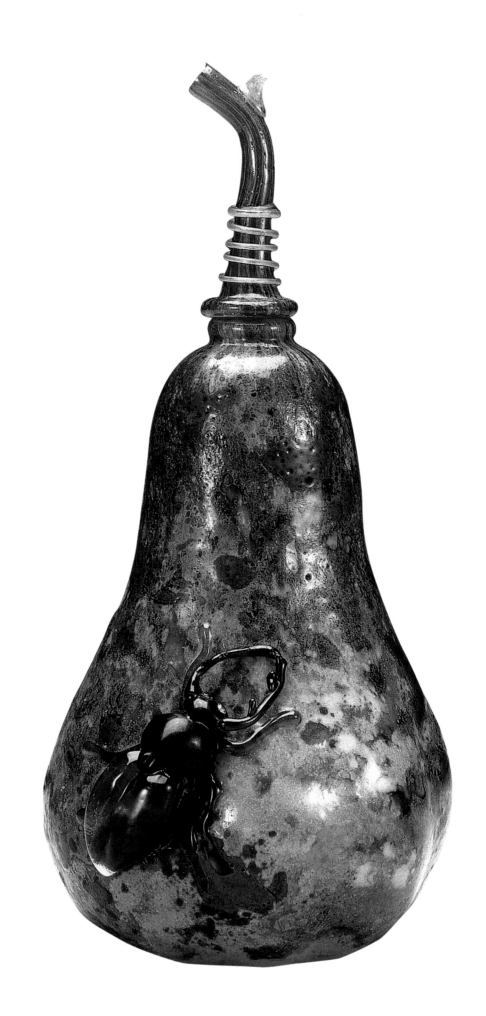

Daum,
Bottle. Polychrome glass surface
and applications in relief.
Private collection, Japan.

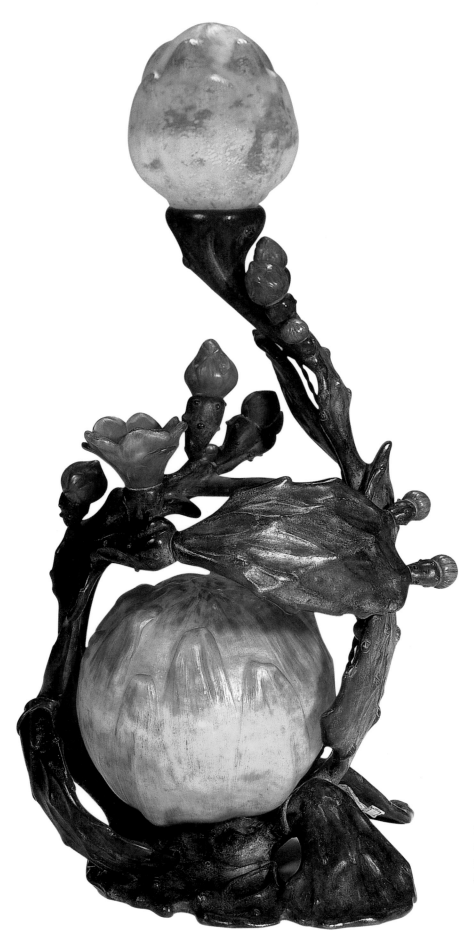

Daum and **Majorelle**,
Prickly Pear Table Lamp, 1902.
Patinated bronze and glass.
Musée de l'Ecole de Nancy, Nancy.

In addition to these prestigious collaborations, Daum studios trained some of Art Nouveau's greats, such as the painter Jacques Gruber, the Schneider brothers, and the master decorator Henry Berger.

At the instigation of Emile Gallé, the Daum brothers were part of the movement that gave rise to the School of Nancy, in which Antonin served as an early Vice-president.

Simultaneously, in 1904 Auguste became Presiding Judge of the Nancy Tribunal de Commerce (commercial trade court). Upon his premature death in 1909, his younger brother took over the family business alone.

After the First World War, Antonin adapted the firm to modern production conditions with the intention of maintaining the focus on quality and aesthetics that had made it famous. Still in tune with contemporary taste, Daum glassworks moved towards Art Deco in the 1920s.

Antonin Daum died in 1930. The by then internationally-recognised glassworks would long remain a family business. In 1982 it was purchased by the Compagnie française du cristal (CFC) and later sold to SAGEM in 1995.

René Jules Lalique (Ay, 1860 – Paris, 1945)

René Lalique was born in the little French village of Ay in la Marne in 1860.

From 1876 to 1878, he apprenticed with a Parisian jeweller named Louis Aucoq. Then he left to study in London for two years at the Sydenham Art College from 1878 to 1880.

After returning to Paris, he earned his living by offering his designs to jewellers and by selling motifs for tapestries, fabrics, and fans.

In 1882, Lalique took a sculpture class taught by Justin Lesquieu at the Ecole Bernard Malissy where he also studied printmaking.

In 1885, his mother's financial assistance allowed him to purchase the studio of Jules Destape; at this time he also sold drawings of his designs, in particular to Cartier, Boucheron, and Verver.

Lalique quickly abandoned the use of the diamonds in jewellery in order to work with materials that were new at the time: semi-precious stones, as well as horn, ivory and glass.

Five years later, Lalique designed pieces for Bing's new Parisian shop called "L'Art Nouveau".

In 1894, Lalique designed costume jewellery for the actress Sarah Bernhardt, which immediately catapulted him into the jewellery (Decorative Arts) sections of the Salons, such as the Salon de la Société des Artistes Français.

Although an excellent sculptor, draftsman, and engraver, Lalique became world famous for his jewellery. He owed his reputation to the exhibitions in which he participated in Brussels, Munich, Turin, Berlin, London, Saint-Louis, and Liège.

In 1900, he won Grand Prize at the Universal Exposition in Paris and was named Chevalier de la Légion d'honneur.

Lalique was then the most famous of the Art Nouveau *joailliers*. His fame was such that when we speak of Art Nouveau jewellery today, we refer to the "Lalique type": works primarily in the category of flora and fauna, including peacocks and insects.

In 1902, he started construction on his design firm.

A commission to create a perfume flacon was the turning point in his career.

René Lalique,
Suzanne Bathing, c. 1925. Glass.
Private collection.

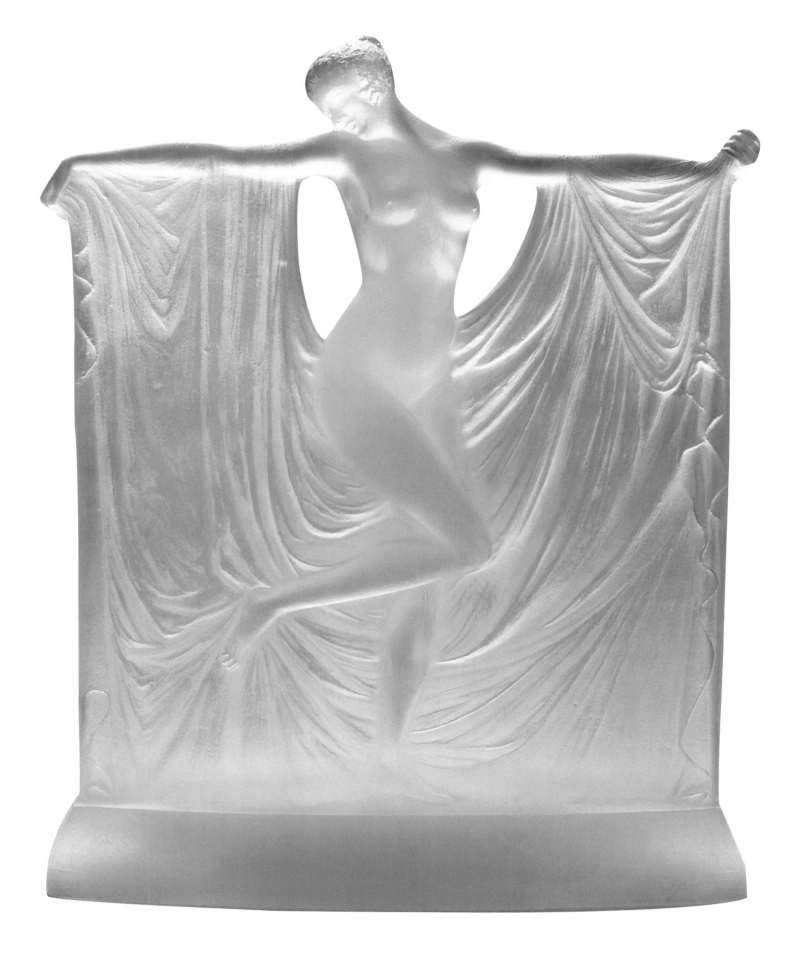

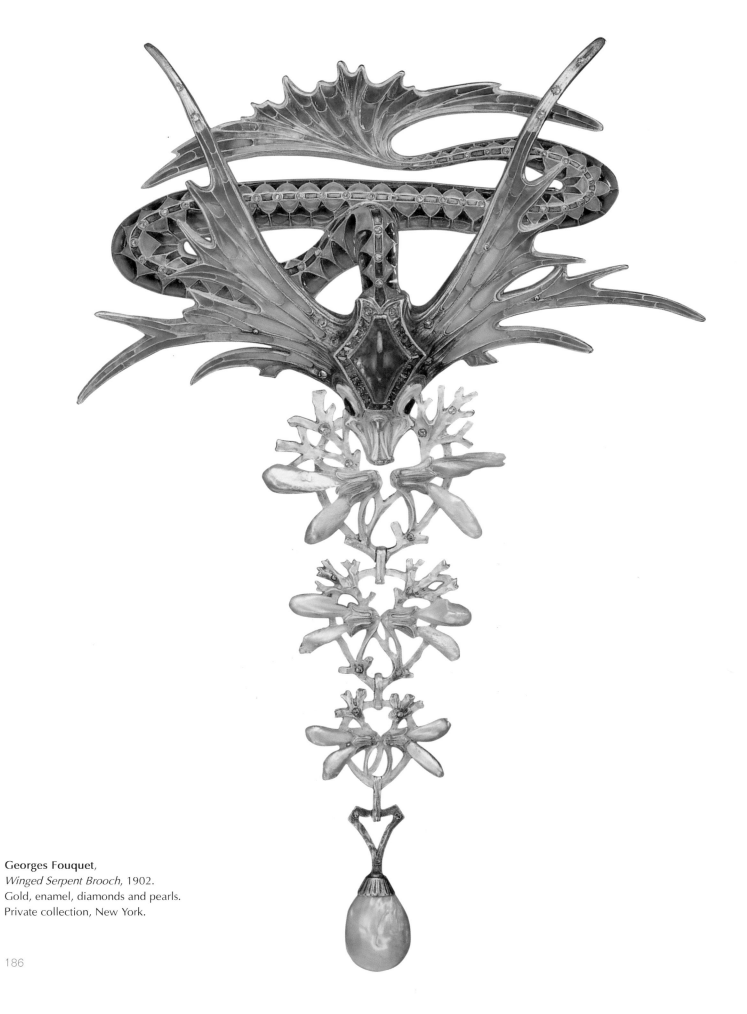

Georges Fouquet,
Winged Serpent Brooch, 1902.
Gold, enamel, diamonds and pearls.
Private collection, New York.

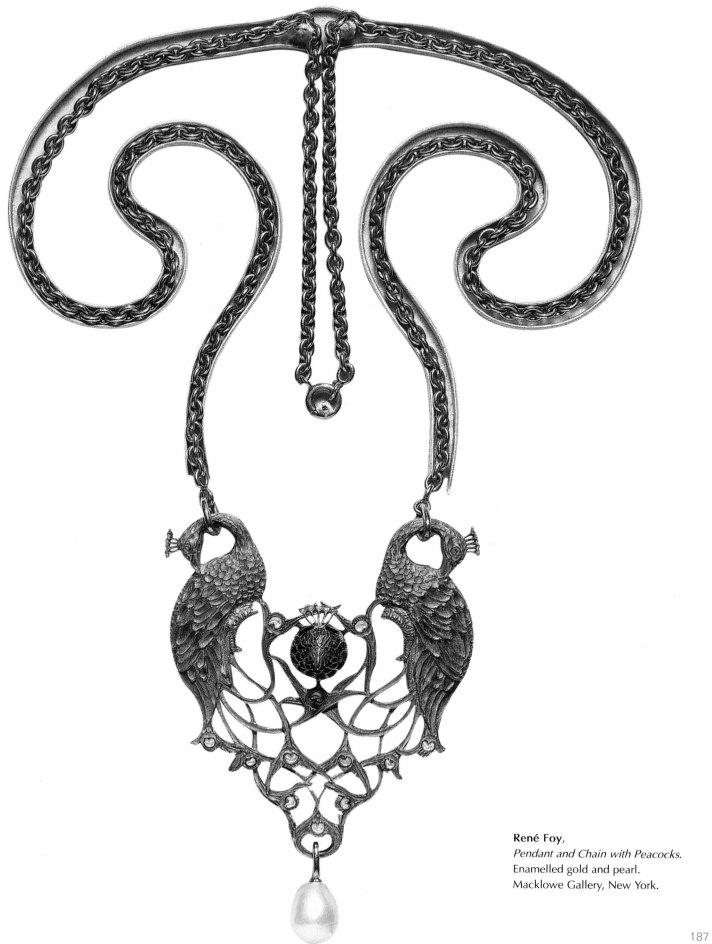

René Foy,
Pendant and Chain with Peacocks.
Enamelled gold and pearl.
Macklowe Gallery, New York.

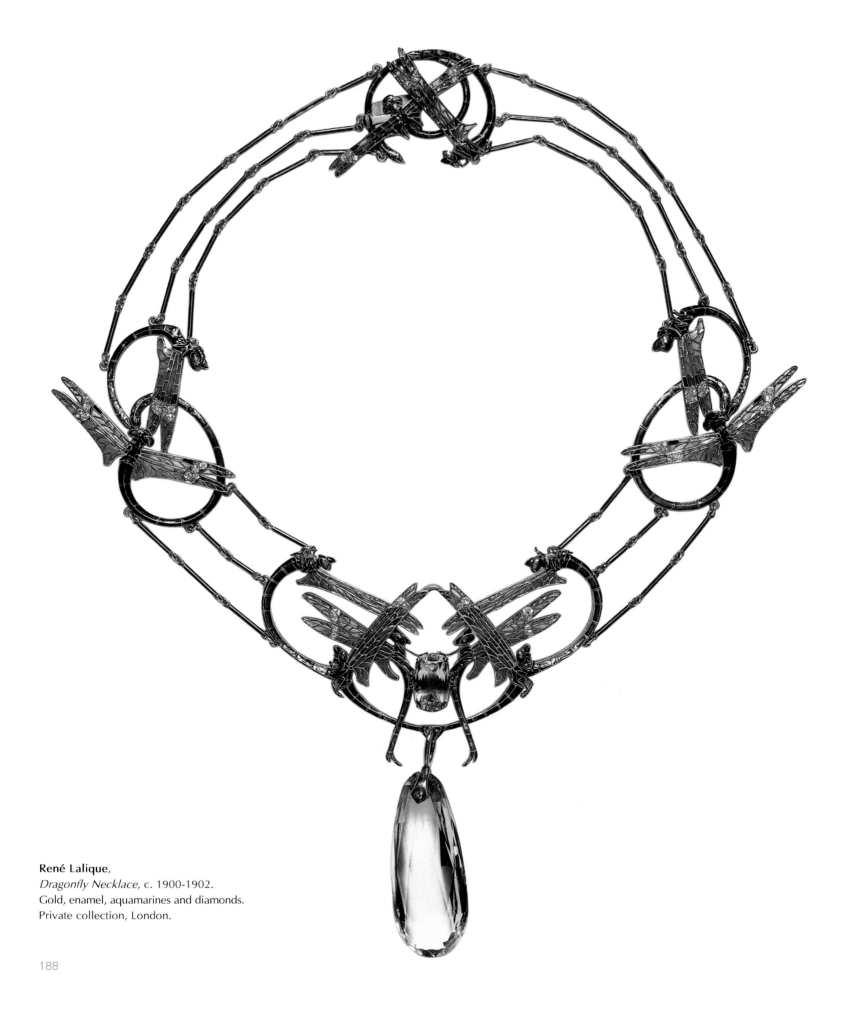

René Lalique,
Dragonfly Necklace, c. 1900-1902.
Gold, enamel, aquamarines and diamonds.
Private collection, London.

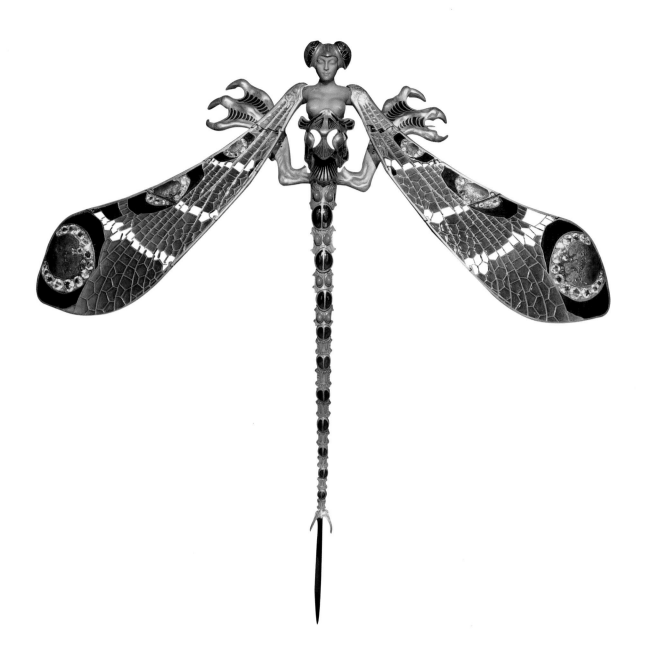

Lalique quickly set himself up in a glass factory where he started working with glass, creating perfume flacons. Soon he was creating glass sculptures using the *cire perdue* or lost wax method.

After the First World War, he bought a glassworks in 1918, in Wigen-sur-Moder (Alsace), where he started a new career as a glassmaker at the age of fifty-eight.

Lalique had married the daughter of the sculptor Auguste Ledru and had a son named Marc who, beginning in the 1930s, followed in his father's footsteps. When he took over the firm in 1945, he changed production from glass to crystal.

Beginning in 1920, Lalique turned towards Art Deco and also created new aesthetic effects: the satiny Lalique and even opalescent glass pieces.

The artist's shining hour came at the 1925 Paris trade show. Not content to show in one pavilion, Lalique appeared in other pavilions as well, thanks to his astonishing glass fountains.

The company he founded is still in operation today.

René Lalique,
Dragonfly Woman Corsage Ornament,
1897-1898. Gold, enamel, chrysoprase,
diamonds and moonstone, 23 x 26.6 cm.
Museu Calouste Gulbenkian, Lisbon.

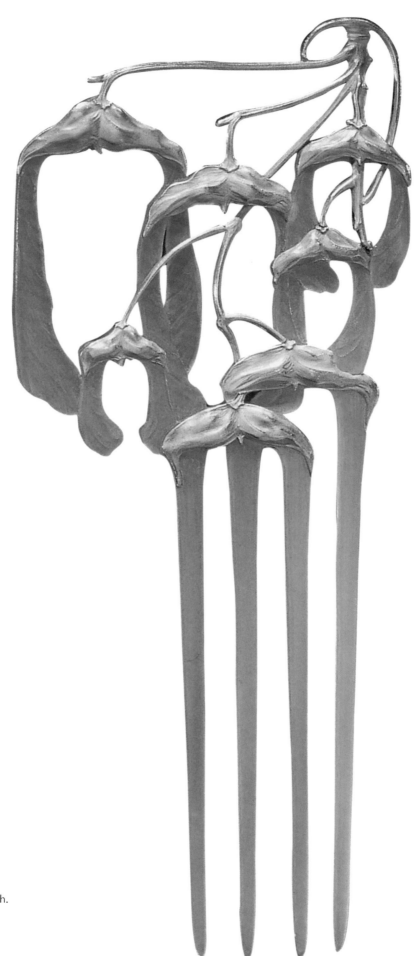

René Lalique,
Sycamore Comb, 1902-1903.
Horn and gold.
Bayerisches Nationalmuseum, Munich.

René Lalique,
Iris Bracelet, 1897.
Gold, enamel and opals.
Private collection, New York.

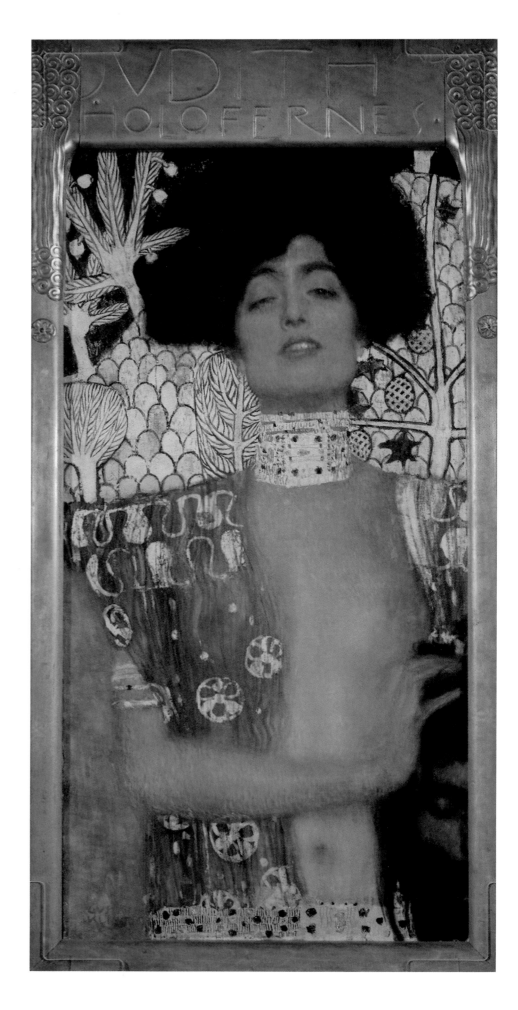

Gustav Klimt,
Judith I, 1901.
Oil on canvas, 82 x 42 cm.
Österreichische Galerie Belvedere,
Vienna.

Maurice Bouval,
Sleep or *Woman with Poppies*.
Gilt bronze and marble.
Victor and Gretha Arwas collection.

Notes

1. The artistic sensibility of a people is first evident in its decorative arts and architecture.

2. *The Studio*, the *Magazine of Art* and *L'Artiste* were art magazines published in London and Paris. This type of publication proliferated in the late nineteenth century as the public showed renewed interest in the decorative arts. *Art et décoration*, first published in Paris in 1897, is another magazine in this tradition.

3. There were many English book illustrators (especially for children's books): William Morris, Walter Crane, Sir J. Gilbert, Dante Gabriel Rossetti and Aubrey Beardsley. France had Eugène Grasset, Dinet and M. Leloir.

4. The school, which arose out of the work of Viollet le Duc, considered the architect as a project manager responsible for designing and harmonising construction, decoration and furnishings.

5. The asymmetrical and unsymmetrical furniture, the straight line broken by curved lines, these light supports, with their knots and curved tree trunks, are simultaneously inspired by Belgium, England and Japan.
 To get an idea of the genesis of Art Nouveau in the decorative arts, add to these influences the School of Nancy (in particular, the glassmaker Emile Gallé) and the Danes of the Royal Copenhagen porcelain factory. It is to Gallé, among others, that we owe the plant stylisation that was most successful motif in glassware, ceramics and silver.

6. In joaillerie, the following should also be mentioned: Lucien Gaillard, Georges Fouquet, René Foy and Eugène Feuillâtre.

7. The exemplary William Morris's tapestries, based on the cartoons of Sir Edward Burne-Jones, should also be included among the refined works that inspired Art Nouveau in England. Burne-Jones's compositions were pure and severe, like noble and solemn music. Among his many talents, Burne-Jones had a profound feeling for decoration: one part of his work is completely decorative.

8. Mucha also designed the tapestries for the Ginzey home in Vienna.

9. Prince Bojidar Karageorgevitch displayed a child's silver set at M. Gratscheff.

10. The Frenchmen Verneuil, Victor Prouvé and even Georges de Feure also produced designs for tapestries.

11. In France, Prouvé producing bookbinding with mosaic.

12. After Jules Chéret (the genre's creator and master), the following artists continued the illustrated poster tradition in France: Eugène Grasset, Alfonse Mucha, Théophile Steinlen, Adolphe Willette, Jules-Alexandre Grün, Henri de Toulouse-Lautrec, Hugo d'Alesis and Pal.

Bibliography

ARWAS, Victor, *Art Nouveau, The French Æsthetic*, Andreas Papadakis Publisher, Londres, 2002

CHAMPIGNEULE, Bernard, *Art Nouveau*, Barron's Educational Series Inc., New York, 1972

COULDREY, Viviane, *The Art of Tiffany*, Quantum Book, Londres, 2001

GREENHALGH, Peter, *L'Art nouveau 1890-1914*, Renaissance du Livre, Bruxelles, 2006

GREENHALGH, Peter, *The Essence of Art Nouveau*, Harry N. Abrams, New York, 2000

LYONNET, Jean-Pierre, DUPOND, Bruno, SULLY JAULMES, Laurent, *Guimard perdu, Histoire d'une méprise*, Alternatives, Paris, 2003

MACKINTOSH, Alastair, *Symbolism and Art Nouveau*, Thames and Hudson, Londres, 1975

VIGATO, Jean-Claude, *L'Ecole de Nancy et la question architecturale*, Editions Messene, Paris, 1998

VIGNE, Georges and FERRE, Felipe, *Hector Guimard*, Editions Charles Moreau, Paris, 2003

VSEVOLOD Petrov, *Art nouveau en Russie, le monde de l'art et les peintres de Diaghilev*, Editions Parkstone, Bournemouth, 1997

WOOD, Ghislaine, *Art Nouveau and the Erotic*, Harry N. Abrams, New York, 2000

Index